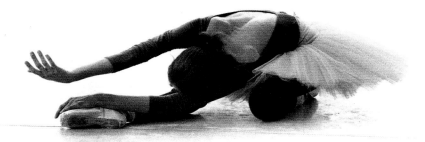

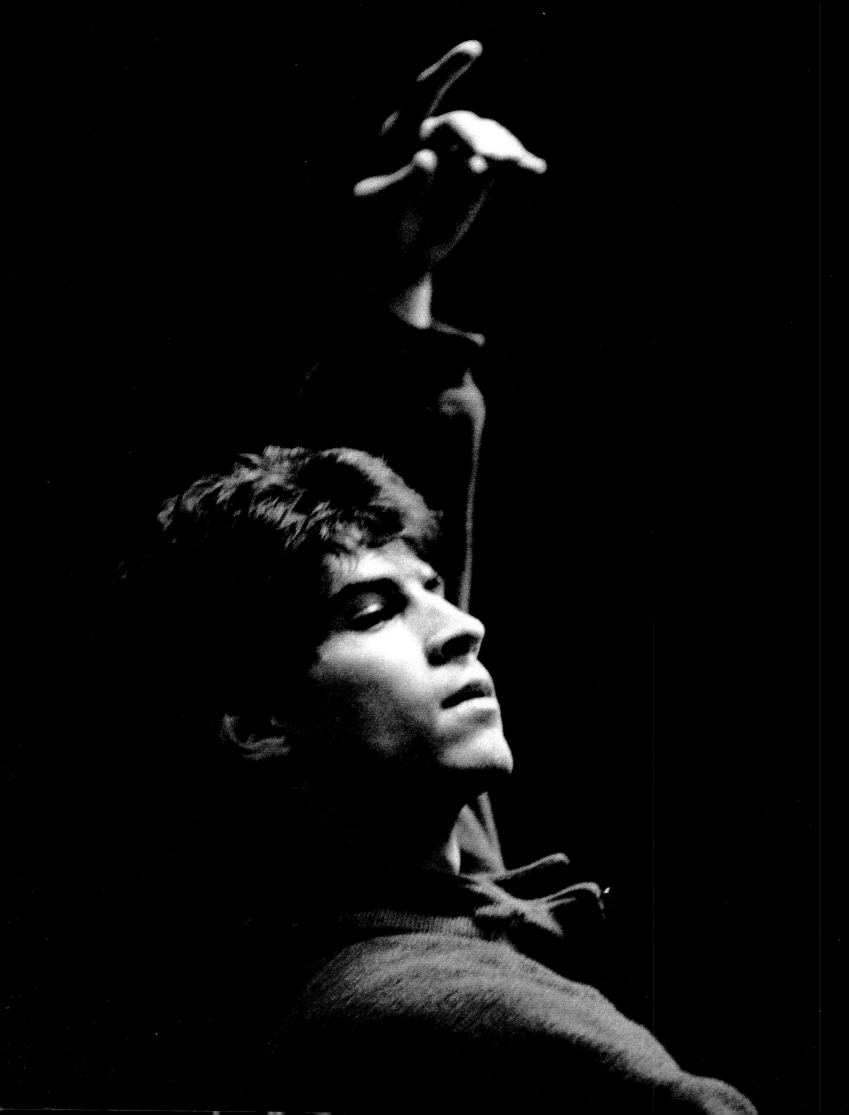

AT THE

BALLET

ONSTAGE, BACKSTAGE

by

Sandra Lee and Thomas Hunt

in association with

SAN FRANCISCO BALLET

Helgi Tomasson, Artistic Director

UNIVERSE

Concept, photography, and design by:
Sandra Lee and Thomas Hunt

Additional writing and editing by:
Patricia Manwaring and Christopher Ulrich

Dancer photo credits:
Cover: corps de ballet dancer Blanca Coma Roselló
First page: principal dancer Muriel Maffre
Title page: soloist Felipe Diaz
Table of contents page: principal dancer Tina LeBlanc
Last page: principal dancer Yuri Zhukov

First published in the United States of America in 1998
by Universe Publishing
A division of Rizzoli International Publications, Inc.
300 Park Avenue South
New York, NY 10010

98 99 00 01 02/ 10 9 8 7 6 5 4 3 2 1

Printed in Italy

Library of Congress Catalog Card Number: 98-61419

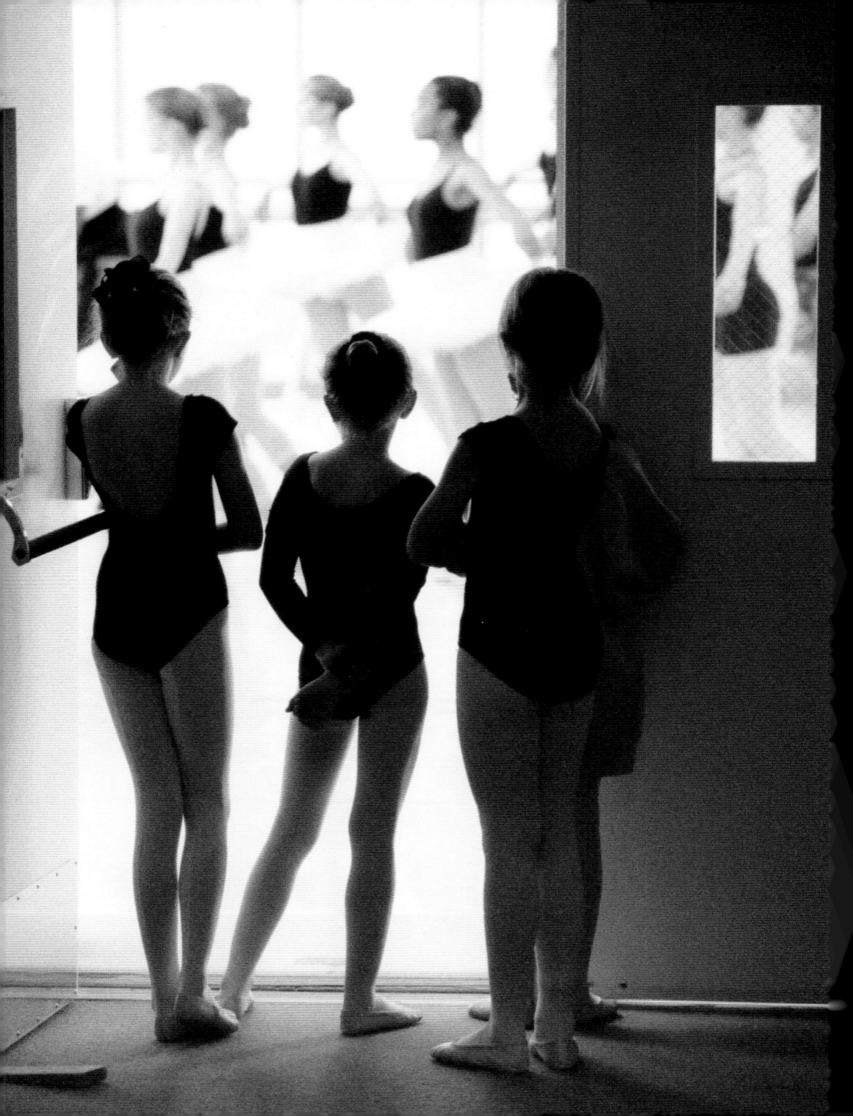

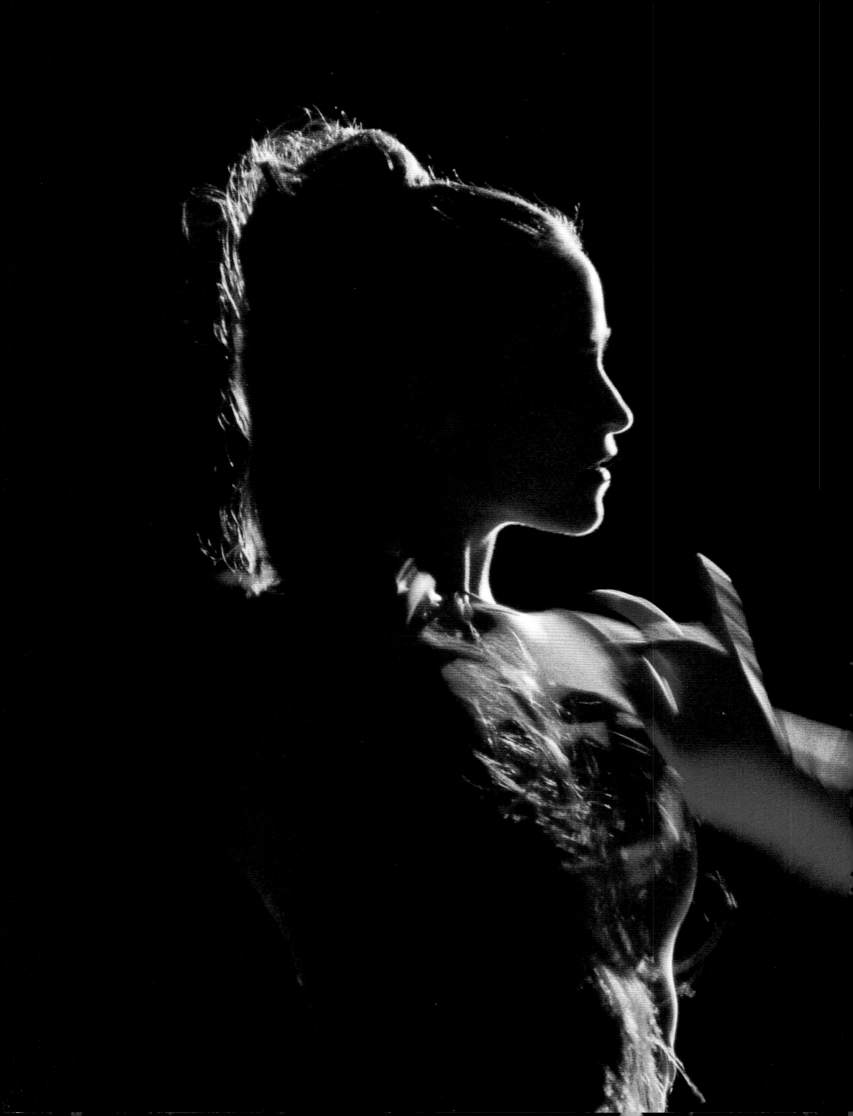

TABLE OF CONTENTS

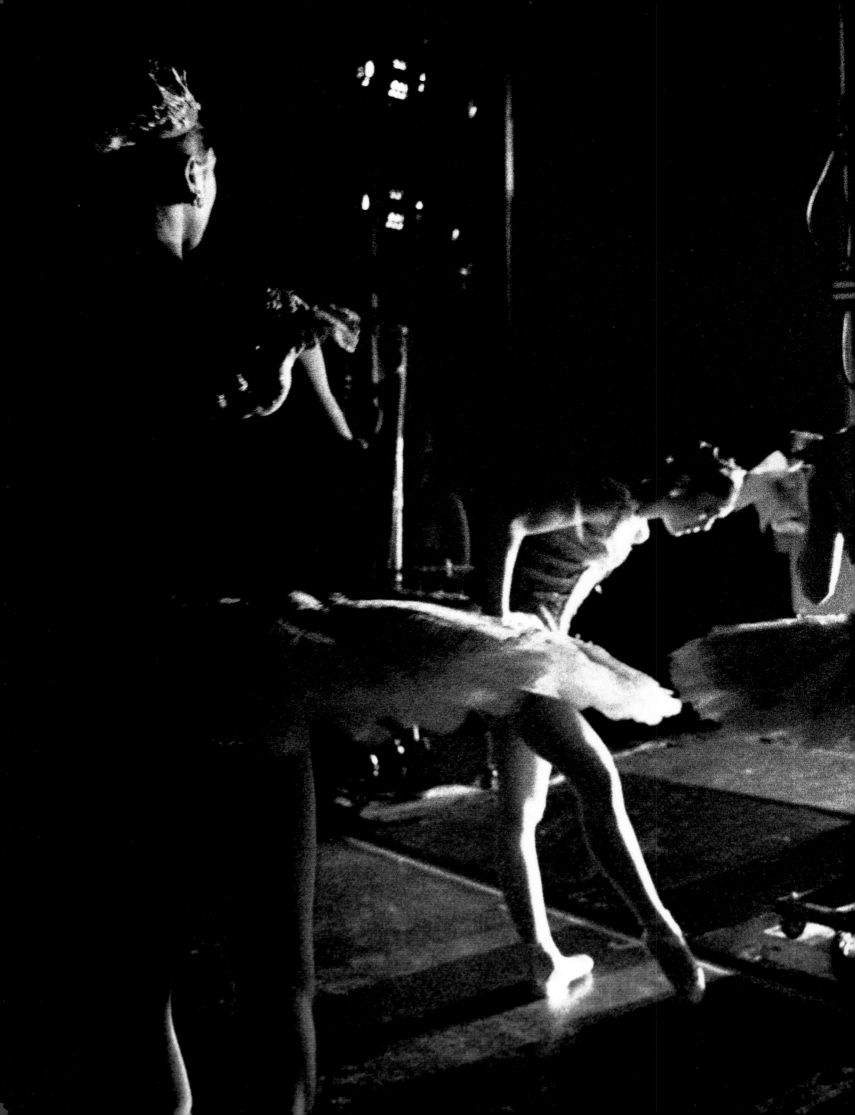

AT THE BALLET

When I was about twelve or thirteen years old, my ballet teacher took a group of us "ballerina hopefuls" to see a dress rehearsal of the Joffrey Ballet at the War Memorial Opera House in San Francisco. We felt so privileged sitting in the orchestra section of the majestic theater. Brimming with excitement, we watched as the dancers exploded onto the stage.

While the rehearsal was teeming with energy and beauty, it is what followed that touched my soul and remains indelibly etched in my memory: Our little group was led backstage, where we quietly watched as the company was being given their notes and corrections. They sat en masse and fatigued on the stage where they had just danced, listening intently to the ballet master. Some discussed their thoughts with their colleagues, suppressing laughter or tears; some would stand, moving in self-critical introspection. But what I witnessed was an incredible sense of community, a commitment to a special and shared goal, and an unmistakable love of their work, their art, and their fellow dancers. I knew at that moment that this was a world of which I wanted to be a part.

Access to that world is not ordinarily available to the audience, who sees the "finished product" with its illusion of effortlessness and transformation—only a small part of the dancers' work. The challenge of the photographers who created this book is then to capture the atmosphere of the very real effort, the magic it creates, and the ephemeral moments that make the profession so compelling. Without them, lost would be the moment the light catches a young dancer's incredulous face as she watches a performance from the wings; a choreographer's body language as the dancers attempt to rehearse his creation; a group of dancers hysterically laughing during rehearsals, the culprit easy to identify.

The photographs in this book not only reveal such moments but take you there from a unique vantage point. You meet the real people behind the illusion and hear in their words about personal struggles, joys, frustrations, and inspirations. You experience the sense of ritual, the constant process of reevaluation, and the humor to retain perspective. Perhaps there even exists a photo that captures the magical moment when a young dancer discovers a world that will determine the direction of his or her life, a world of which he or she must be a part.

- *Joanna Berman*

Principal dancers Joanna Berman and Jeremy Collins in Tomasson's Romeo and Juliet.

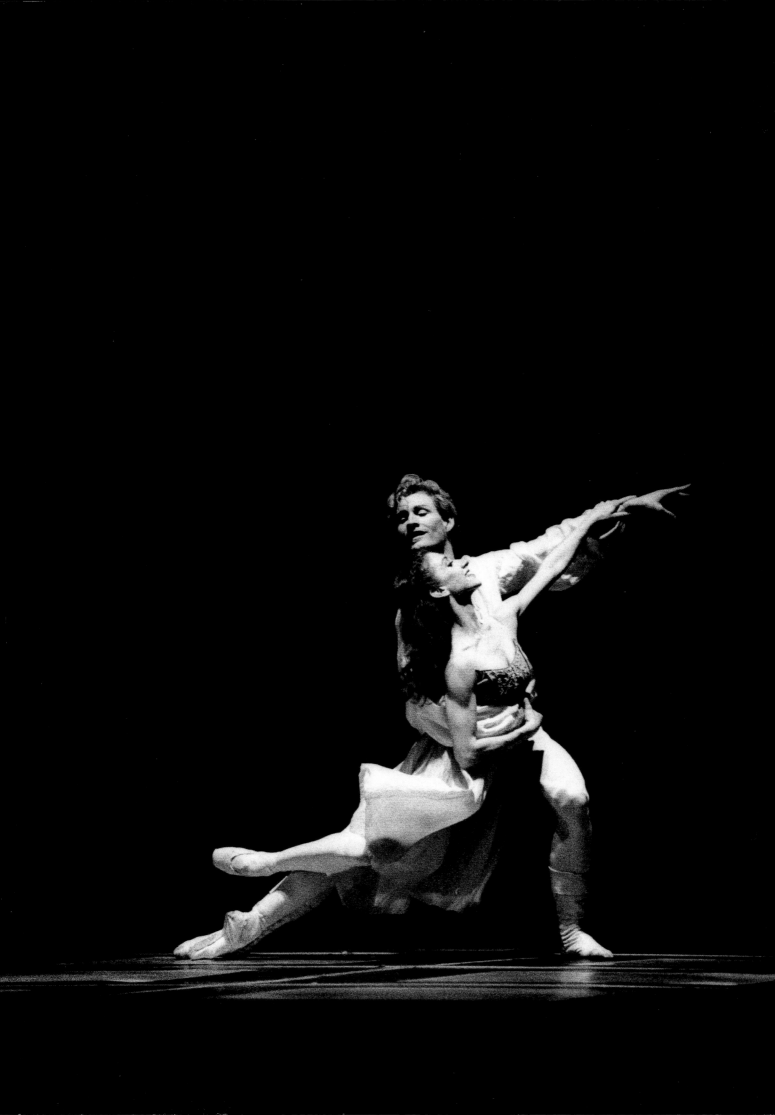

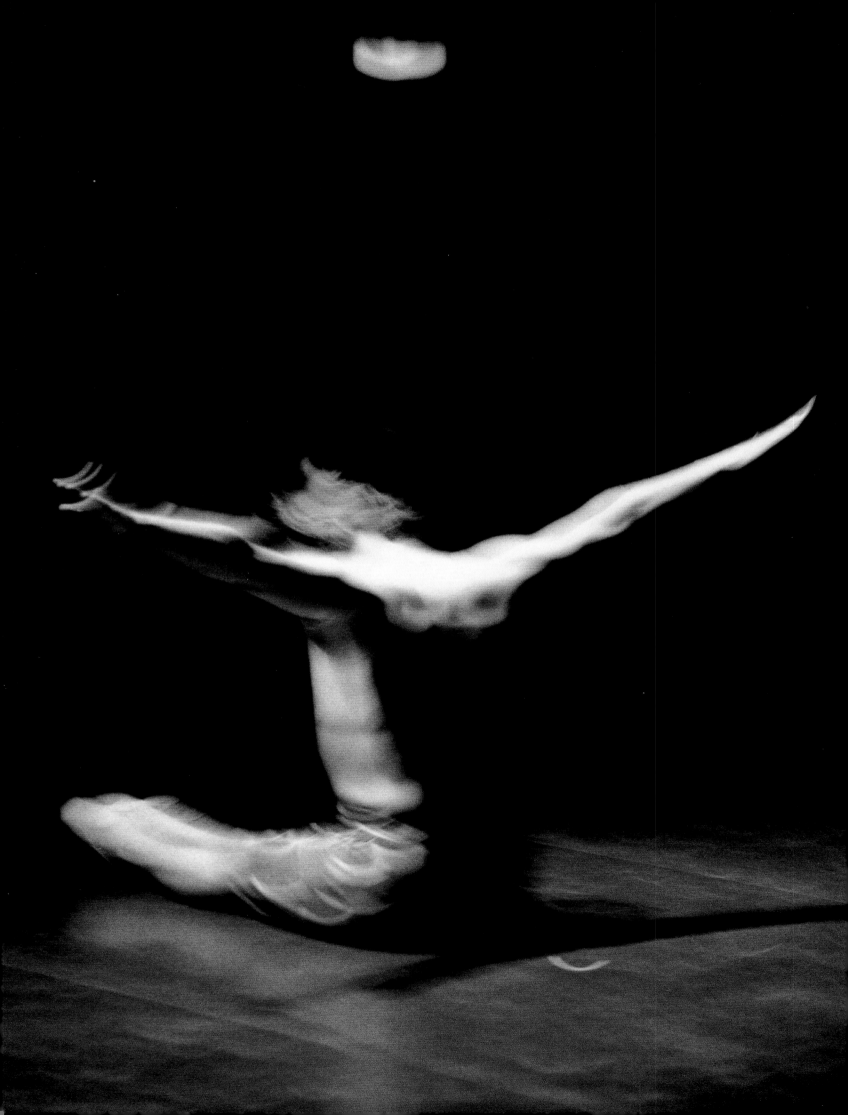

It is the dream of thousands of young dance students throughout the world to be selected for a position in a world-class company such as San Francisco Ballet. While a few realize this dream, the majority stray from such a difficult and competitive path. Through talent, good fortune, and extreme dedication, those who succeed achieve a deep awareness of their bodies as they move through space, and their souls as they touch an audience.

After years of rigorous training, young artists who are invited into San Francisco Ballet will likely begin as members of the corps de ballet. Such a position entails learning many new parts, struggling to find a place within the company, and striving to dance in precise unison with other dancers. In this company of sixty-five dancers, the corps de ballet comprises roughly half, while soloists and principals make up the remainder. One particular challenge in a corps member's career is standing out as a candidate for soloist while maintaining unity with the rest of the corps.

Soloists are cast in more technically demanding roles where they are the focus of attention. Achieving this level can involve a certain fearlessness onstage, as is the case for soloist Kristin Long, who told us that she feels completely at home when performing—and it shows.

Principal dancers have achieved the highest recognition in the company. The paths to this level and the qualities that make up a principal are as varied as the artists who earn the title. Some dancers, such as Roman Rykine from Russia, begin their professional careers as principal dancers, but this is rare. Most rise through the ranks, spending a few years in the corps and then a few more as a soloist before being promoted to principal. Julia Adam, a principal dancer from Canada, was told as a soloist that she would probably not be promoted to principal. She said this freed her mind and gave her a new abandon in her dancing. Artistic Director Helgi Tomasson noticed this change and promoted her to principal the following year.

Dancers in the corps are often given soloist and sometimes principal roles to test their potential and encourage their development as artists. When Elizabeth Loscavio was nineteen and a member of the corps de ballet, Tomasson gave her the demanding pas de deux: Marius Petipa's *Le Corsaire*, to learn in just a few hours. Replacing a principal dancer who was injured, she performed beautifully that night and quickly advanced through the ranks thereafter.

As Artistic Director, Helgi Tomasson sets the tone and direction for the company. He selects the dancers, determines who will advance, casts the ballets, crafts the repertoire, choreographs, coaches, and has the final say on all artistic decisions relating to the company and the school. When he is not in San Francisco working with the company, Tomasson can most likely be found traveling around the world looking for dancers, choreographers, and pieces for the repertoire. In addition, he looks at other companies to keep up on what is happening in the world of dance.

Many company dancers have expressed their belief that Tomasson has a knack for finding talented artists who will work hard, and, most importantly, work well with their peers. He is also known for creating a repertoire that mingles exciting new ballets by the world's best contemporary choreographers with a variety of well-known modern works, as well as full-length classics such as *Giselle, Romeo and Juliet, Swan Lake,* and *The Sleeping Beauty.*

At any given rehearsal it is quite common for several languages to be spoken, as the company is comprised of dancers from Australia, Belgium, Canada, China, Cuba, Denmark, England, France, Japan, Russia, Scotland, Spain, Switzerland, the United States, and Ukraine. Though the ethnic histories of the company members are richly diverse, the often multilingual dancers share a common culture of passion for ballet.

We began photographing San Francisco Ballet in September 1992 and continued through April 1998. Over this time we were able to build a comfortable relationship with the company, which helped us to achieve a unique and authentic view into their world. The text is derived from interviews and conversations with dancers, choreographers, and others associated with the company. It has been a privilege spending time with these remarkable artists, and we hope to communicate through photography, text, and design, the experience of being onstage and backstage at the ballet.

- Sandra Lee and Thomas Hunt

Principal dancer Stephen Legate in Val Caniparoli's Lambarena.

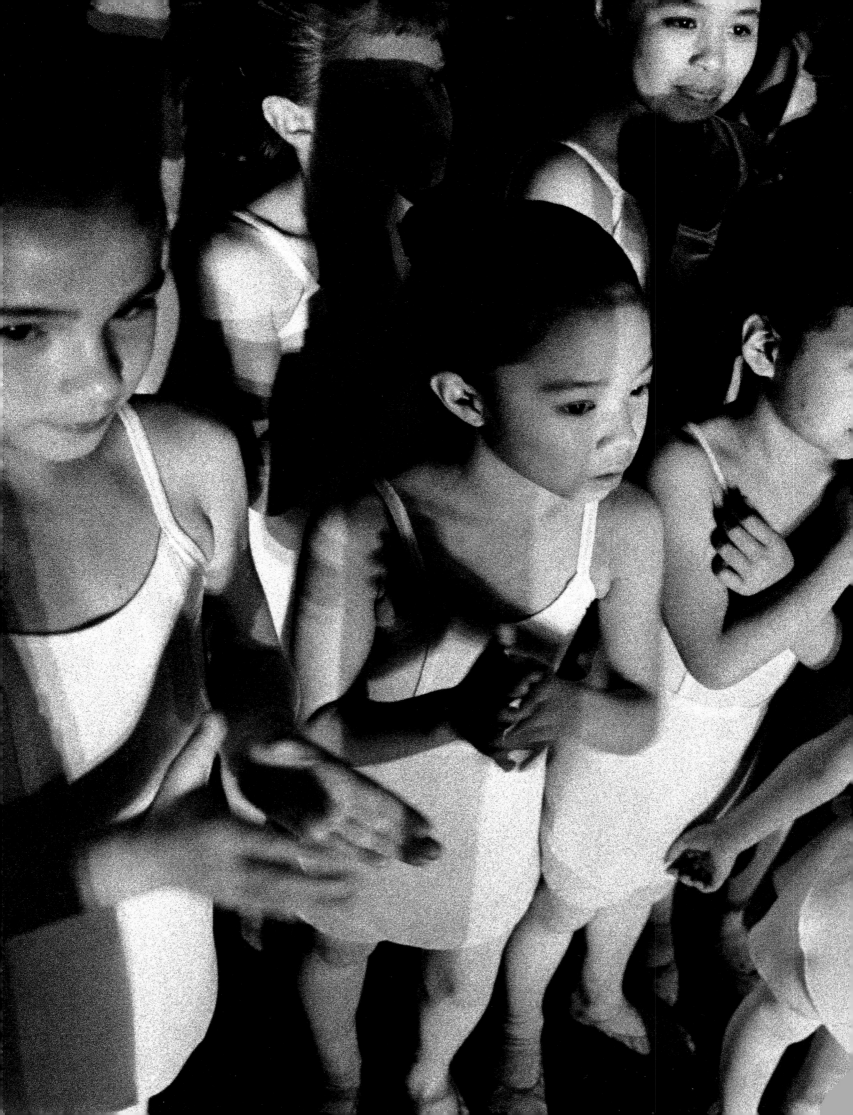

FIRST STEPS

"SOMETIMES YOU CAN TELL from the first day you meet a child that this one is a dancer.
It doesn't happen very often, but it happens. You can see the passion in their eyes." - *Associate director of the school,*
Lola de Avila. Level-two student in class (above). Level-two students stretching in class (right).

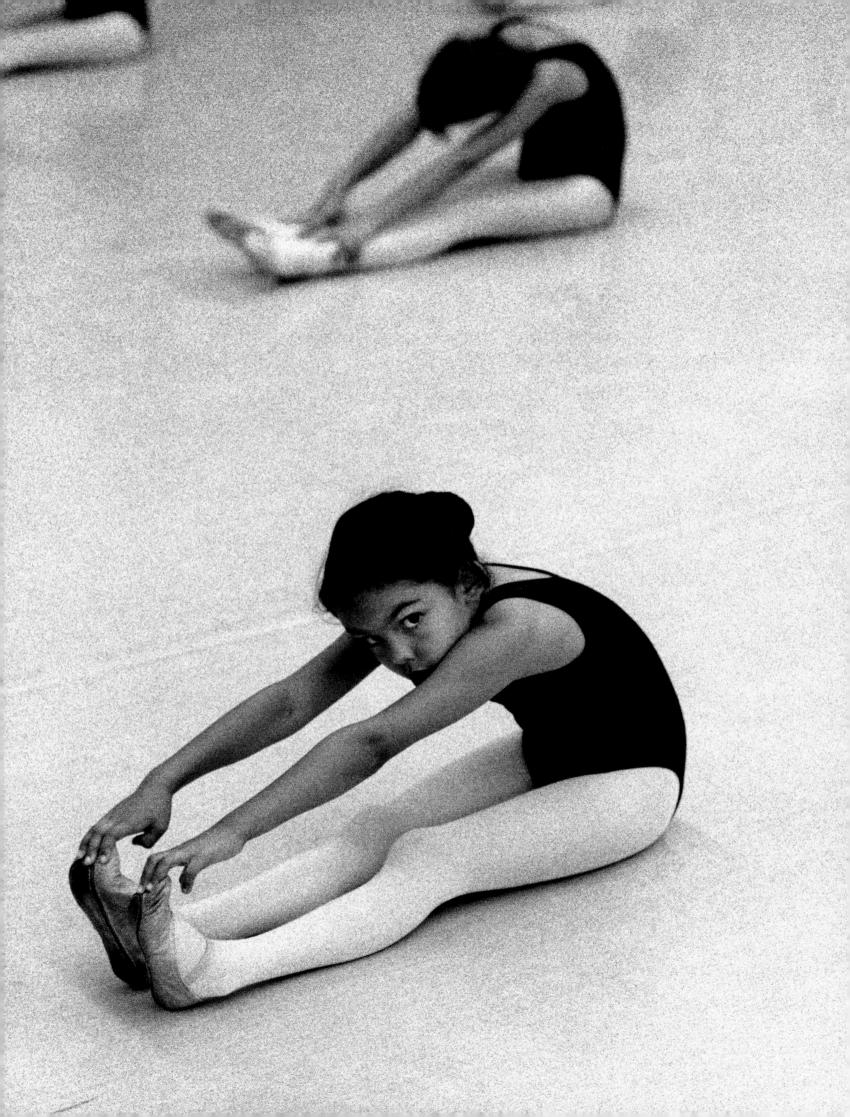

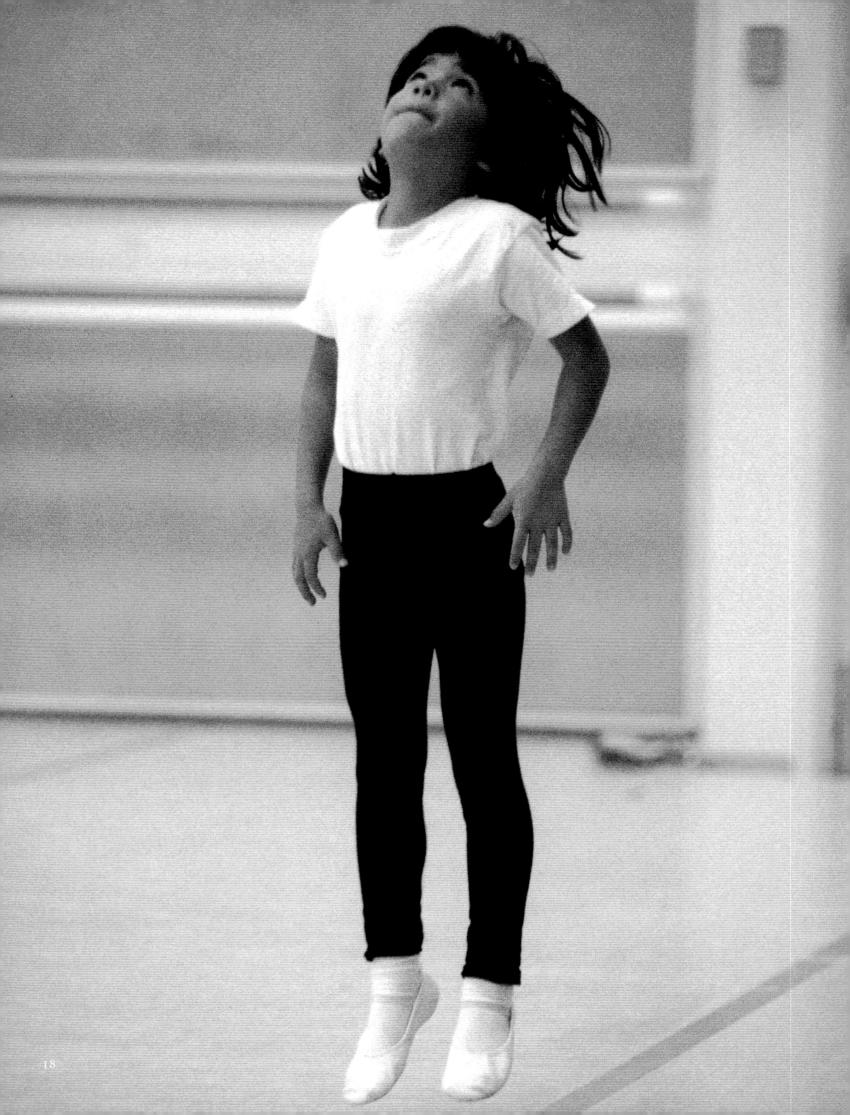

MANY OF THE PROFESSIONAL DANCERS in San Francisco Ballet have risen through the ranks of the San Francisco Ballet School. The school, which shares a building with the company, begins accepting students as young as age seven into the first of eight levels. The youngest children attend class two or three days a week to begin learning the basic positions, steps, and vocabulary of ballet. Students follow a structured training program designed to increase technical skills, stamina, and discipline. *Boys in level-one practice their jumps.*

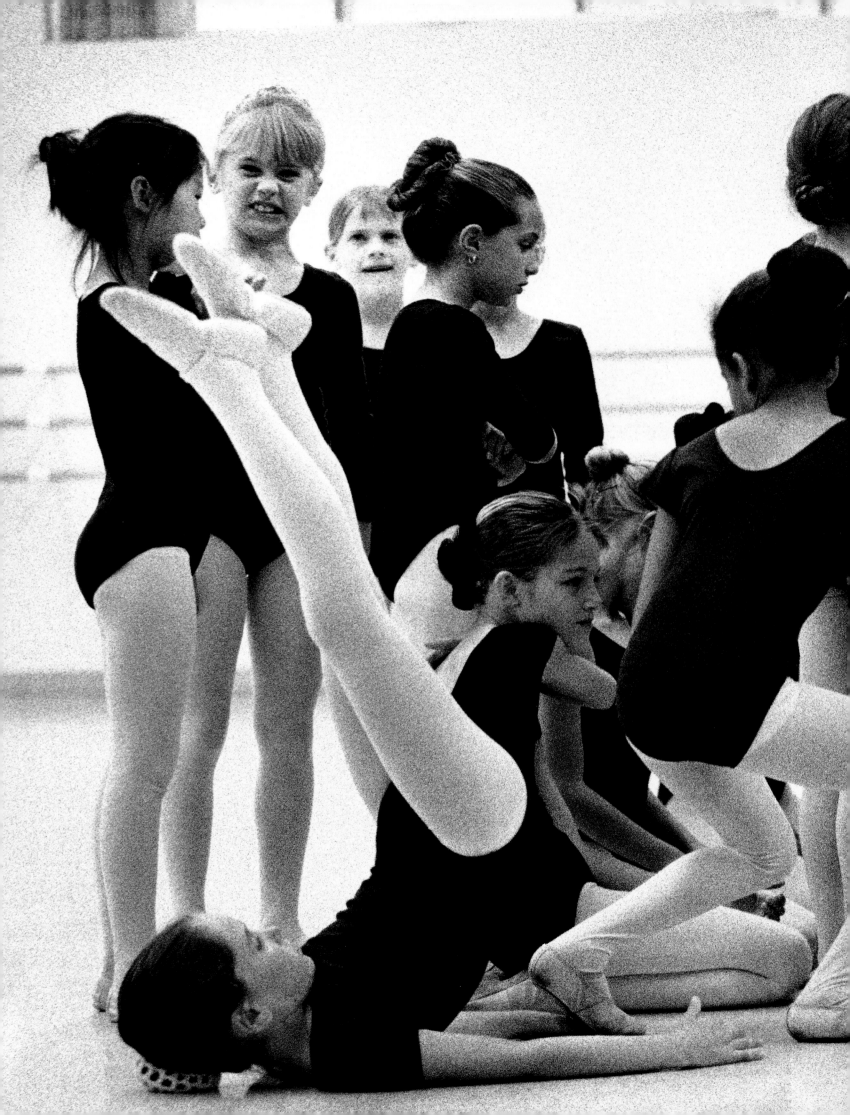

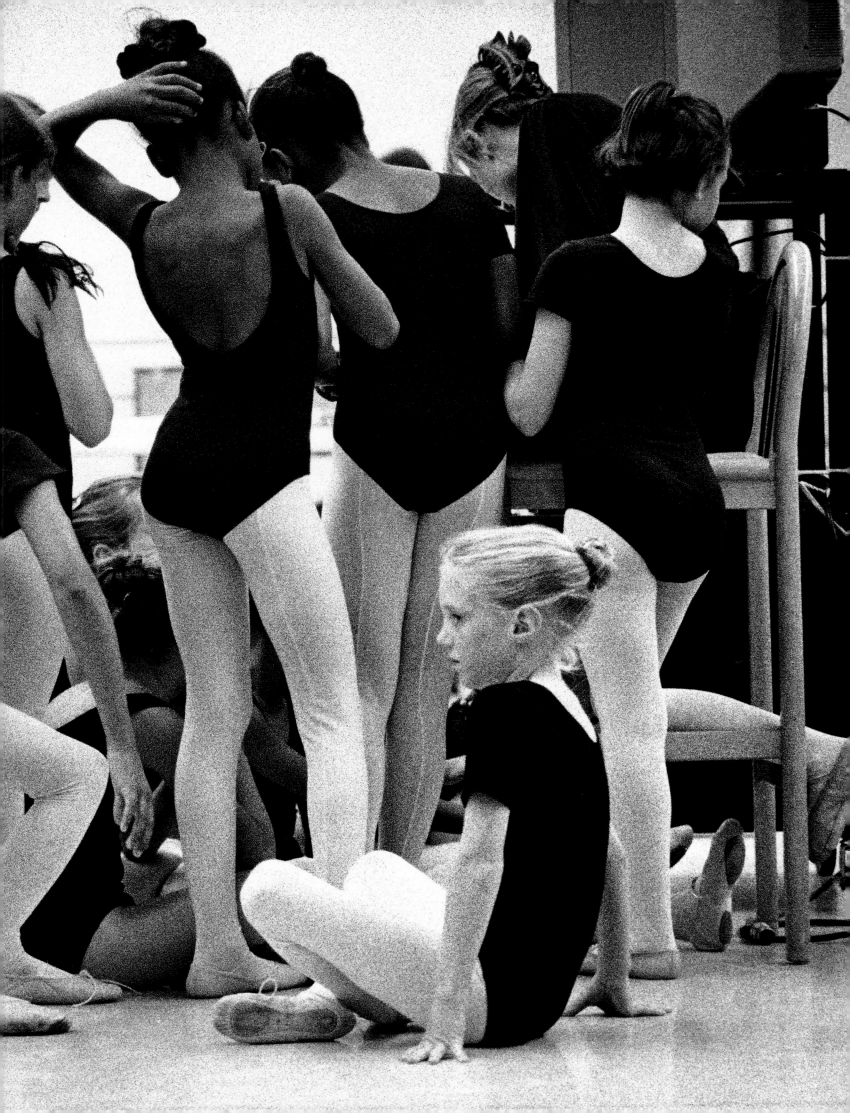

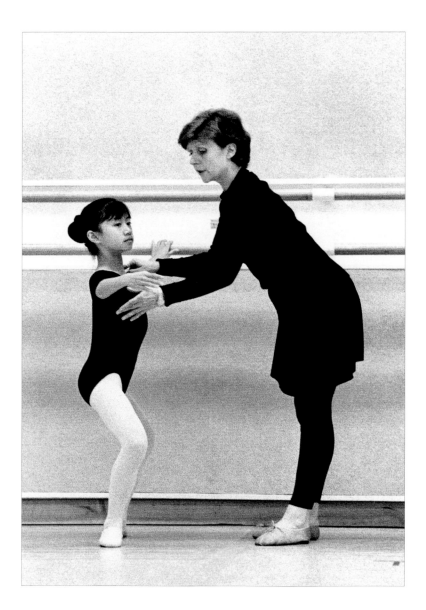

"YOU HAVE TO BE VERY CLOSE to your students. You teach them, but you have to be open to learn from them. It's also very important that you explain why they do what they do, not just how to do it. They are not machines; they have to know why they must do something a certain way. If you teach like this from the beginning, they can correct themselves and eventually, they become their own teachers." - *Lola de Avila, associate director of the school. Level-two student receiving corrections from Lola de Avila (above). Level-two student in class (right).*

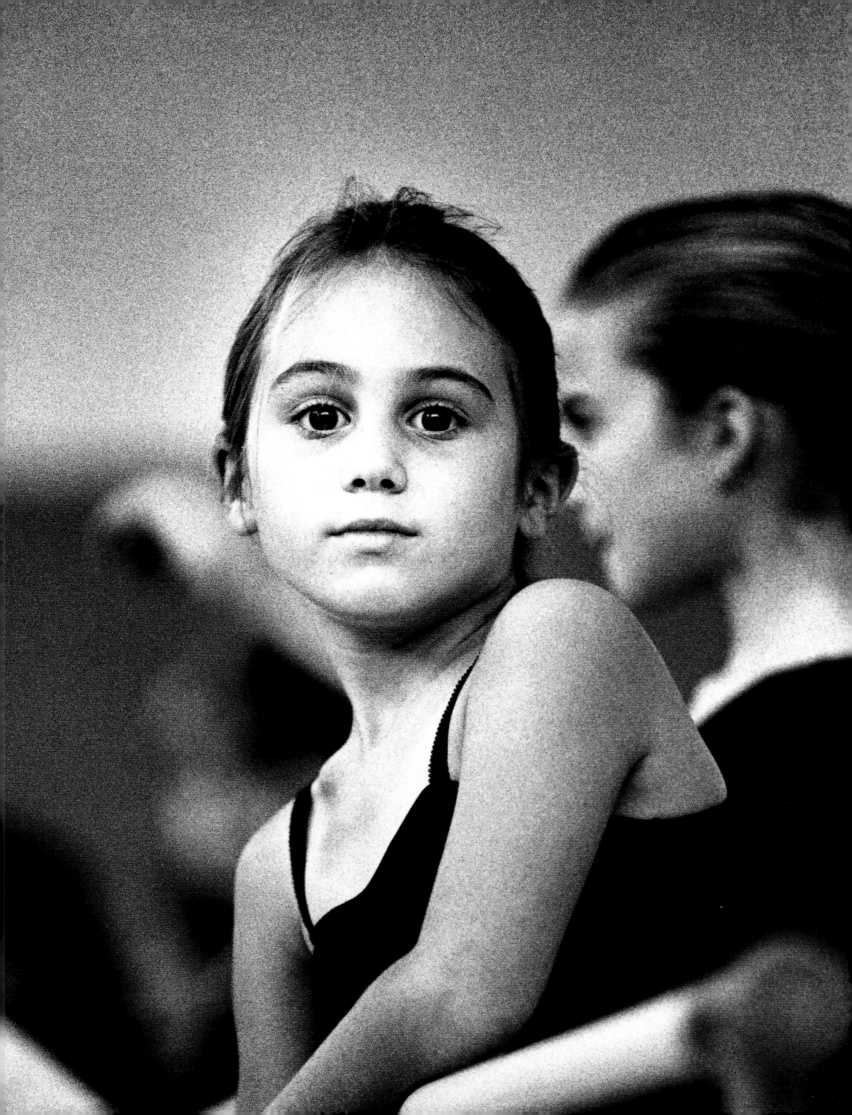

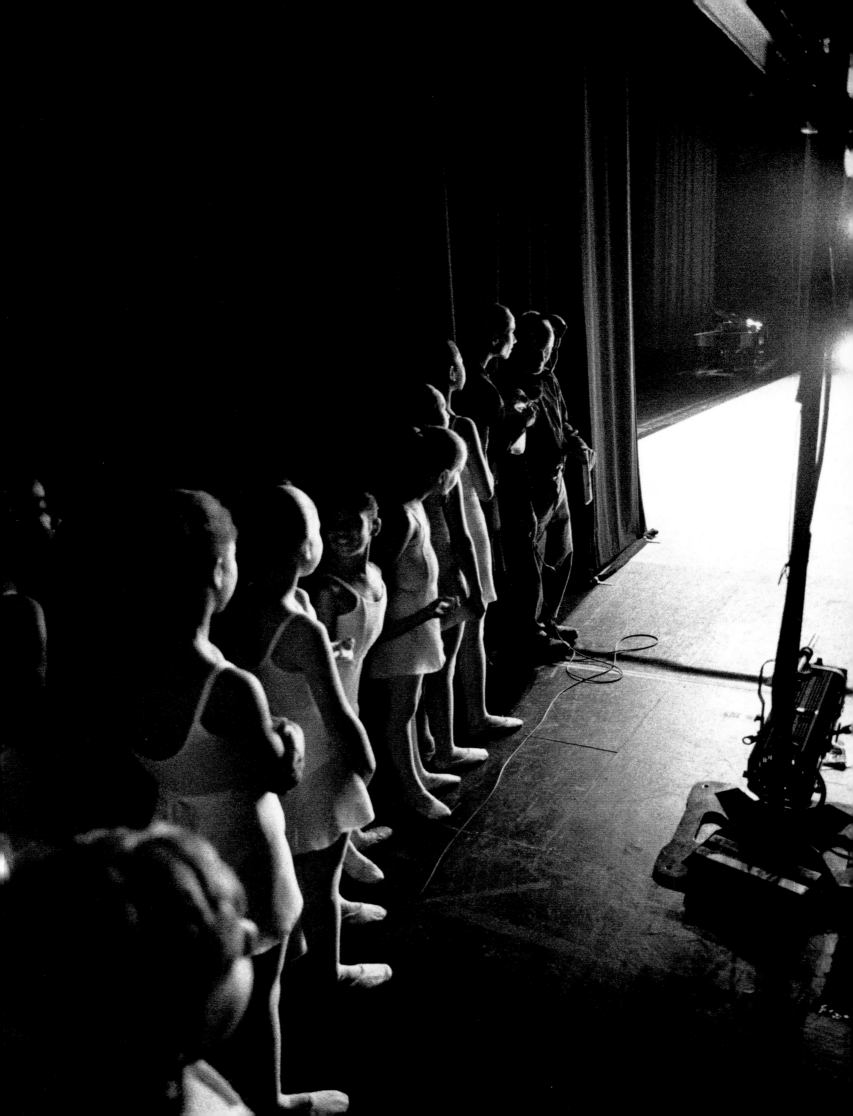

THE HIGHLIGHT OF EVERY YEAR is the Student Showcase performance, when students from levels two through eight perform in front of a live audience. Advanced students perform ballets from the company repertory, as well as works created especially for them by the Artistic Director or members of the company who are interested in choreography. Younger students perform in demonstrations created by their instructors. The evening ends with a promenade that features every student in the school. *Students wait in the wings for their cue.*

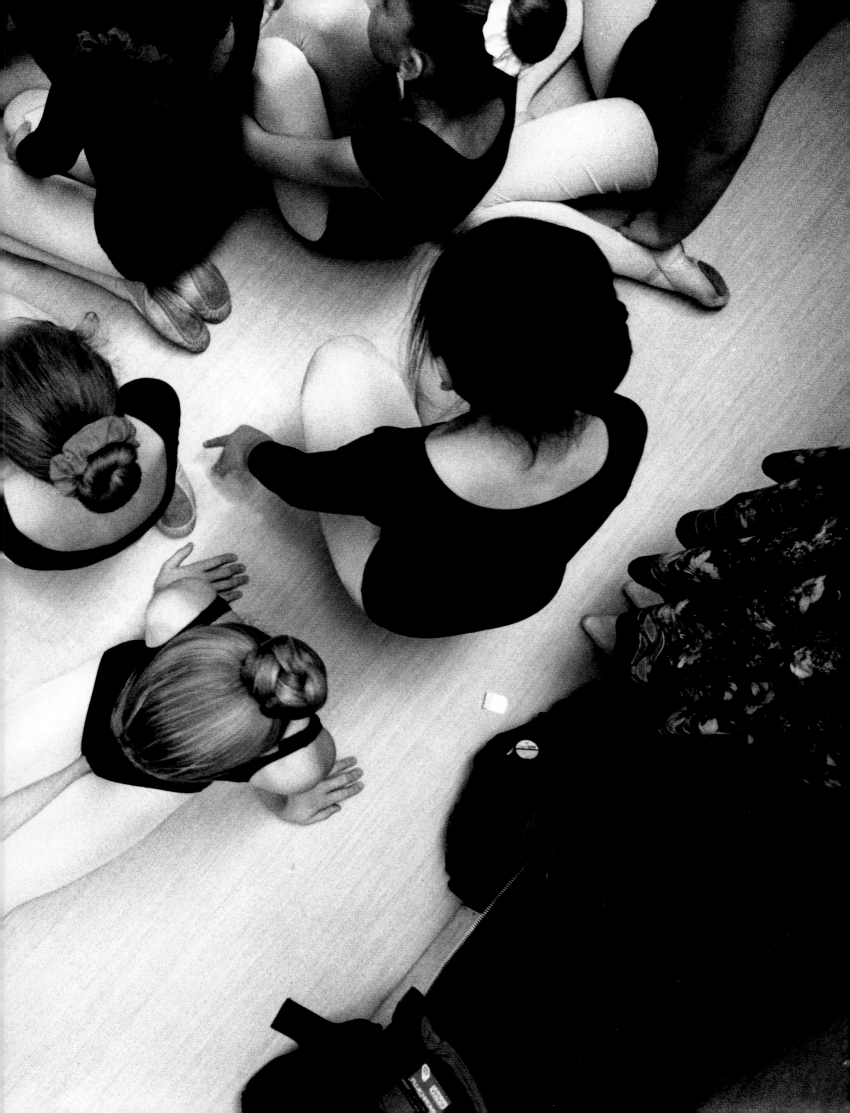

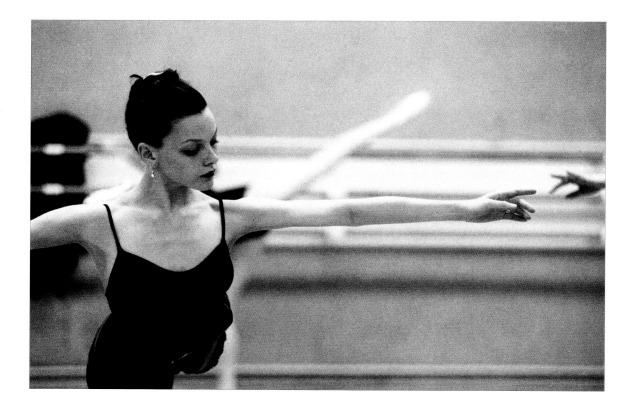

MANY DANCERS IN THE COMPANY speak of having fallen in love with ballet around the age of eleven or twelve. Because they commonly advance one level per year, this coincides with participation in levels four or five. By the time they reach level six, they are studying intensively six days a week and their true potential as professional dancers begins to emerge. Though not all students ultimately pursue ballet as a career, they gain a lasting self-discipline and grace that they can draw from for the rest of their lives. *Level-eight student in class (above).*
Level-six student onstage at a Student Showcase performance(right).

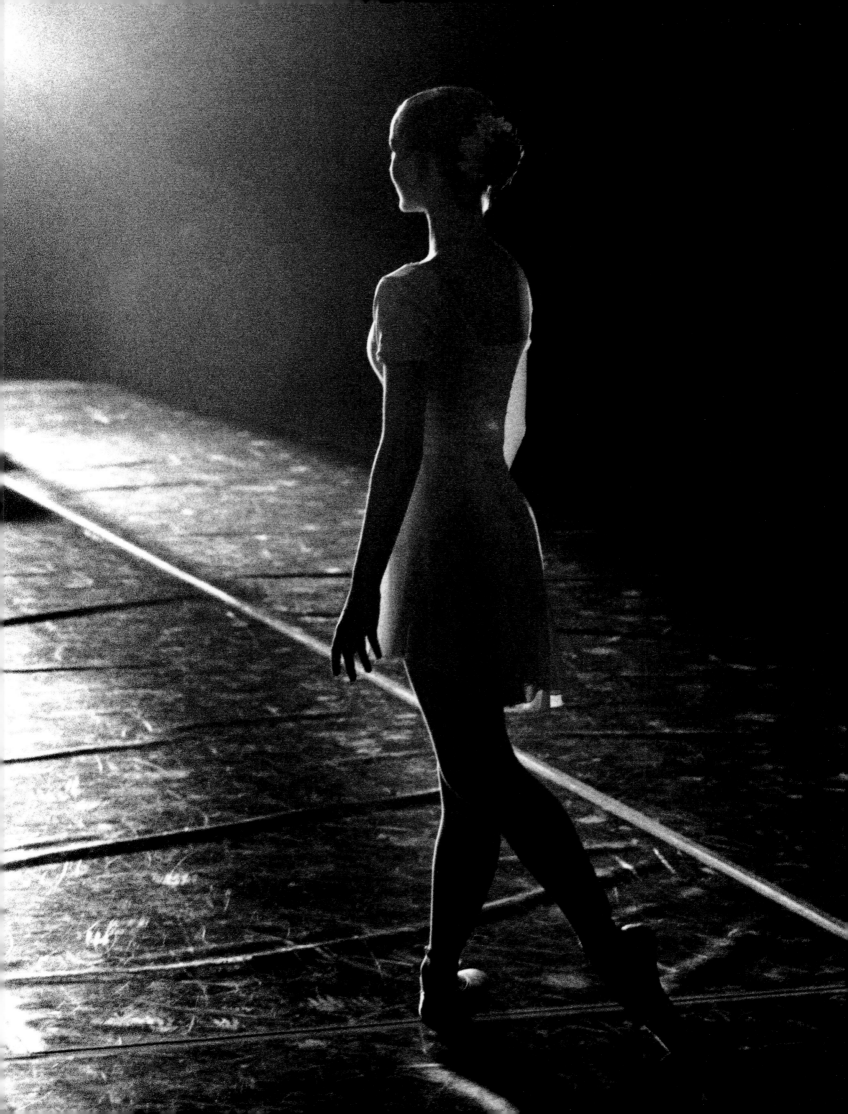

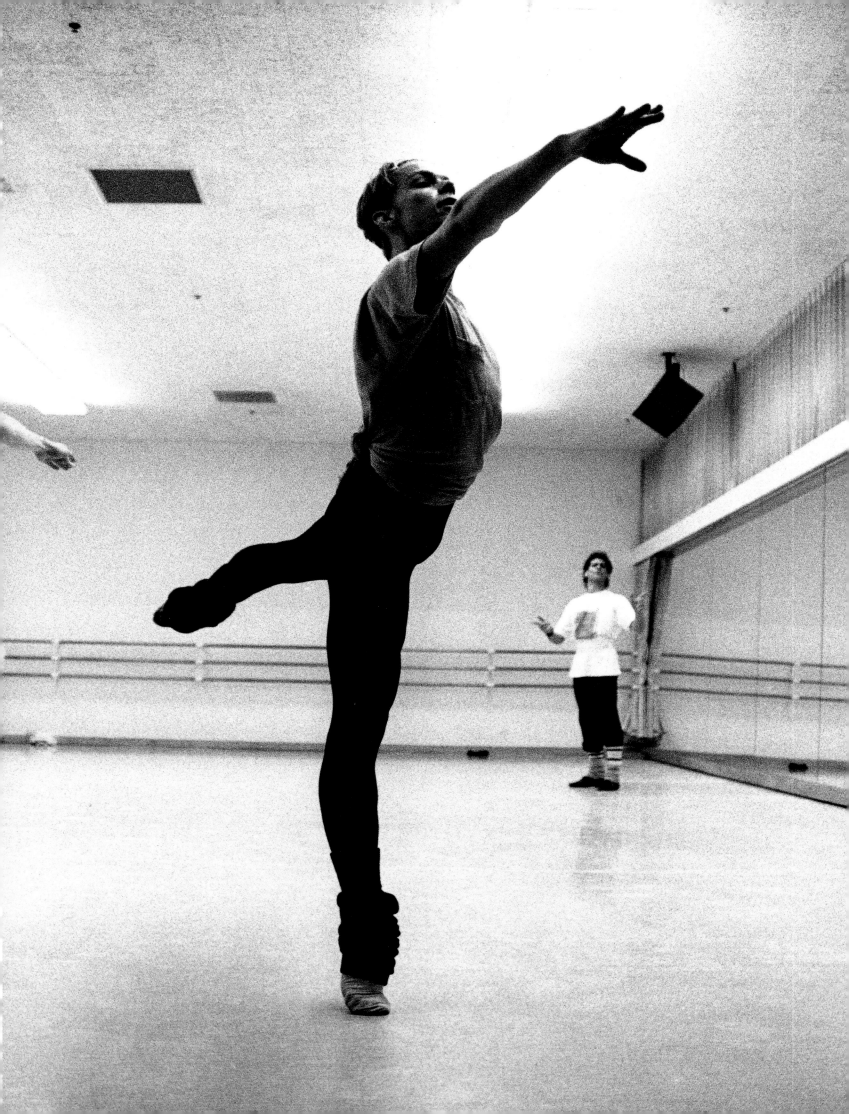

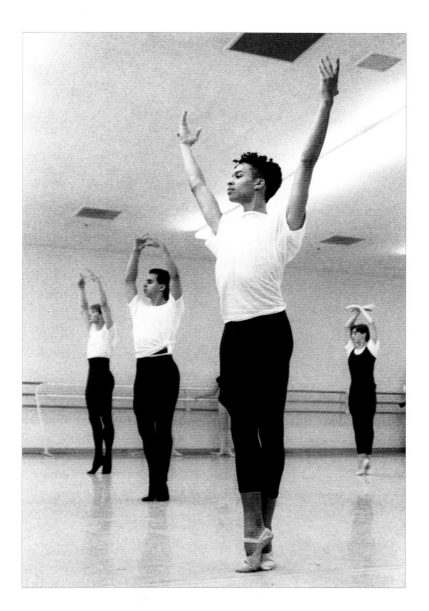

LEVEL EIGHT is a pre-professional class. Dancers at this level have already begun to work with the company in performances throughout the season. At any time, one of the students may receive an offer from the Artistic Director to join the company as an apprentice or as a member of the corps de ballet. Of the approximately fifteen dancers in level eight each year, only one or two will be selected for the company. *Jorge Esquivel teaches Erik Wagner (left) and Ikolo Griffin (above). Both dancers are now members of the company.*

THE DAILY RITUAL of company class begins in a peaceful, meditative atmosphere. As dancers arrive, they select their favorite place at the barre, set down their dance bags, and slip on layers of warm-up attire that is unique to their personalities and bodies. Each dancer then begins to stretch in preparation for the class ahead. The teacher arrives moments before class begins. If it isn't Helgi Tomasson, it may be one of the ballet masters or mistresses. (In this company, the ballet masters and mistresses are distinguished former dancers themselves, with an exceptional memory for choreography, an ability to teach and lead, and a strong relationship with current company dancers and the Artistic Director). With a cue to the pianist, the teacher begins leading the dancers through combinations of pliés, tendus, dégagés, frappés, and grands battements. These steps build upon each other, gradually encompassing more of the body and requiring increased strength and endurance. *Ballet mistress Bonita Borne as she prepares to lead company class.*

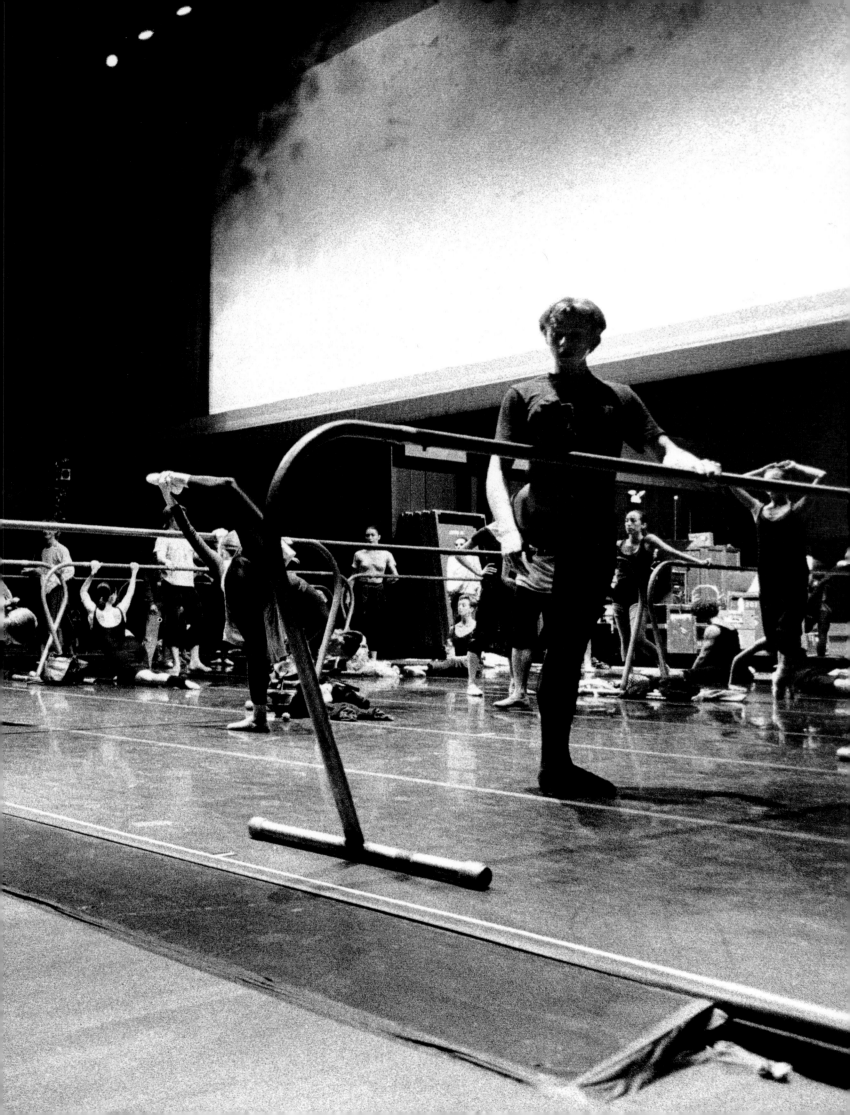

MOST PEOPLE HERE have been the pick
of the pick at their school, so it's overwhelming to
come and see that everyone is an amazing dancer.
To thrive in this environment, you have to work and
grow continuously.

Becoming a soloist gave me confidence, and it gave
me the freedom to work at being the kind of dancer
I wanted to be. All of a sudden it's not your duty to
look like everyone else. Your whole purpose is to be
unique, and there is a mental switch that takes place,
a freedom it gives you.

I admire dancers who are able to lose themselves in
what they are doing. Sabina Allemann can do this. So
can Joanna Berman. They are able to surpass everything
that is happening.

I also get inspired when I encounter choreographers
whose love of dance is so evident. Whether in how they
choreograph or coach, they teach something about the
art form that you can't get anywhere else. They don't
have illusions about the difficulties, and they have this
overwhelming need to express themselves through
movement.

I FEEL DRIVEN to pursue this.
Sometimes I am hypercritical though, and I get so
focused inwardly that I lose perspective. During those
times, I often go to the ocean. It's so vast that it
makes everything seem smaller. This is something I've
done since I was small.

I grew up in a very supportive environment. It wasn't
a household that focused on money or status. It was
more like, 'Do what you love.'" - *Deirdre Chapman*

Soloist Deirdre Chapman in company class.

I FEEL MY STRENGTH IS THAT I AM NOT AFRAID TO GO AFTER WHAT I WANT.

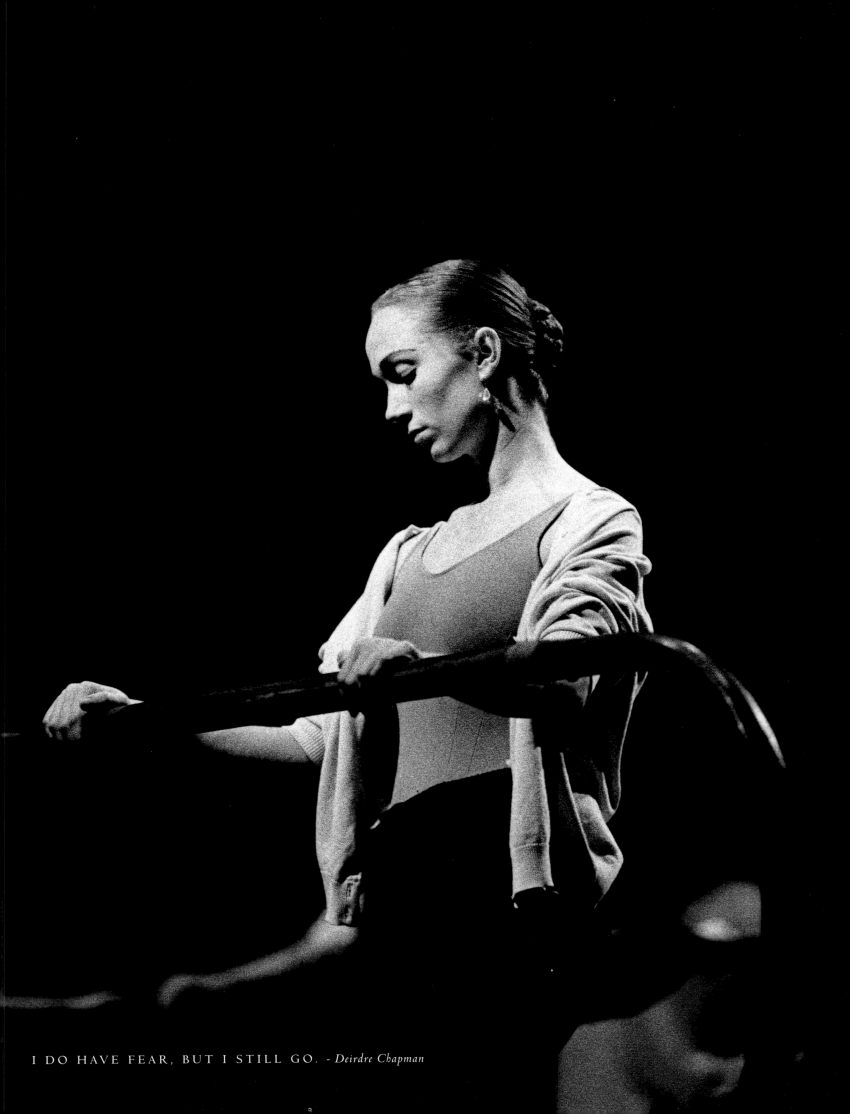

I DO HAVE FEAR, BUT I STILL GO. - *Deirdre Chapman*

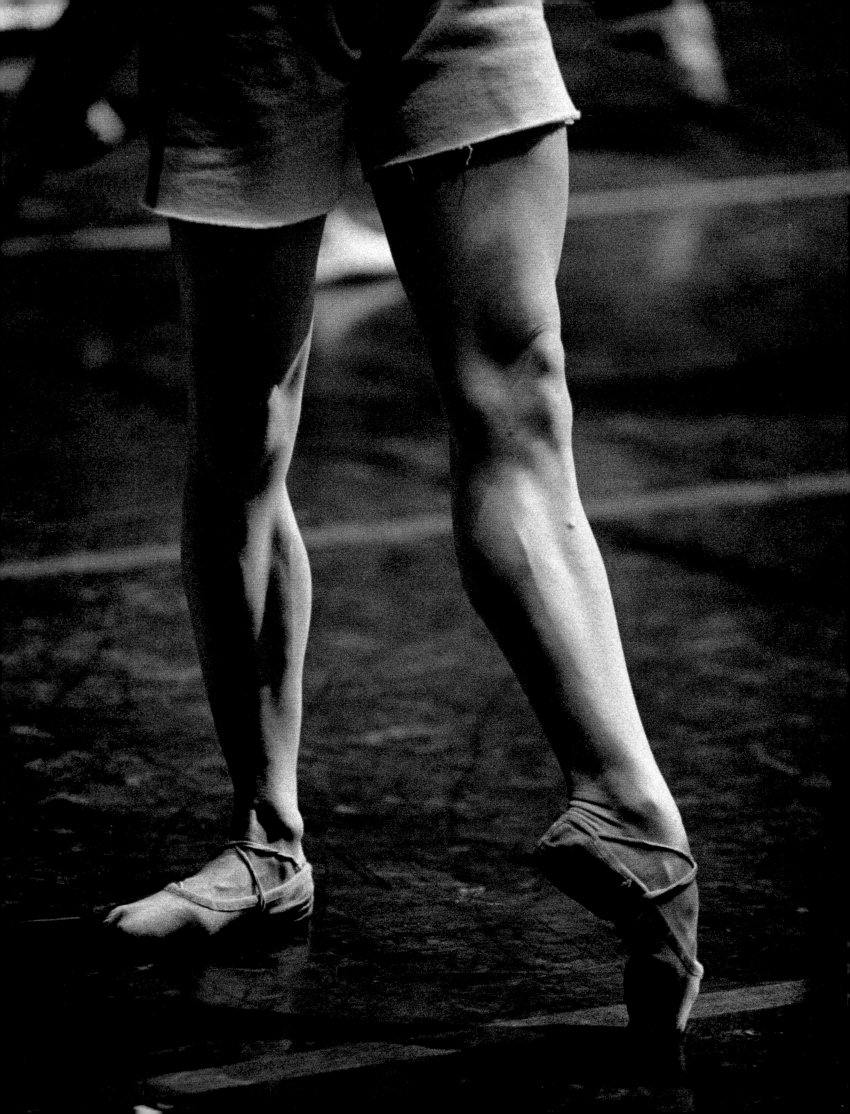

A HIGHLY ARCHED and supple foot is the ideal shape to lengthen and complete the line of the body.
Few dancers are gifted with perfect feet, so many will spend hours stretching with a friend, or under a heavy couch.
Rachel Greenwood at the barre during the tendu exercise (left). Galina Alexandrova receives corrections as her legs and feet
naturally strike the pose Degas made famous with his sculpture, Petite danseuse de quatorze ans *(above).*

at age four and eventually came to the SFB school when I was fourteen. They placed me in level five and with the help of Irina Jacobson I made it to level seven, and then I became an apprentice. Somehow I knew if I didn't get in then, I would never make it." - *Virginia Long. Corps de ballet dancer Virginia Long at the barre in company class.*

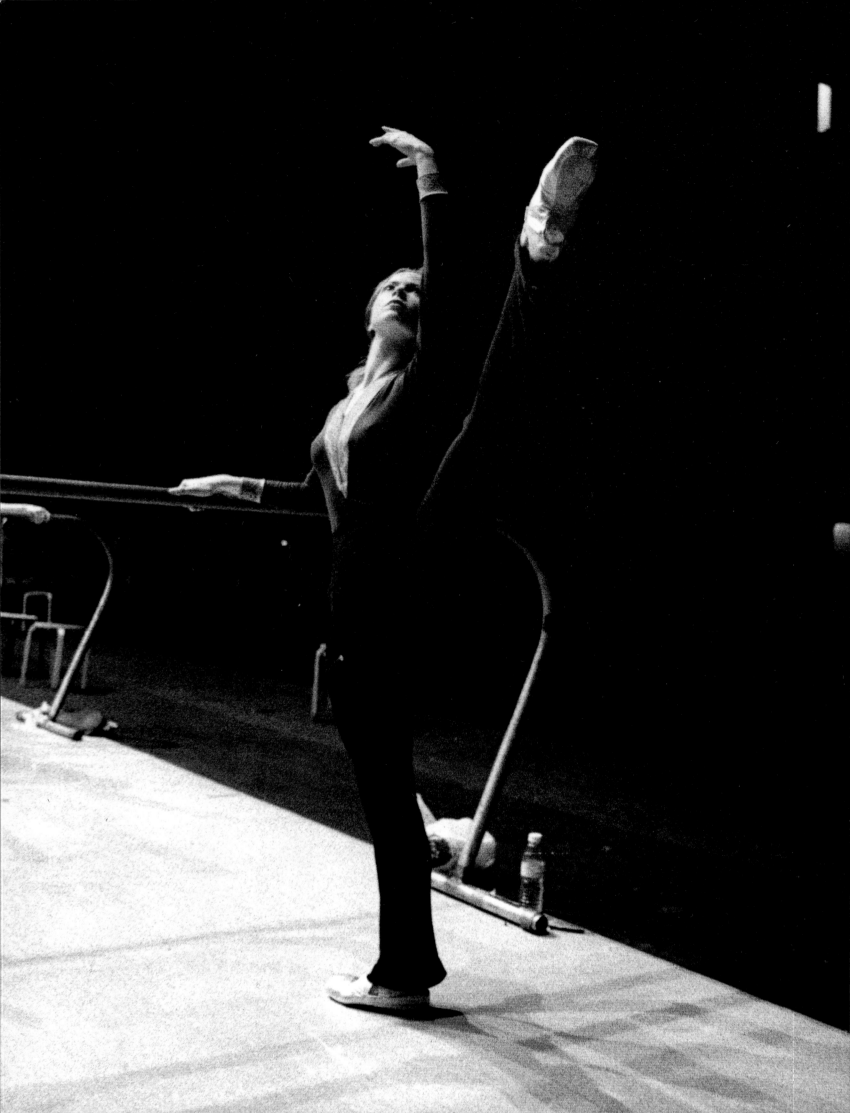

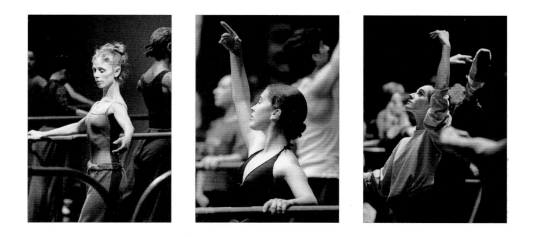

AT EACH CLASS, principals share the floor with soloists, corps members, and apprentices. Occasionally, visiting artists will attend class to get a feel for the company or to audition informally for the director. The dancers are under the constant scrutiny of the director, the ballet masters, and the teachers. Such an atmosphere creates a competitive, yet supportive arena in which dancers learn and demonstrate their skill and artistry. Who is coming into their own? Who does a visiting choreographer want to cast in an exciting new ballet? Who is always working hard? Important casting decisions can be influenced by a single company class. *Soloist Jennifer Karius (left), principal dancer Julia Adam, soloist Kristin Long, and corps de ballet dancer Blanca Coma Roselló (above, left to right).*

"WHAT I ADMIRE ABOUT THE DANCERS IS GRACE, but not as in graceful. It's more like a spiritual quality. There is a time when you see dancers and they are so perfectly in their bodies, the steps, and the music. That to me is grace. That's when I fall in love." - *Lighting designer Lisa Pinkham.*
Principal dancer Muriel Maffre stretching in company class.

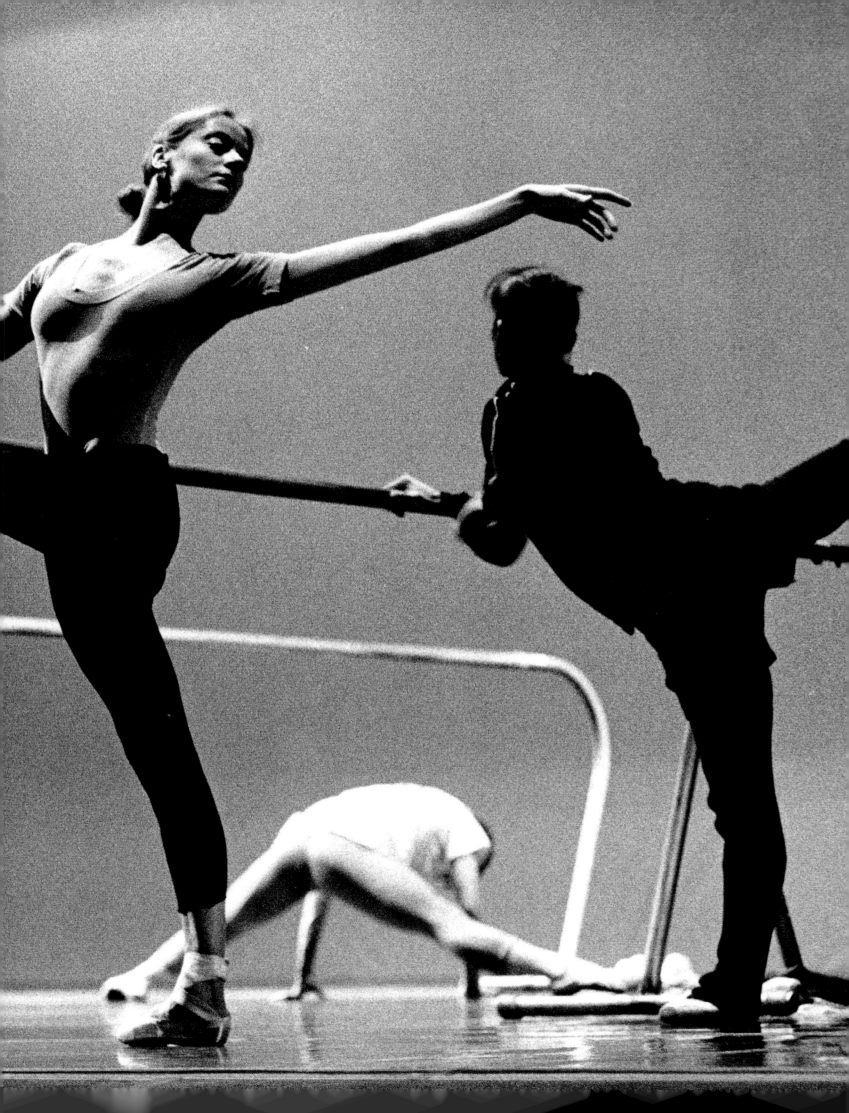

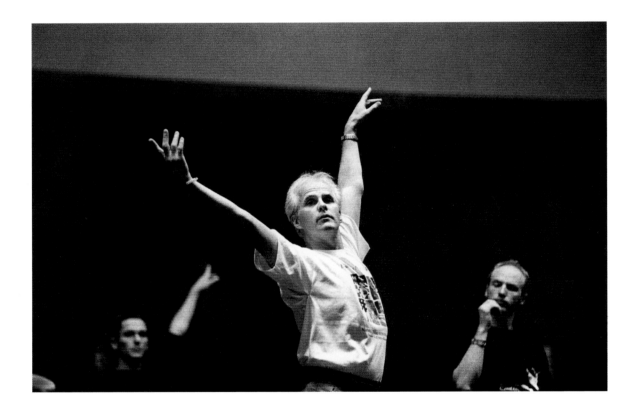

FOR THE SECOND HALF of class, the dancers move to the middle of the floor, where they work
without the support of a barre. During the transition to the center, the pianist plays a melody of his or her choice,
dancers stretch, and the teacher begins to choreograph a slow, sustained combination called the adagio.
Artistic Director Helgi Tomasson demonstrates the adagio combination (above). Principal dancer Yuan Yuan Tan executes the adagio (right).

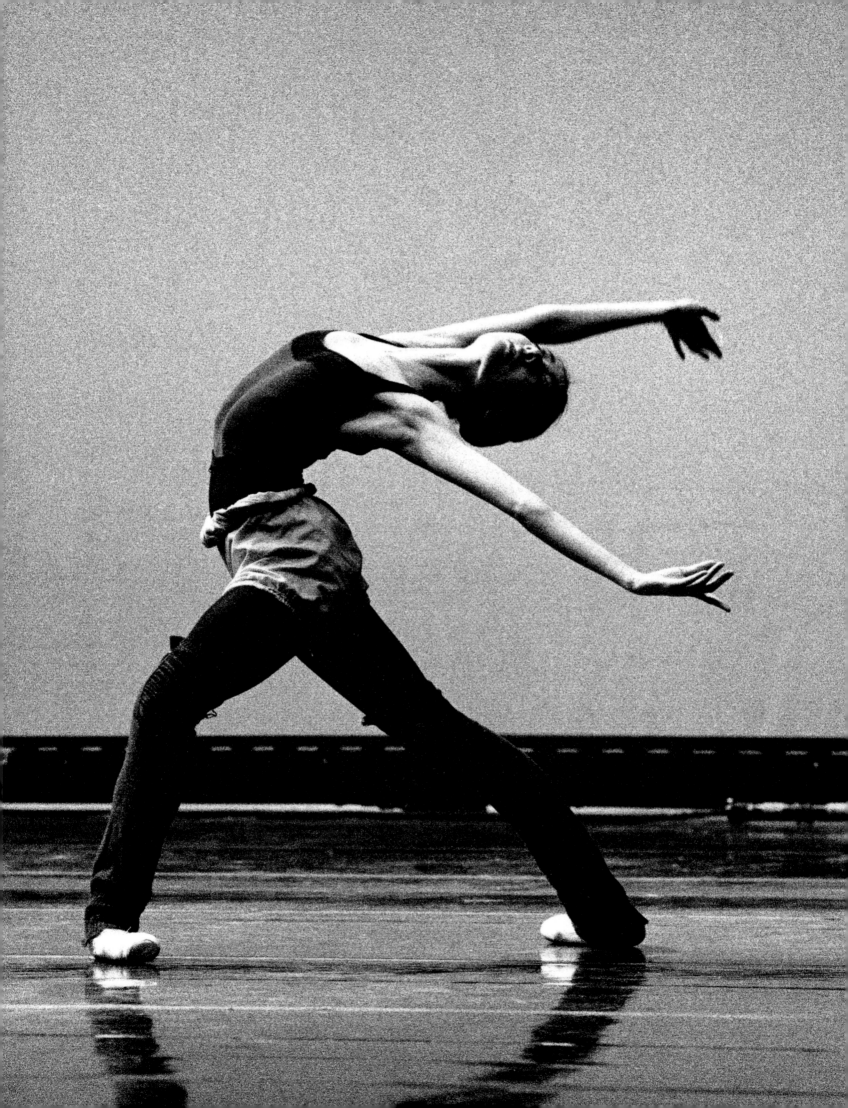

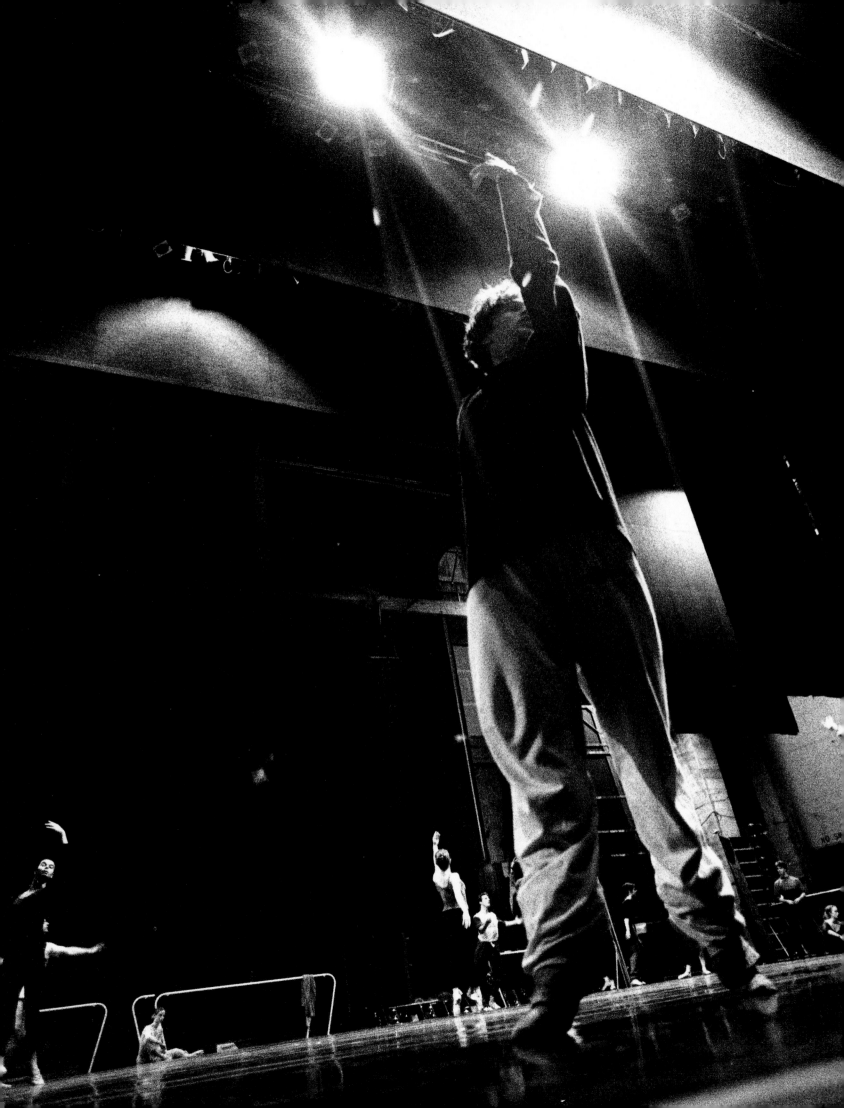

CLASS CONTINUES with combinations of dégagés, waltzes, pirouettes, and jumps. The tempo of the music increases for a climax—the grande allegro—in which dancers brush, glide, turn, and leap across the floor in an extended movement pattern. Though the combinations vary from day to day, class has an unchanging structure devised by genera- tions of ballet masters that is utterly familiar to every dancer. *Corps de ballet dancer Peter Brandenhoff (left), corps de ballet dancer Sara Sessions, soloist Leslie Young, corps de ballet dancer Chidozie Nzerem (above, left to right).*

DURING THE COMPANY'S PERFORMANCE SEASON class moves to the Opera House stage. In this setting, where dancers are often preparing mentally for an evening performance, the class is a particularly beautiful experience mixed with seriousness and magic. The curtains are opened wide, exposing the full volume of the theater, and the dancers' colorful clothing contrasts sharply with the blackness of the backstage rigging and wings.

Associate director of the school, Lola de Avila, teaches company class onstage.

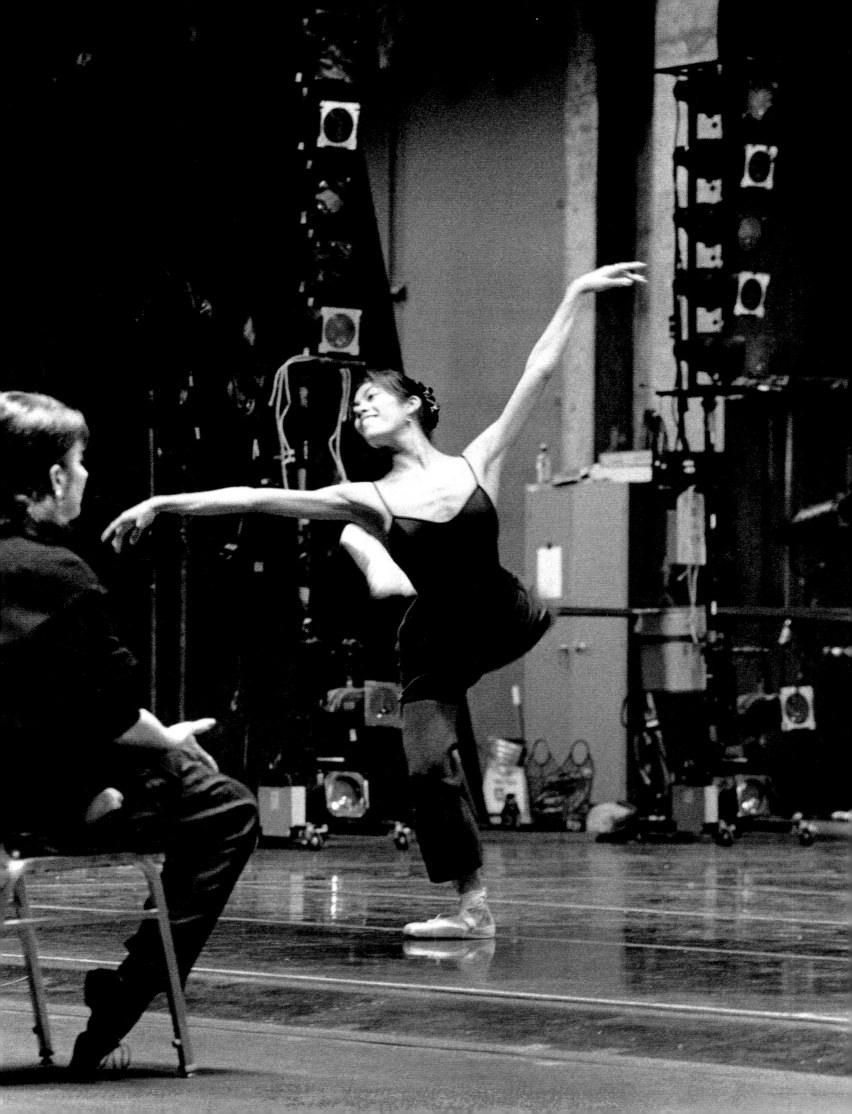

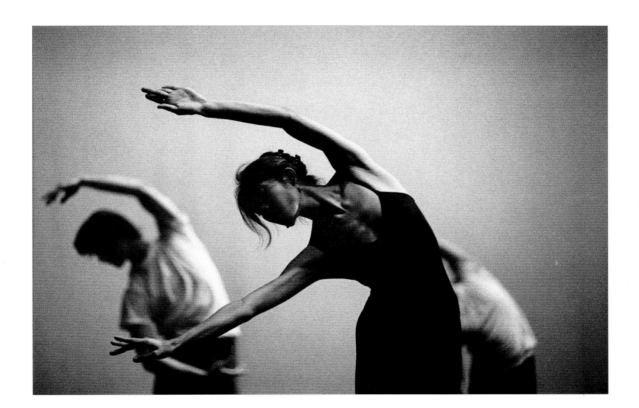

"I TOTALLY WANTED TO BE A SOLID GOLD DANCER when I was young. I was really into jazz, but
then I discovered ballet and came to the SFB school. I really wanted to get into this company. It's very difficult and a lot
of my friends didn't make it. After my second year in level eight, I didn't think I would make it, but then Helgi came up
to me after *Nutcracker* and offered me a contract. Finding that one love and keeping it alive is very important. I feel lucky
to have discovered what I love." - *Marisa Lopez. Corps de ballet dancer Marisa Lopez in company class.*

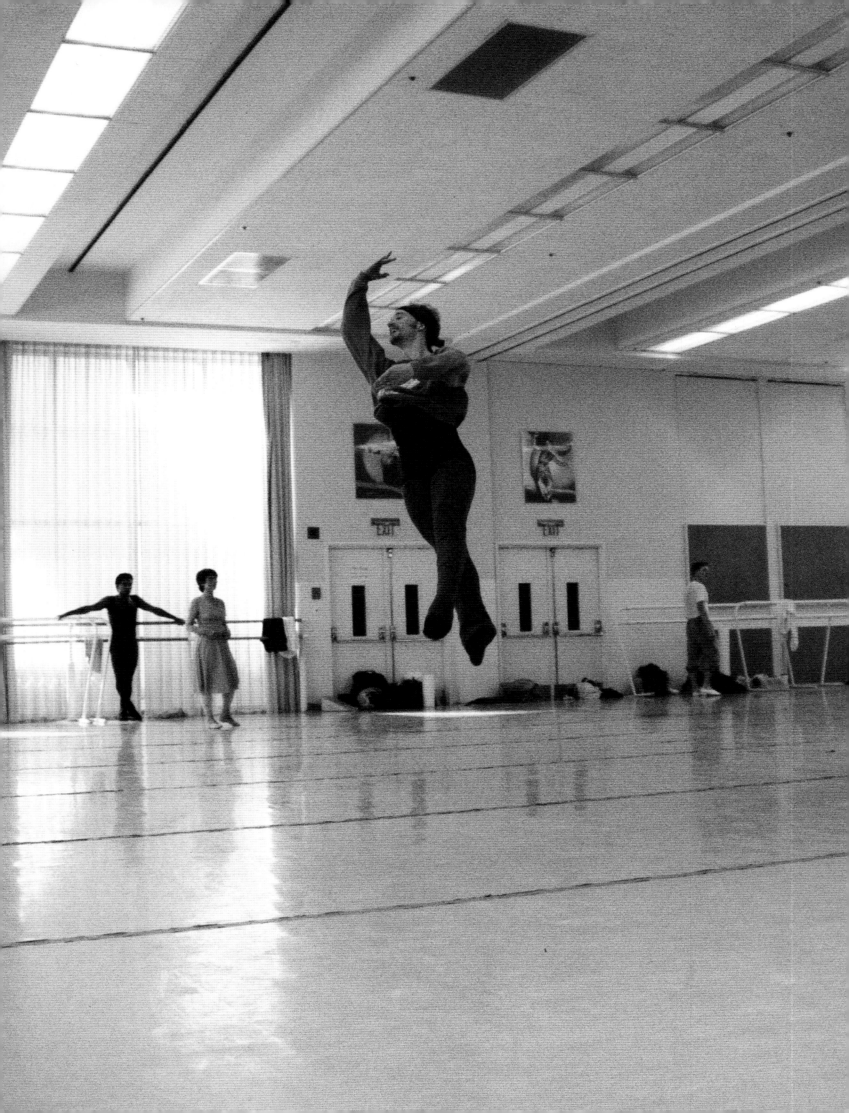

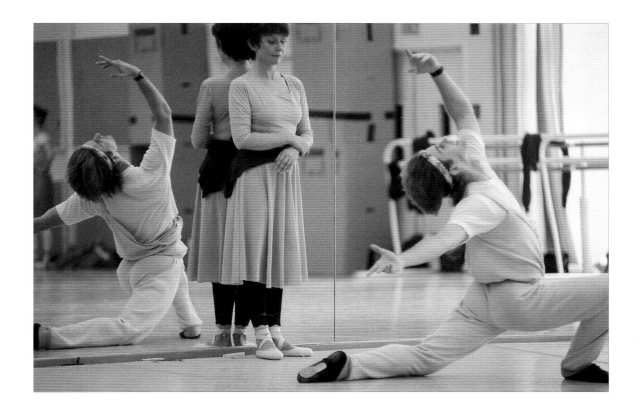

I STARTED BY TAKING A RANDOM CLASS through a Montessori school at eleven, and I got a paper route to pay for half of it. At fourteen I studied in Monte Carlo and that's when I knew. It just hit me. As the French say, 'coup de foudre,' which means, 'struck by lightning.' Eventually I came to SFB and it was the place to be; it's a beautiful city and it just felt right." - *Christopher Anderson. Soloist Christopher Anderson in class (left). Principal dancer Stephen Legate (above).*

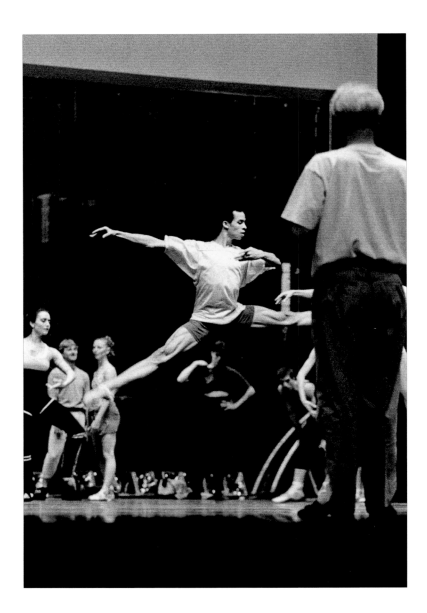

THERE ARE DAYS DURING CLASS WHEN EVERYTHING FALLS INTO PLACE and a dancer feels almost superhuman. Pirouettes and jumps are effortless; the muscles respond to every request; everything seems easier. *Corps de ballet dancer Ikolo Griffin "on" during a class onstage at the Kennedy Center in Washington D.C.*

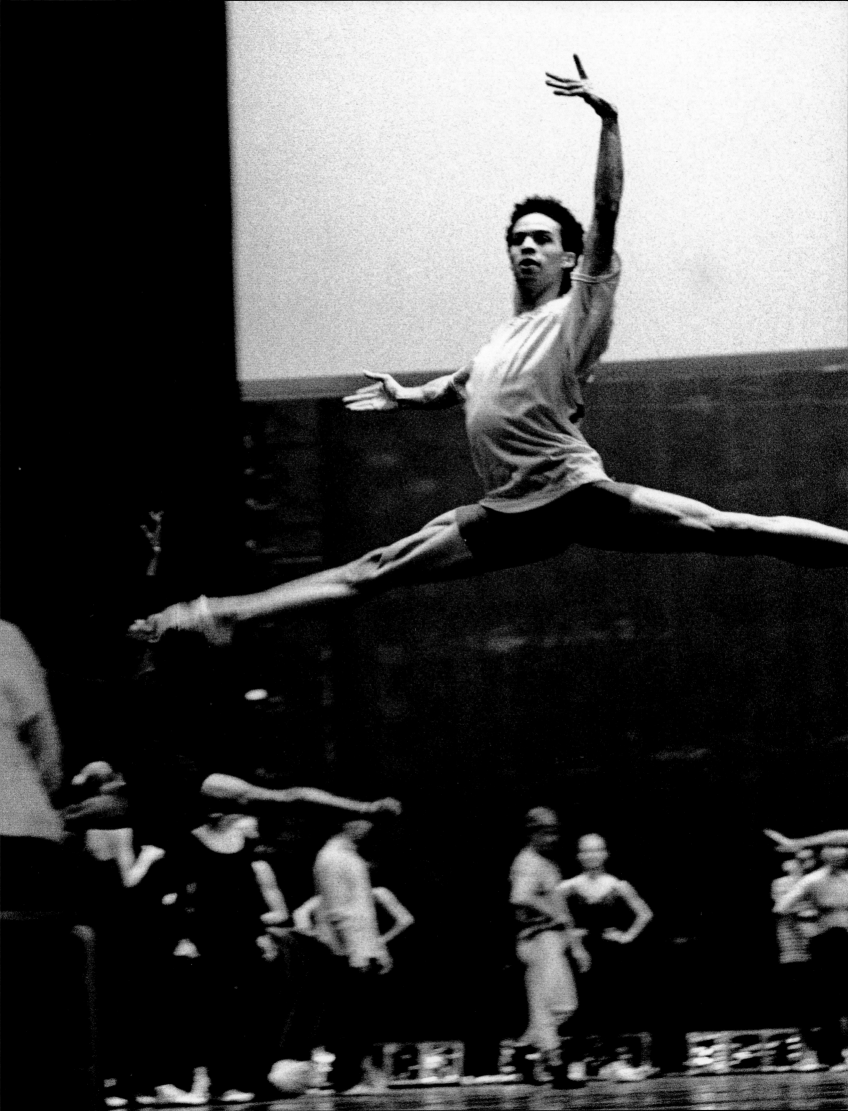

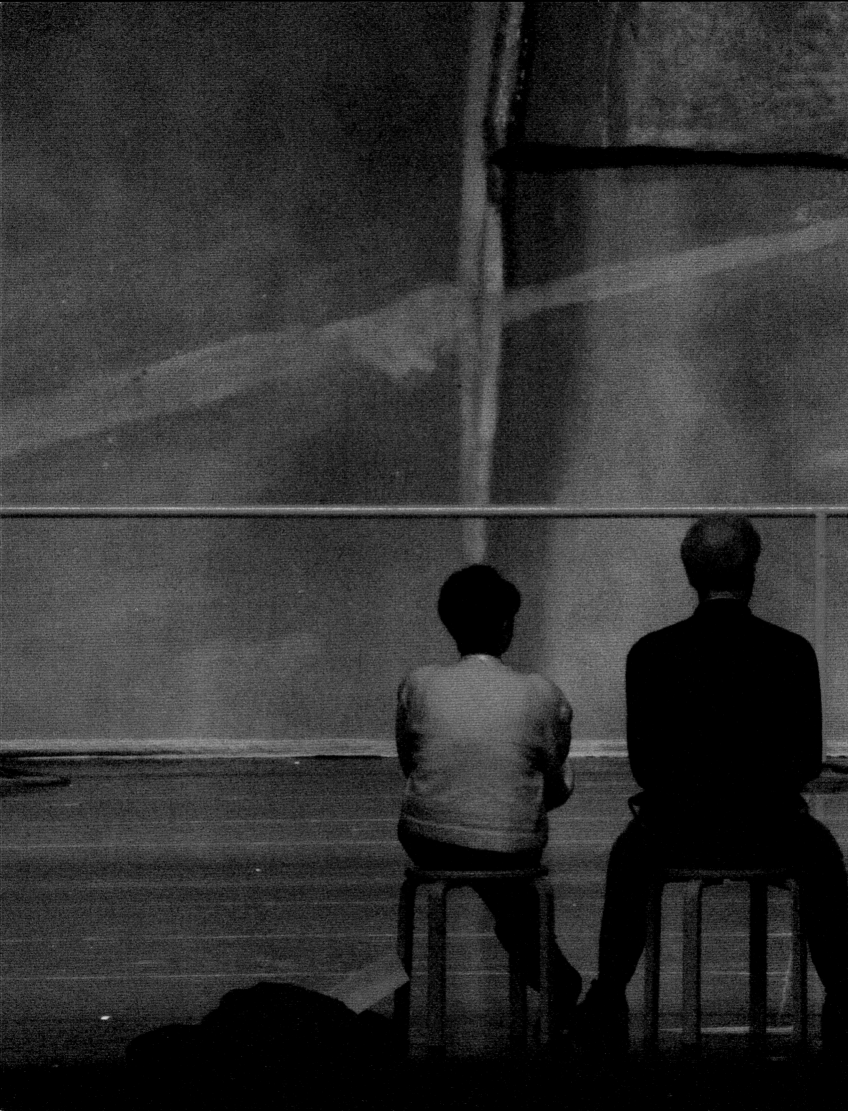

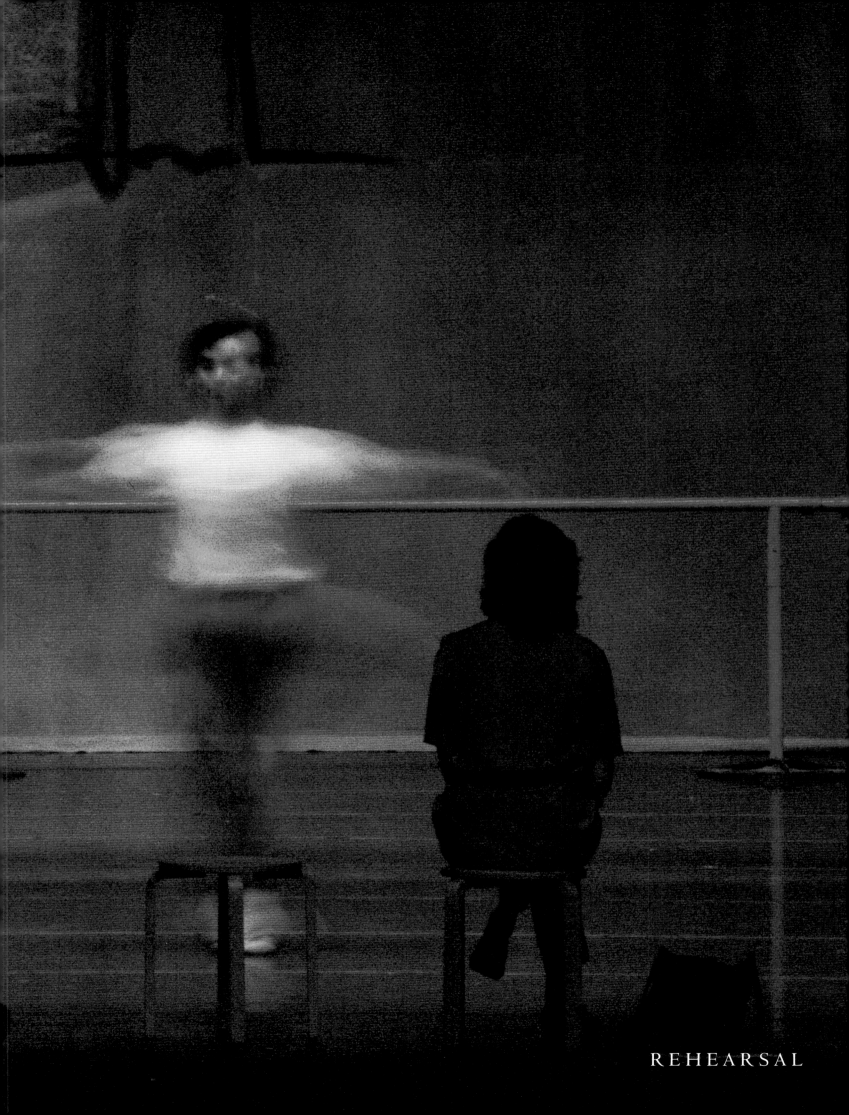

REHEARSAL

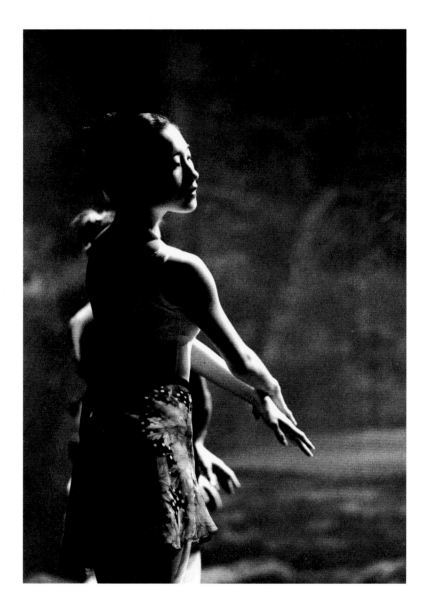

REHEARSAL IS A MAJOR PART OF ANY DANCER'S LIFE. Collectively, hundreds of hours are spent preparing one new ballet for just six or seven performances in the season. During the forty-two weeks that the dancers are employed each year, they commonly rehearse all day, six days a week. By far, the most physically demanding time of the year is the fourteen weeks where a full day of rehearsal is followed by a performance each night. It is common for several of the dancers to have sustained an injury by the end of the season. *Corps de ballet dancer Sonja Kostich (above) and members of the company (right) in rehearsal for Tomasson's* Swan Lake. *Previous page: Soloist Ming-Hai Wu in rehearsal for David Bintley's* The Dance House.

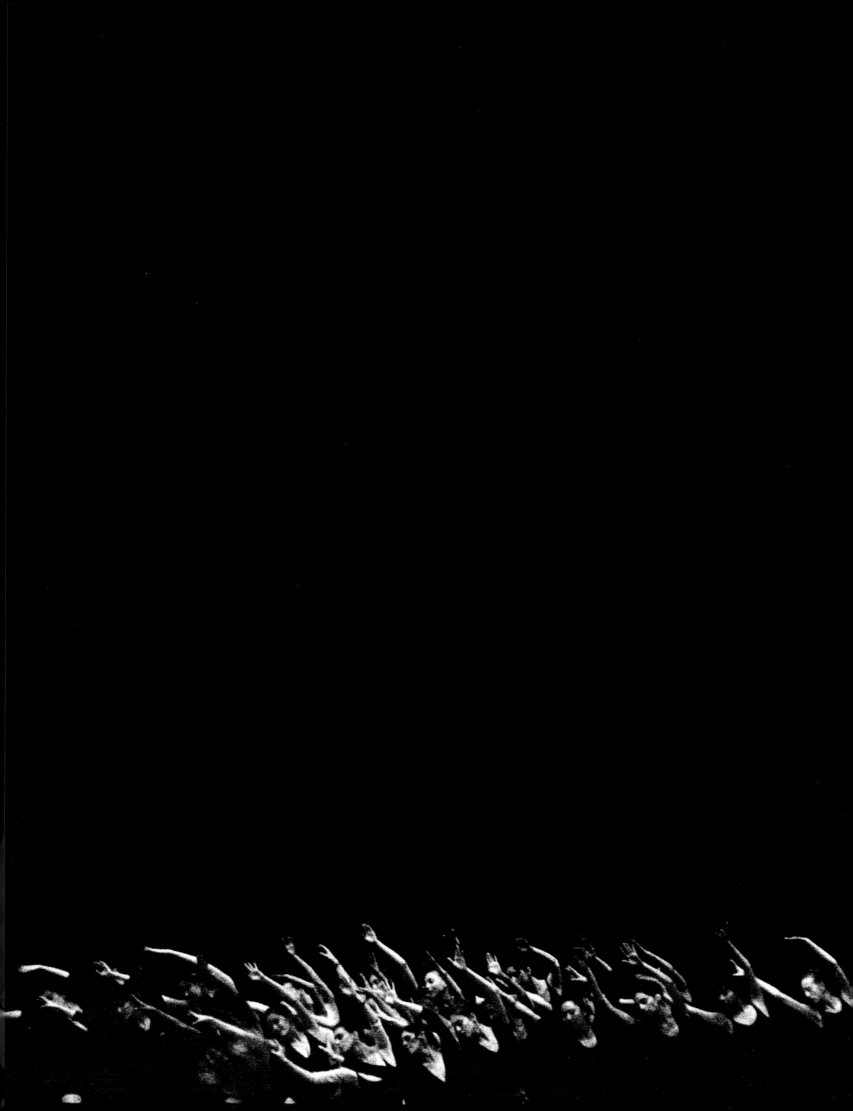

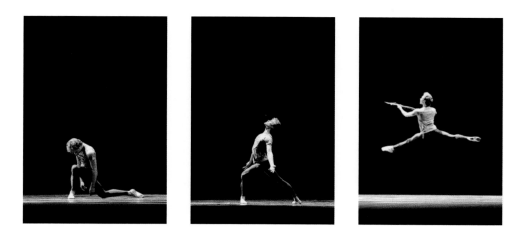

"I LOVED MUSIC and my parents wanted to put me in the right frame, so they brought me to the Vaganova Ballet School. They would say, 'We want our son to dance.' I joined the Kirov Ballet at sixteen and stayed with them for seven years. Then, in 1989, I was on a long tour and thinking about changing my country because the Kirov was very transitional then. When we performed in San Francisco at the Opera House, I crossed the road to take class with San Francisco Ballet. Soon after, Helgi offered me a contract, and it was the first year in Russia that they decided to try democracy, so they let me go. My favorite roles are in ballets like *Swan Lake*. I like to lead a character through the evening and show the beauty of the dance." - *Yuri Zhukov. Principal dancer Yuri Zhukov in rehearsal for Tomasson's* Swan Lake.

"WHEN I WATCH DANCERS I LOOK FOR WARMTH, generosity, and an ability to communicate with an audience. I also look for an acute attention to the music; for people who live it, who reside in it—they're just wearing the music." - *Anita Paciotti. Ballet mistress Anita Paciotti conducting a rehearsal for Jerome Robbins's* In the Night. *Principal dancers Yuri Zhukov and Julia Adam dance the second pas de deux.*

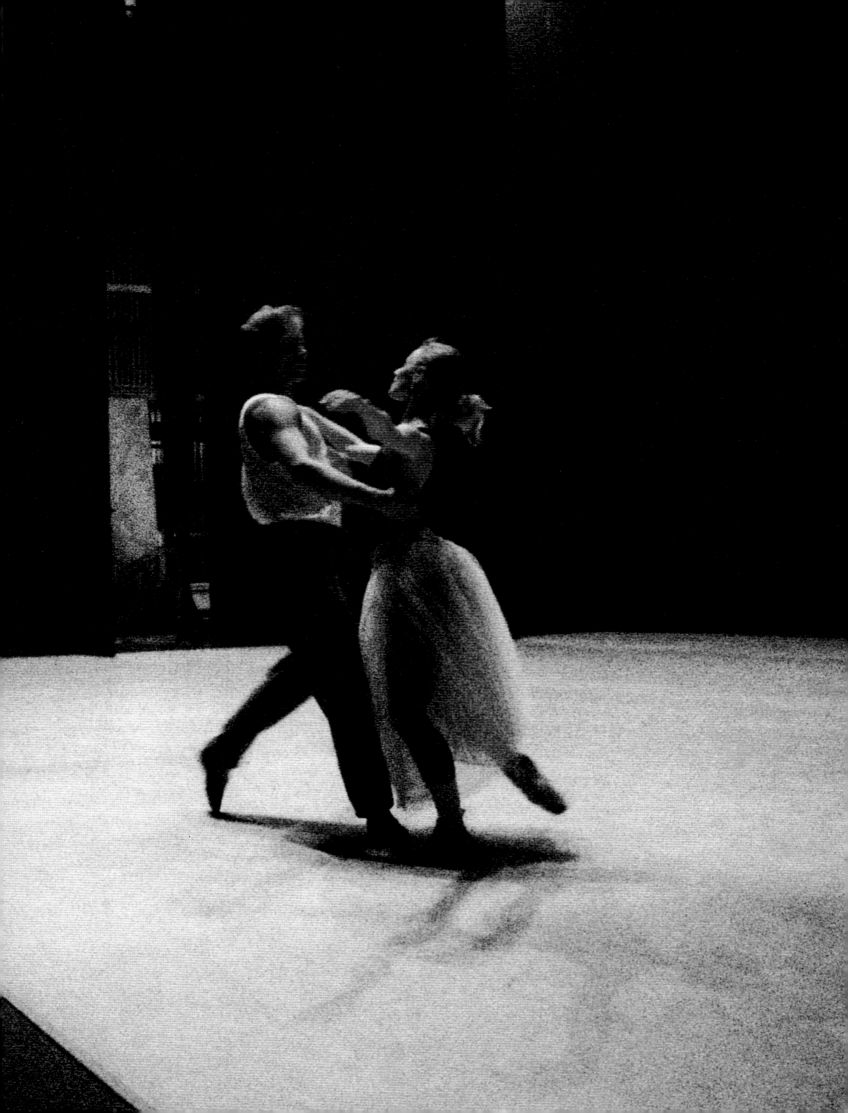

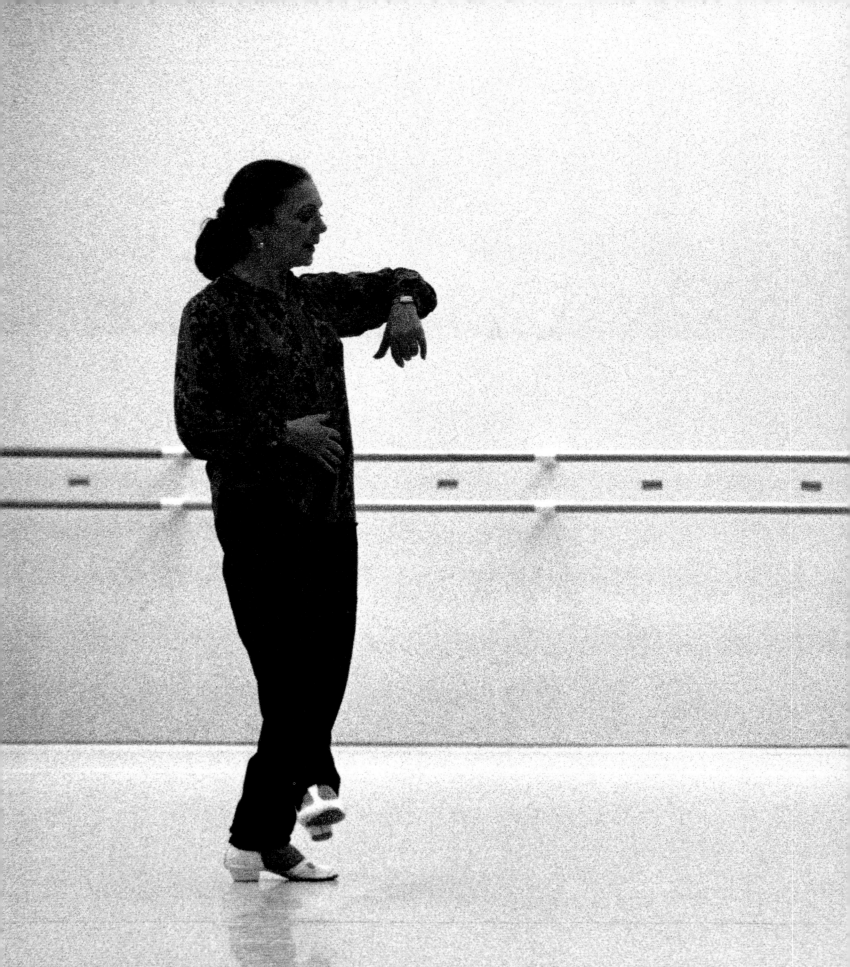

"IN 1933 I started at the Vaganova Ballet School in Leningrad. That's sixty-five years in ballet! Our Kirov Ballet immigrated to Siberia for three years during World War II and when we came back to Leningrad, the city was ruined. I danced with the Kirov for twenty years and then I went to an academy for teachers where I was instructed by Vaganova. I was very lucky to have her as the best teacher and choreographer. She taught me how to make a good dancer. She used to ask me to teach for her when she didn't feel well; maybe she knew it would be my way. I began to teach full-time in the Vaganova School but then my husband, Leonid Jacobson, got his own company. When he died in 1975, this was a very hard time in my life.

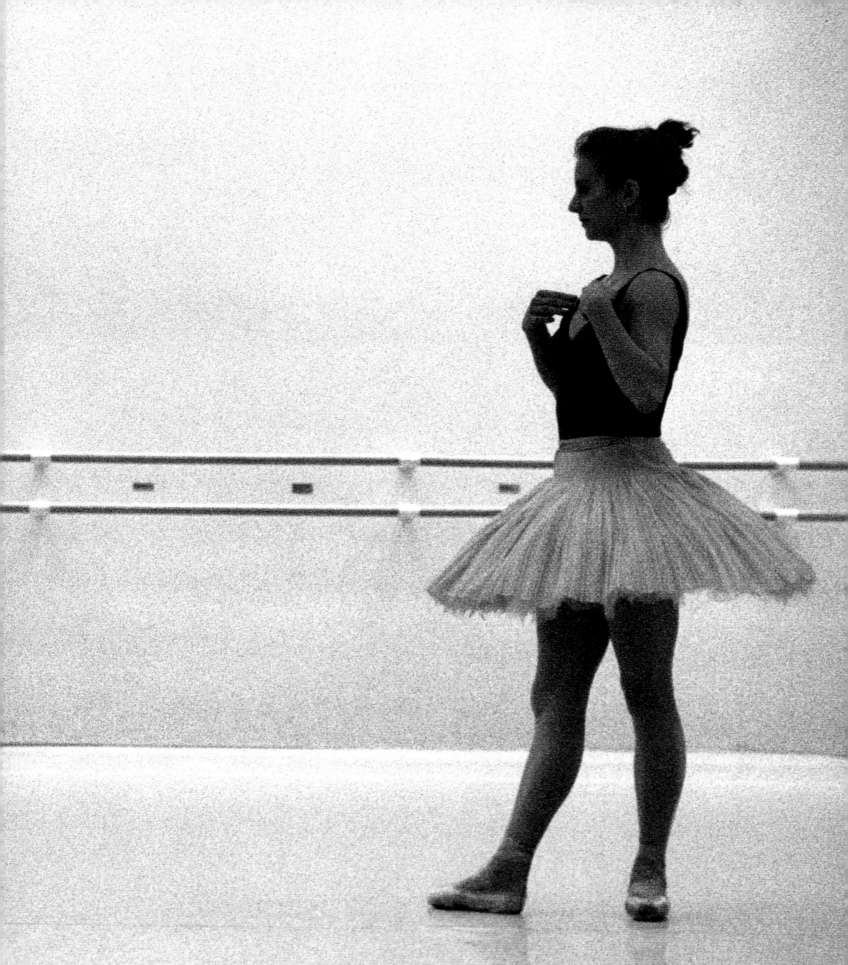

After that, I spent five years shuttling back and forth between Hamburg and The Royal Ballet, and then Helgi invited me to come here. I knew I liked his dancing because I saw him at the Moscow Ballet competition when he won the silver medal and Baryshnikov won the gold. The first year I was here he made *Swan Lake*. I liked his production very much. I could feel passion, style. I try to bring the best of what I can but help the dancers discover what *they* feel. If all dancers begin to work the same it's not interesting. You see, ballet is not just about fouettes and pirouettes, it is something to tell an audience, to make them *feel*." - *Irina Jacobson. Irina Jacobson coaching principal dancer Elizabeth Loscavio in a rehearsal for Tomasson's* Swan Lake.

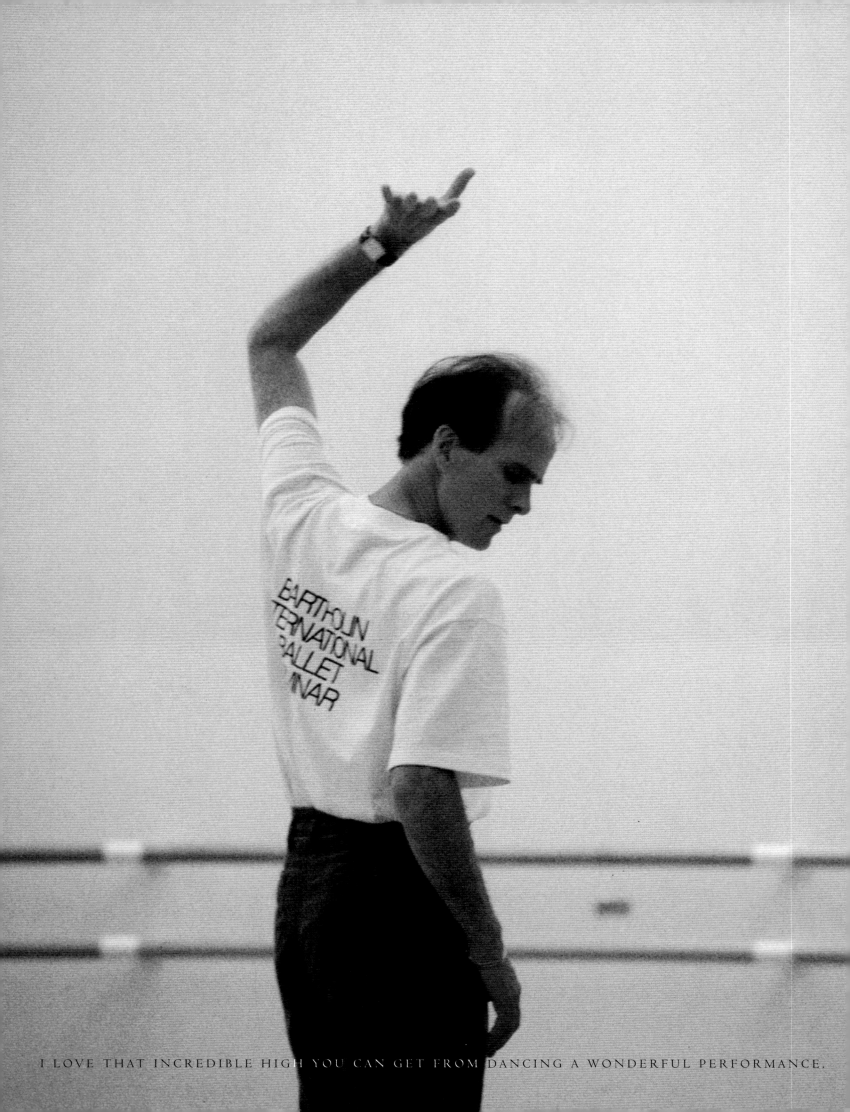

I LOVE THAT INCREDIBLE HIGH YOU CAN GET FROM DANCING A WONDERFUL PERFORMANCE.

When dancers come to audition for you, what qualities do you look for? There is no set formula. The way they dance or what I feel can be done with their talent. And, of course, there are times I need somebody taller, or I have to have the feeling that the dancer will work with another dancer, and that dictates who I'm looking at. Other than that, it's just maybe the way that they move in class or the way they hold themselves. Or there's something in their eye that catches my eye, something about the art form and the way they approach it. Sometimes I feel that real potential exists but is hidden, sort of the way a sculptor chips away at stone. You never know, but you can just feel there is something beneath. *Can you put your finger on what helps a dancer make it?* It's really a difficult thing. I think it's almost likely that you have to devote everything you have to dance. At the same time, though, I think it's very healthy to have one foot in reality and to be more grounded. It seems that the style of dance that is required now tends to be very hard on the body. I can't be sure, but it seems that careers are shorter now than they were. *Did you have a mentor?* Jerome Robbins is the one who brought me over to this country on a scholarship when I was eighteen. He was someone who took me under his wing and he had a profound influence on my career. I had seen his company; they toured Europe in the late fifties. I had also seen a performance of Balanchine's *Theme and Variations* at Ballet Theatre. Those were two types of work I'd never seen before, and I felt instinctively right about it; I just thought, "That's what I have to do." Throughout my dancing career I did a lot of Jerry Robbins's work, and since then I have always kept in contact with him. *What do you consider to be your greatest achievement?* I am very proud of the three full-length ballets that I have staged. I also feel very proud of some of the original works I have done. But at the same time, I feel that I've had to take this company and make it much higher caliber. It's hard enough just to direct, and it's hard enough just to choreograph. Doing both has been an eye-opener, both challenging and rewarding. I am very proud of the way this company dances now. *When you are watching a performance, what qualities in a dancer will catch your eye?* There are so many good dancers out there. Then there is that rare occasion when you see someone who's moving beyond being very, very good, and it's extremely uplifting. I have also seen dancers working very well for a long time, and then all of a sudden one day it's like something clicked in their head and they reach a new level. A lot of times this comes from maturity. Young dancers today have such incredible technique. Sometimes I see the potential and think, "Wow, wait a minute. This is something really fantastic." And then you feel somewhat responsible if you get them to come here.

What are your strengths? I think one of my strengths is that I have a certain gift to assemble with a wonderful result. What that gift is exactly I can't break down, but I'm aware of it. A lot of people have come here for what I have assembled in the repertoire. Also, I think I have an innate musicality, which I try to use in my choreography. *What is your weakness?* If only I could satisfy all the dancers. You always have to make choices, and what is fair to one is always unfair to another. And that causes me a lot of distress. When I have to let dancers go, I don't want to tell them. *What are your goals for the company?* It's similar to when I was dancing: It took some years to get the experience to become a soloist and then even more to become a principal. It's difficult to get to the top and be considered one of the best in a handful of the best. It's frustrating, challenging, invigorating—all those things. But it's even harder if you get there to stay there. In a way, it's looking like the same thing here. The company is dancing the way I envisioned five years ago, but now the question is: What is the next step? I would love for this company to be seen more, to travel more, and to get the recognition I think it deserves. Within the dance community, everyone knows it, but I would love to be able to extend that further so that there is a wider public audience. *What do you like most about what you do?* What I enjoy most is choreographing in the studio. I enjoy teaching when I have time and I'm not bombarded with something one minute before class. I also enjoy being in the studio helping dancers with the choreography, coaching them. *When you watch the company perform, what goes through your mind?* I find that if I see a performance two nights in a row, it starts to blur. It's healthier for me to step away from it. I don't watch every performance. At the end of last season, I missed the last four days, and when I came back, I thought, "Ah, yes!" We were on tour and they were dancing for a new audience that had not seen them before. Feeling the audience's reactions to this incredible company and the way they danced—it was wonderful.

Helgi Tomasson choreographing Nanna's Lied.

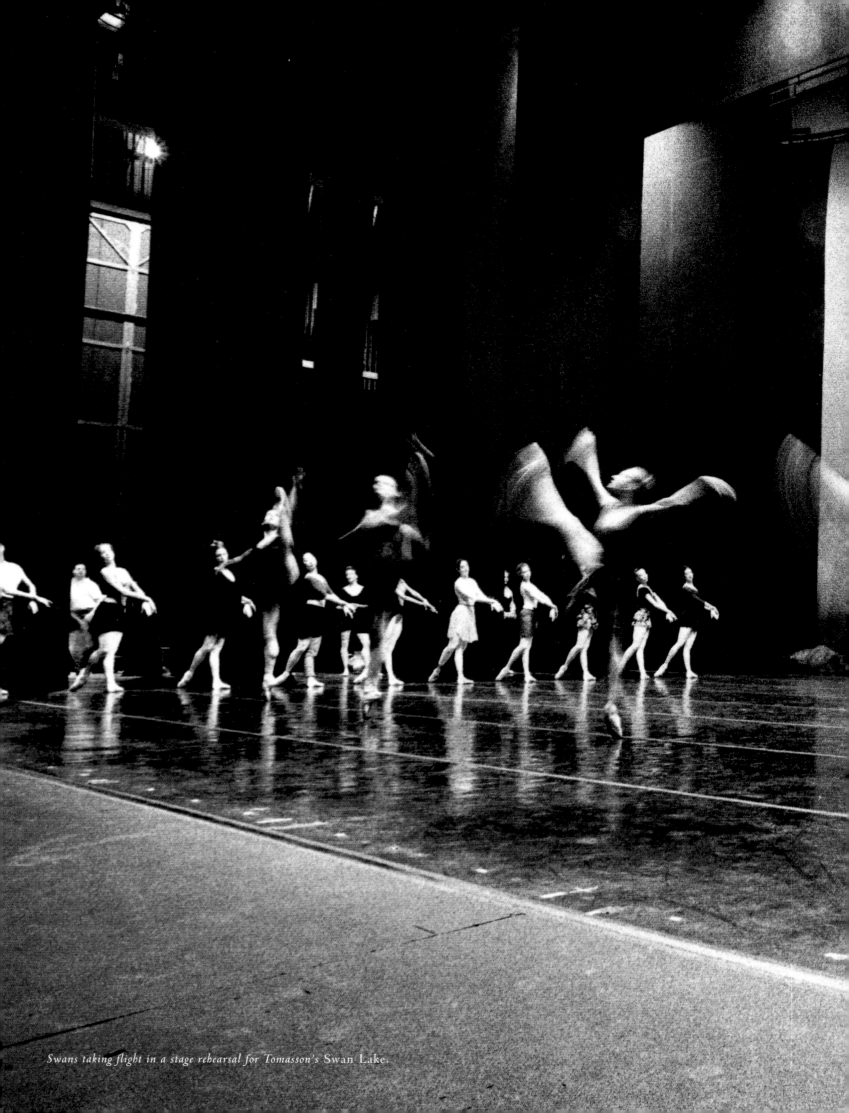

Swans taking flight in a stage rehearsal for Tomasson's Swan Lake.

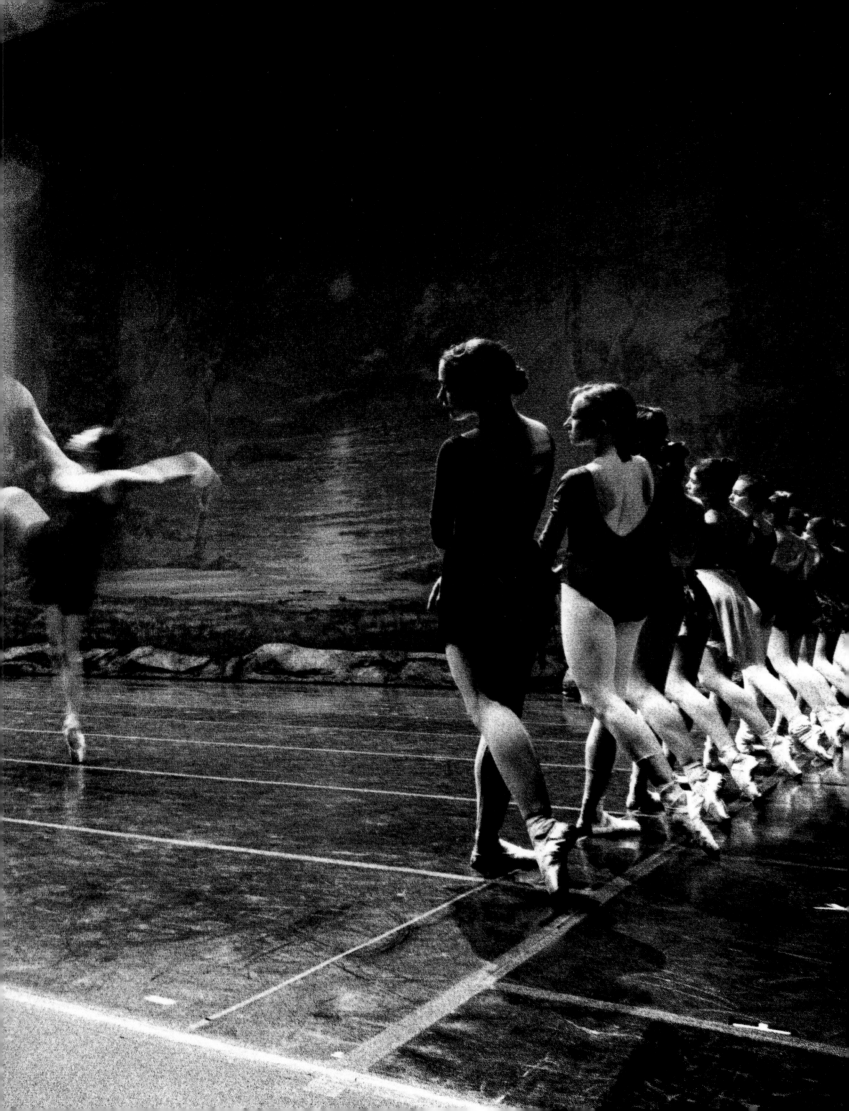

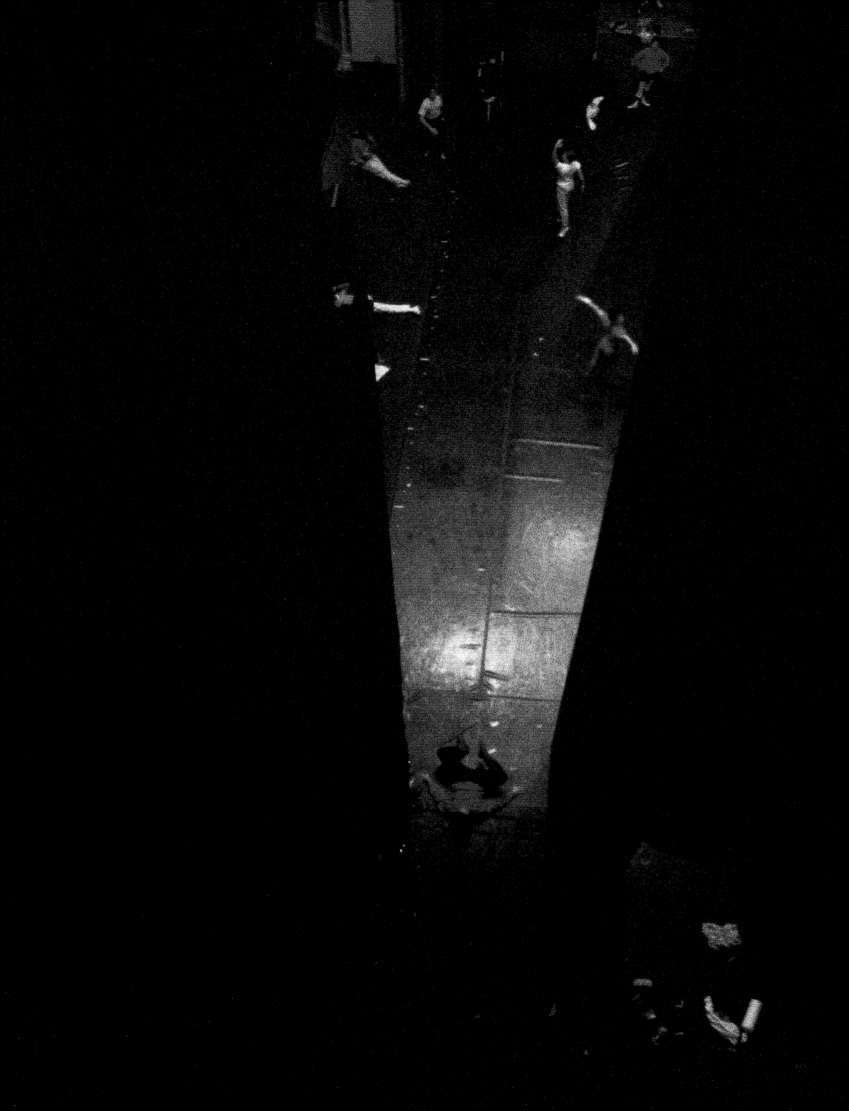

ANYONE WHO WALKS BACKSTAGE at San Francisco's War Memorial Opera House is immediately dwarfed by the blackened walls and structural braces bearing enormous vines of stage lights. The lighting produces a surreal quality as dancers and randomly placed equipment are transformed into works of art.
Corps de ballet dancer Justin McMillan (above). Overhead scene from above a rehearsal (left).

"I ALWAYS LOVED FRED ASTAIRE and Gene Kelly, and at ten or twelve it really hit me how much I loved dancing. Not a lot of other boys were doing it, but enough were that I wasn't completely alone. I loved the competition, trying to win. I loved expressing what I felt as a human. I loved the danger, the feeling that more than likely I was going to fail.

I still have deep love for what I do, and I'm proud of surviving. I'm proud of facing *Theme and Variations* and *The Lesson*, and *Swan Lake* is very close to my heart. I've enjoyed my work with James Kudelka and with David Bintley over the years. I am also proud of my commitment, my desire to continue, and the stamina I have to see things through the down times. The work comes first, and I come second.

From aikido (the martial art) I've learned the path of least resistance: to take what's presented and incorporate it, to use other forces to my advantage instead of fighting them. I have also discovered the necessity to be clear and express who I am if there is a conflict. The act of fully expressing myself usually takes care of the problem. And it doesn't bother me to be different. I embrace difference, I respect other peoples' boundaries, and I am very flexible.

What makes my dancing work is that I know how to take all the elements and combine them in an interesting fashion—to mix the salad in a way that is appetizing. It's as though I don't have one quality that is exceptional or phenomenal; my strength lies in being well-rounded.

Sensitivity and fear are my weaknesses. I can be afraid of the inherent volatility of life. I'd also like to change the tendency I have to hate myself. Even more than the fear, it roars, it breathes fire, and I have to slay it.

I do feel that being made a principal was an acknowledgment, an outward sign that I'd done a good job and that Helgi had plans for me. I had proven myself, but it was only the beginning. It was like he opened a door, but I had the responsibility to carry it through.

The love I have for dancing, for the physical challenges of this life, will always be there. I'm thirty-five now, which may be the greatest challenge yet. I'm very interested in the aging process.

In other dancers I look for those who truly reveal themselves in their work—dancers who are honest. I look for a performance that only exists at that time, something being shared right then.

I like the physical challenge of this life, working intimately with people, and exploring the different sides of myself. In *Nanna's Lied* I dug into the darker side of my personality. The urges I had to hurt, to take joy in manipulation, and the temptation to lust for power. I feel this is an appropriate place to explore these sides and purge those things within me. It's not the easiest way to do it but the gratification is deep because the challenge is great." - *Anthony Randazzo*

Principal dancers Elizabeth Loscavio and Anthony Randazzo in Tomasson's Swan Lake.

WE DREAM VERY BIG AND WE FOLLOW THOSE DREAMS. FOR ME THE INSECURITY OF THAT

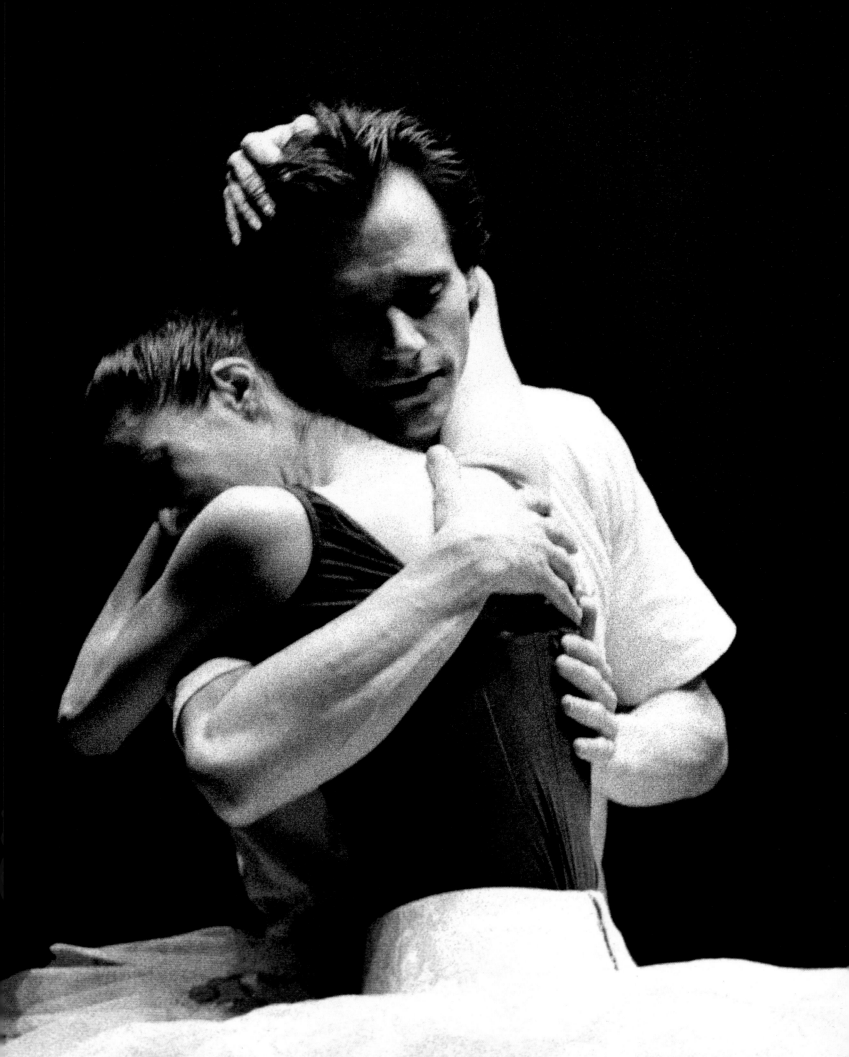

IS EXCITING. IT HAS MADE MY SUCCESSES VERY SWEET. - *Anthony Randazzo*

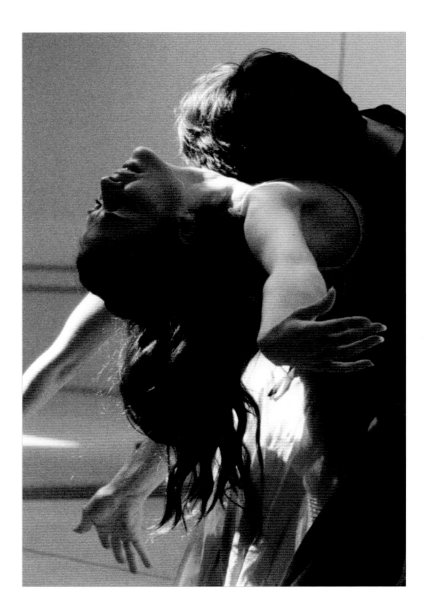

" I WENT AWAY FROM HOME to study ballet at age nine. I got very homesick, but I always had an inner voice, a core sense of strength. My parents expected a lot from me, and I wasn't going to give up. I have many more weaknesses than strengths. You never think you're good enough. But I would hate to live in a world of smooth sailing. There's a feeling you get when you dance that fulfills you; the physicality, the expressionism. I love feeling very spent at the end of a rehearsal." - *Sabina Allemann. Principal dancers Sabina Allemann and Rex Harrington rehearsing Tomasson's* Romeo and Juliet.

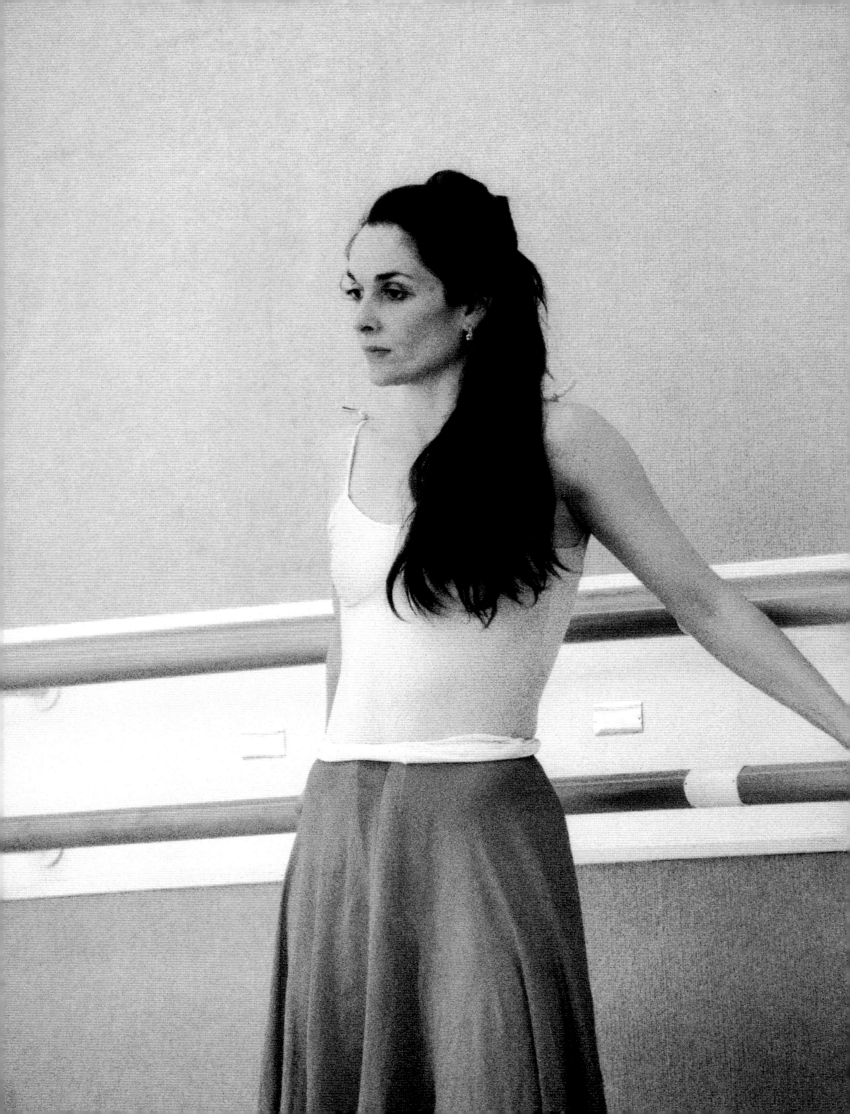

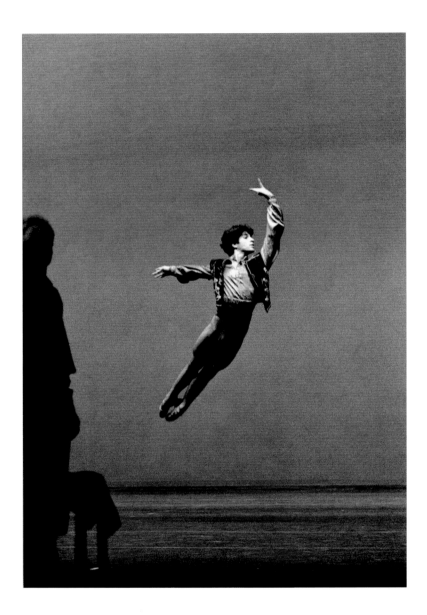

"When I was in school, there was a lot of competition among the men. We used to have play competitions. We'd have five guys in the studio doing pirouettes. The most I have ever done is sixteen. I was just spinning. But I have heard of someone doing eighteen. Doing pirouettes in class is different from doing them onstage, though. In class you don't feel any pressure." - *Vadim Solomakha. Soloists Vadim Solomakha (right) and Felipe Diaz (above) rehearsing Jules Perrot's* La Esmeralda.

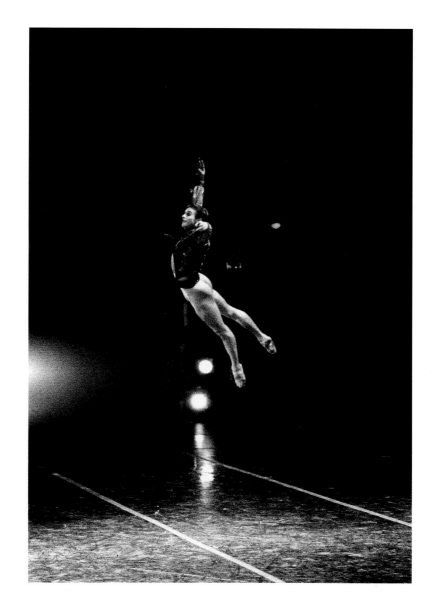

"I HAVE REALLY AMAZING MEMORIES
here; I think my relationship and my partnership with
Sabina (Allemann) has been amazing. The one thing
about moving around is that you don't always dance
with someone and build something. I'm really proud
of what Sabina and I have built. Our *Sleeping Beauty*s
together and *Swan Lake* and *Valses Poeticos* by Helgi were
wonderful. Doing *in the middle, somewhat elevated* and
Bugaku at the Paris Opera with Muriel (Maffre) was
really a highlight.

People might think I'm very confident, that I'm really
in control, yet I've always doubted myself. I think that
I am very definite about things, but in the ballet world,
you're always saying to yourself, 'Well, what are *they*
thinking?' For years it really got in the way, but near
the end of my career my attitude was 'It's me, I may as
well get on with this.'

When I moved to the U.S. it felt very different. I think
American audiences found my performances to be too
subtle. When they see Europeans dance, they think it's
small or diluted, and when Europeans see Americans
they think, 'God, it's so in-your-face.'

While I was dancing people really put out for me,
so now, as a ballet master, I just want to do the same.
I think it's really wonderful if I can guide people in a
way that they can find things for themselves. I enjoy
seeing them grow and learn and trust themselves to
find what they're looking for, especially when young
people are doing something for the first time and
you've seen them grow, and you've worked with them.

I think we're very blessed children, and we are children.
Even older people who dance have a young spirit.
Being surrounded by young, beautiful, athletic people
who are striving for their art form—it's incredible."
- Ashley Wheater

*Principal dancers Muriel Maffre and Ashley Wheater rehearsing
William Forsythe's* in the middle, somewhat elevated.

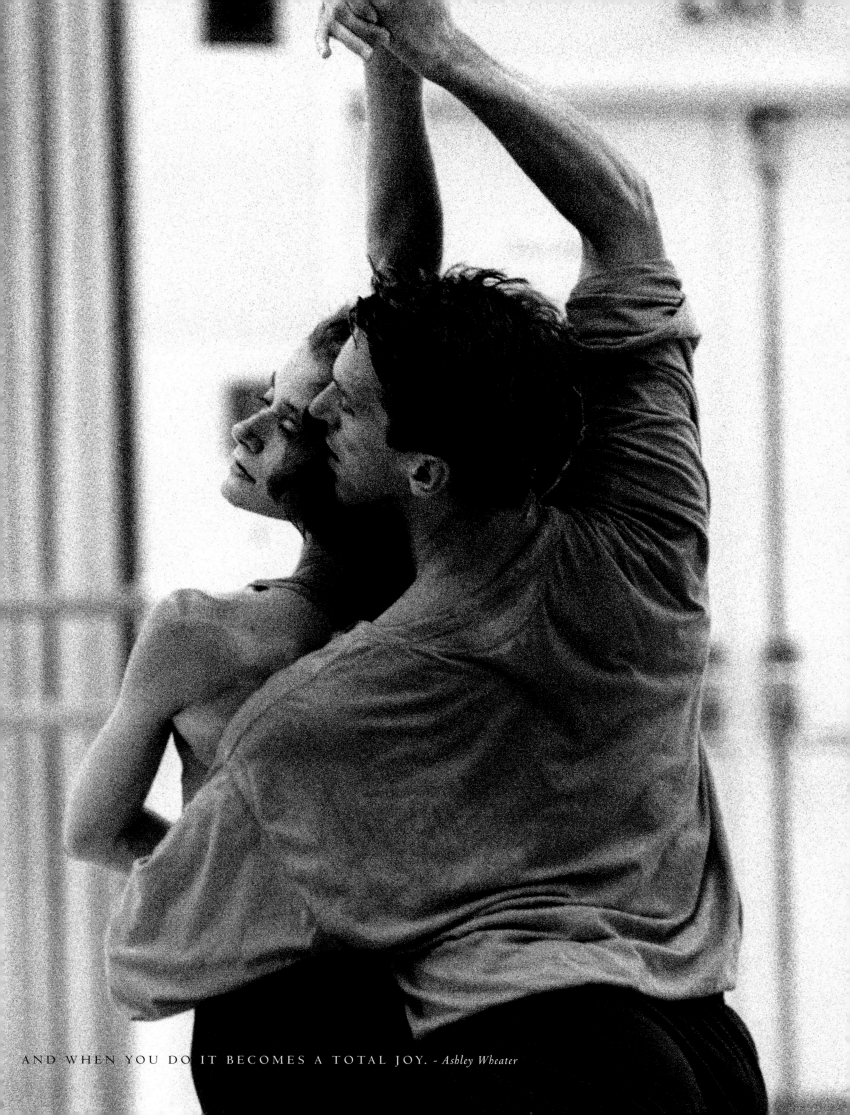

AND WHEN YOU DO IT BECOMES A TOTAL JOY. - *Ashley Wheater*

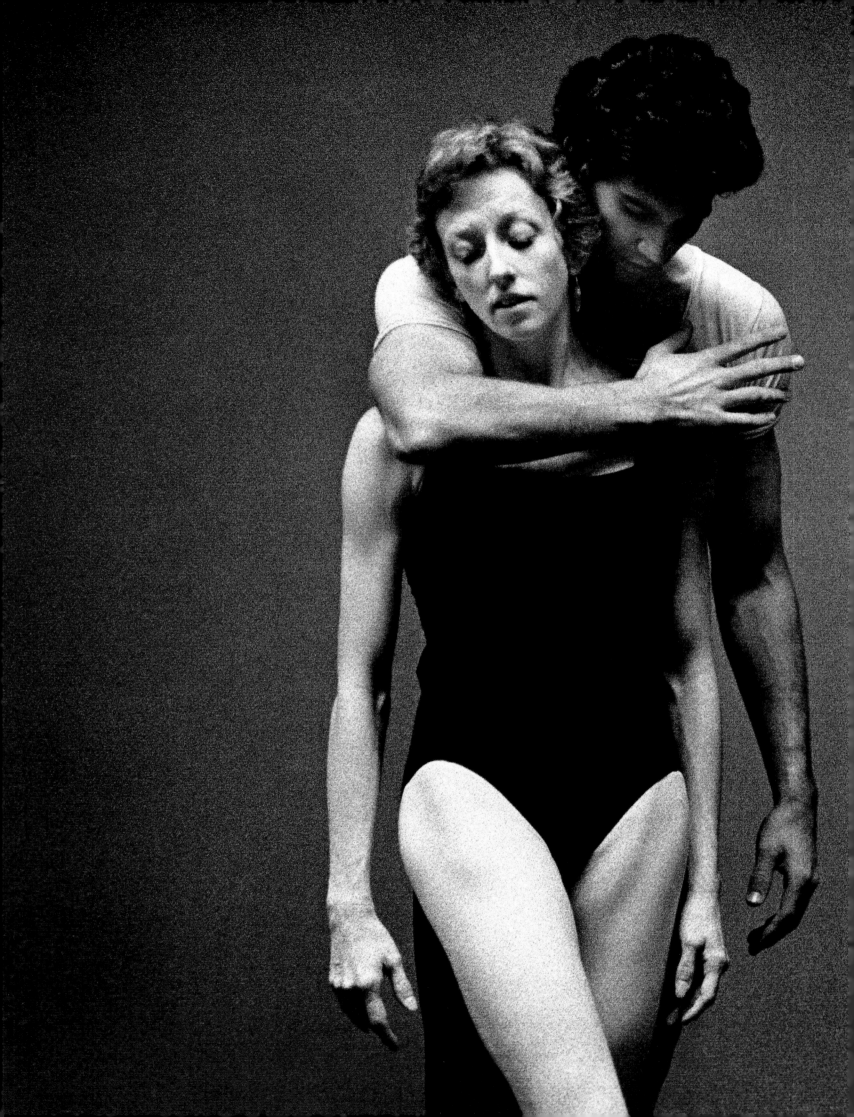

"I ALWAYS THOUGHT THAT I'D END UP IN NEW YORK, but I fell in love with a San Franciscan (my husband). I stayed here because it's an incredible company. The variety and number of roles I've had the opportunity to dance, the choreographers I've gotten to work with, and my peers. It's a combination I've not seen anywhere else. The one thing I would change if I could is time. I want it all to be starting over again." - *Katita Waldo. Principal dancer* *Katita Waldo with principal dancer Benjamin Pierce rehearsing George Balanchine's* Stravinsky Violin Concerto.

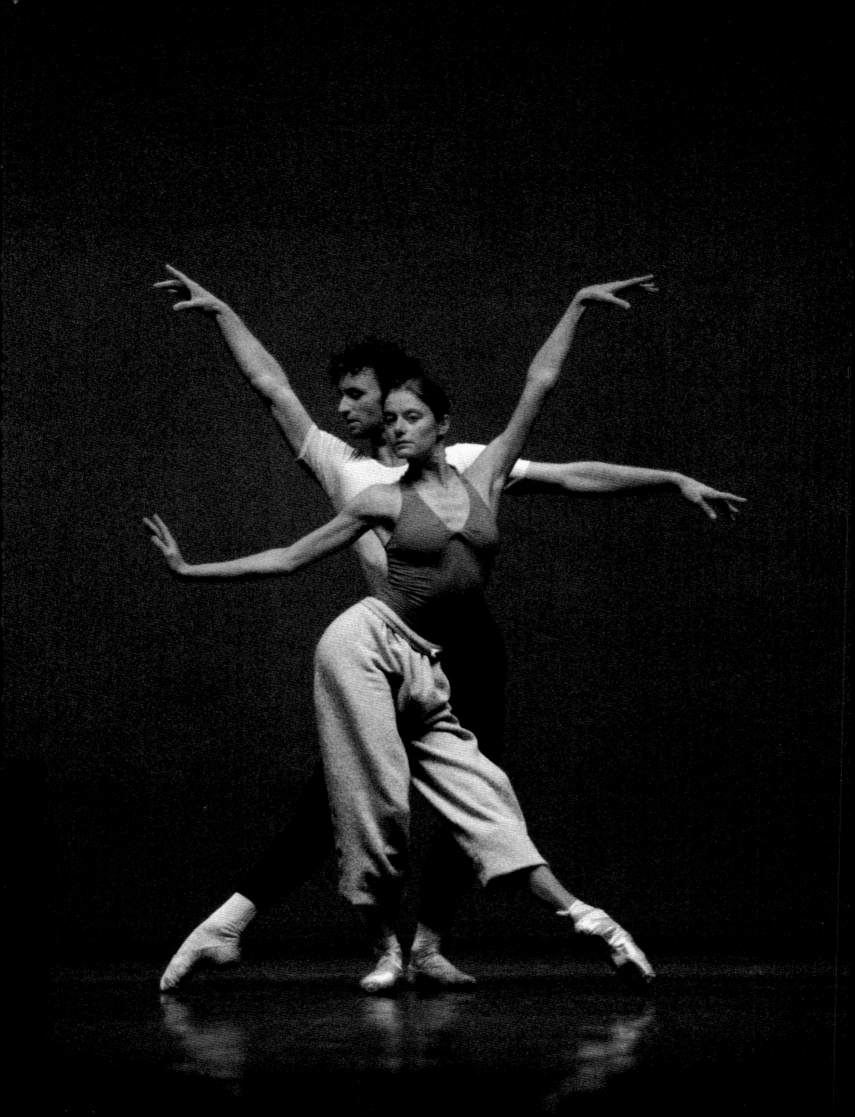

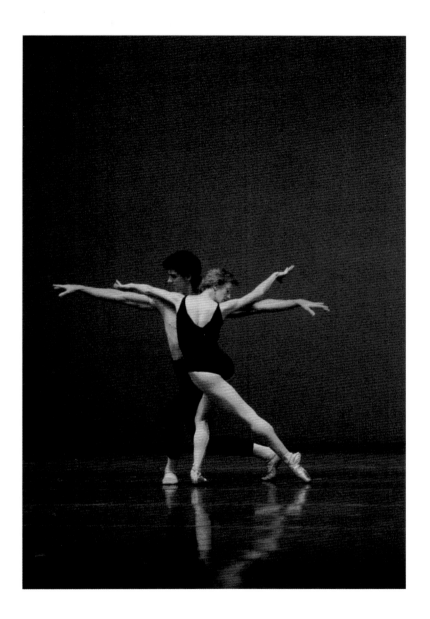

"ONE DAY DURING CLASS one of my instructors told me to think of every movement as if it had a tail on it."
- *Muriel Maffre. Principal dancers Muriel Maffre, Cyril Pierre (left), Benjamin Pierce, and Katita Waldo (above)*
in rehearsal for George Balanchine's Stravinsky Violin Concerto.

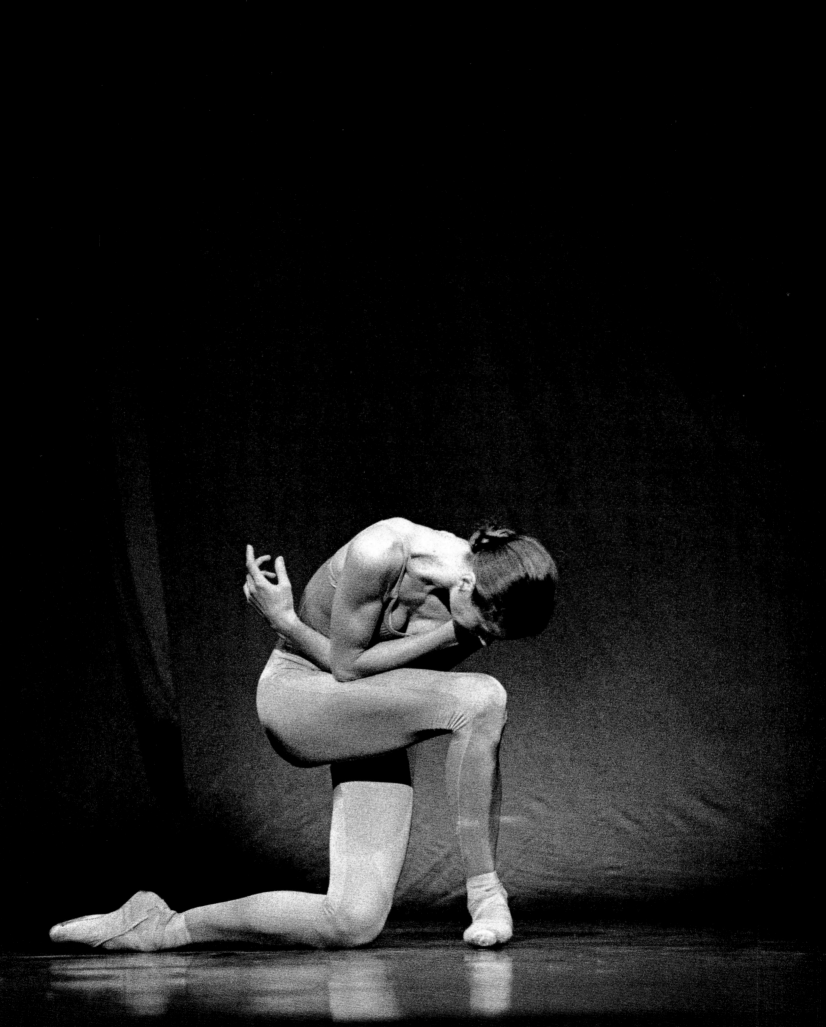

MY MOTHER WAS TAKING BALLET AND I WANTED TO DO IT ALSO.

I REACHED MY FULL HEIGHT of 5'10"
at age thirteen, and I was fired from the Paris Opera
Ballet School at fifteen for my height and character. At
the time they told me, 'You are a beautiful plant, but
you cannot dance.' My mother tells me now that I
never smiled during this time. Still, I had this passion
for dance and I would not give up.

From there, I went to the National Conservatory
of Advanced Studies in Paris, graduating at seventeen.
Then, at eighteen, I entered the Paris International Bal-
let Competition and received the gold medal.

I feel my strength is my stubbornness, my will. I never
considered my physique to be a strength because it
has brought me more suffering and hurt: Everything
shows, everything is amplified.

I'm such a perfectionist that I can destroy myself.
The more I go forward with my dancing, the lonelier I
become. I am very close to my boyfriend, but otherwise
I don't socialize.

In other dancers, I admire truthfulness. I do not like
dancers who make it a performing art, instead of just
an art. The element of the audience is there, and it will
influence you, but to me it's not about showing off.

I look up to Nureyev, Pavlova, Nijinsky, Bette Davis,
and Josephine Baker. In Bette Davis, I admire the
strength of her personality and what she did with it,
the wildness of her style.

I do not have a favorite role; I don't approach anything
that way. Even if I don't look forward to something,
I always transform it so there is something I will gain."
-Muriel Maffre

Principal dancer Muriel Maffre in rehearsal for Ben Stevenson's
Four Last Songs.

I FOUND I COULD EXPRESS MYSELF WITHOUT USING WORDS. - *Muriel Maffre*

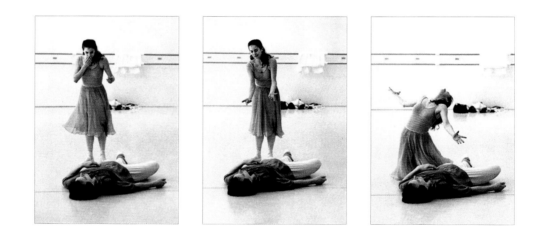

The final rehearsal before the premier performance for principal dancers Elizabeth Loscavio and Anthony Randazzo in Tomasson's Romeo and Juliet.

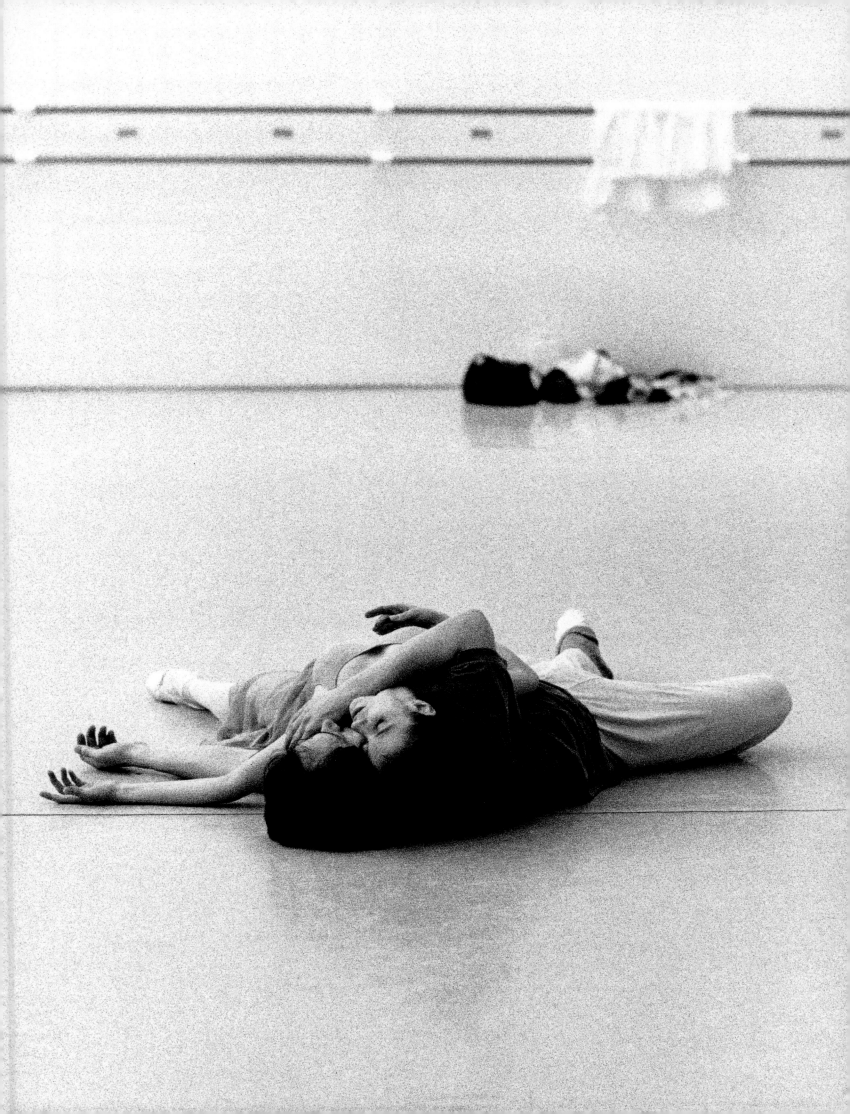

LIFE IS NEVER COMPLETED. You're always on a path to a place and that place always changes. The goal, the adventure keeps changing.

Going to SAB (the School of American Ballet) at thirteen was like being a grown-up. I couldn't believe my parents let me go. On Saturdays, I would sneak in and sit behind the barre to watch the company, and all these incredible artists were in class: Gelsey Kirkland, Peter Martins, Helgi, Stephanie Saland.

I am inspired by dancers who are rehearsing in the studio or dancing in class, and they're committed to working every day with the same sort of work ethic; and by those who are noble in their performance and hold true to the value of the choreographer's intent.

I like getting a sense of energy on the stage, whether it's between me and my partner or in a group and I'm catching somebody's eye. I feed off that energy. And I've always wanted to create a sense of unity, rather than dancing selfishly. Even if you are doing a solo, you're not doing it for yourself; you're doing it to give it away.

What I love about this art form is the quiet freedom of expression. Often too much emphasis can be placed on the performance. It's the process to that freedom that matters to me.

Sometimes during a performance I think about the technique and sometimes the rhythm—the breath of the music. Sometimes it's 'Keep that shoulder down.' There are times in *Swan Lake* when I'm standing on the side and the Prince comes onstage to dance with Odette and I'm thinking, 'Pick me so we can change the story.'

I'll never forget that feeling of dancing the Snow Queen one evening in the *Nutcracker,* and I balanced in an arabesque for so long that people were cheering for me in the wings and the stage manager had to tell them to stop. Sometimes the orchestra is just right, and you're wearing just the right pointe shoes, and you just do it. It all clicks." - *Kathleen Mitchell*

Soloist Kathleen Mitchell rehearsing George Balanchine's Rubies *onstage at the New York State Theater.*

I HAVE AN OPTIMISTIC ATTITUDE AND I'M CONSISTENT.

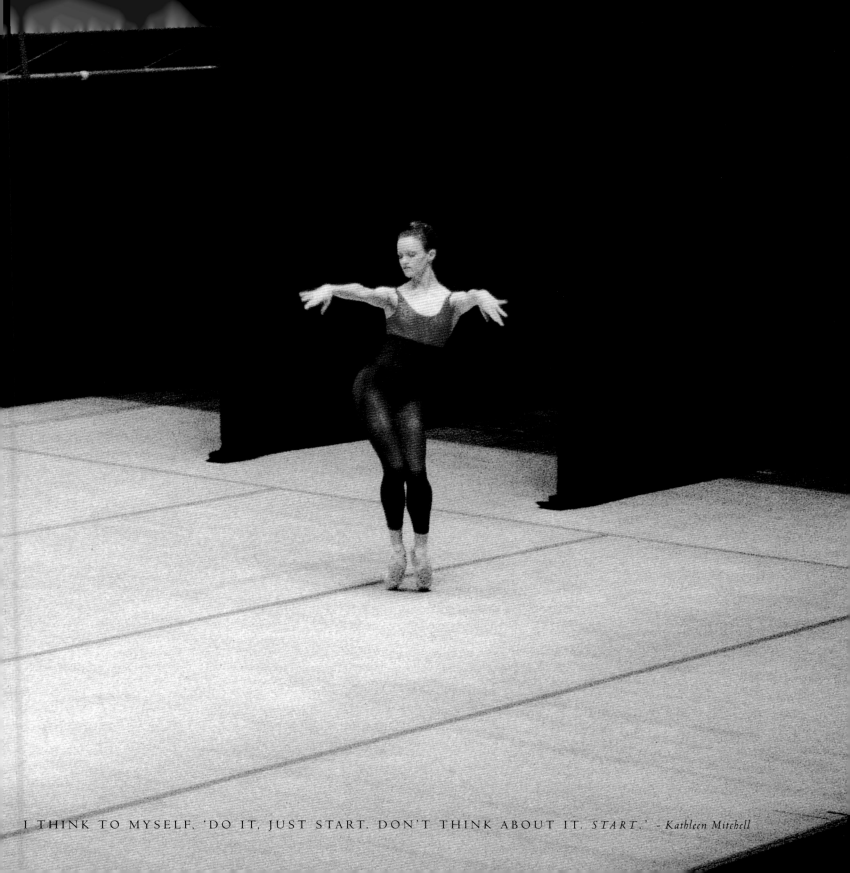

I THINK TO MYSELF, 'DO IT, JUST START. DON'T THINK ABOUT IT. *START.*' - *Kathleen Mitchell*

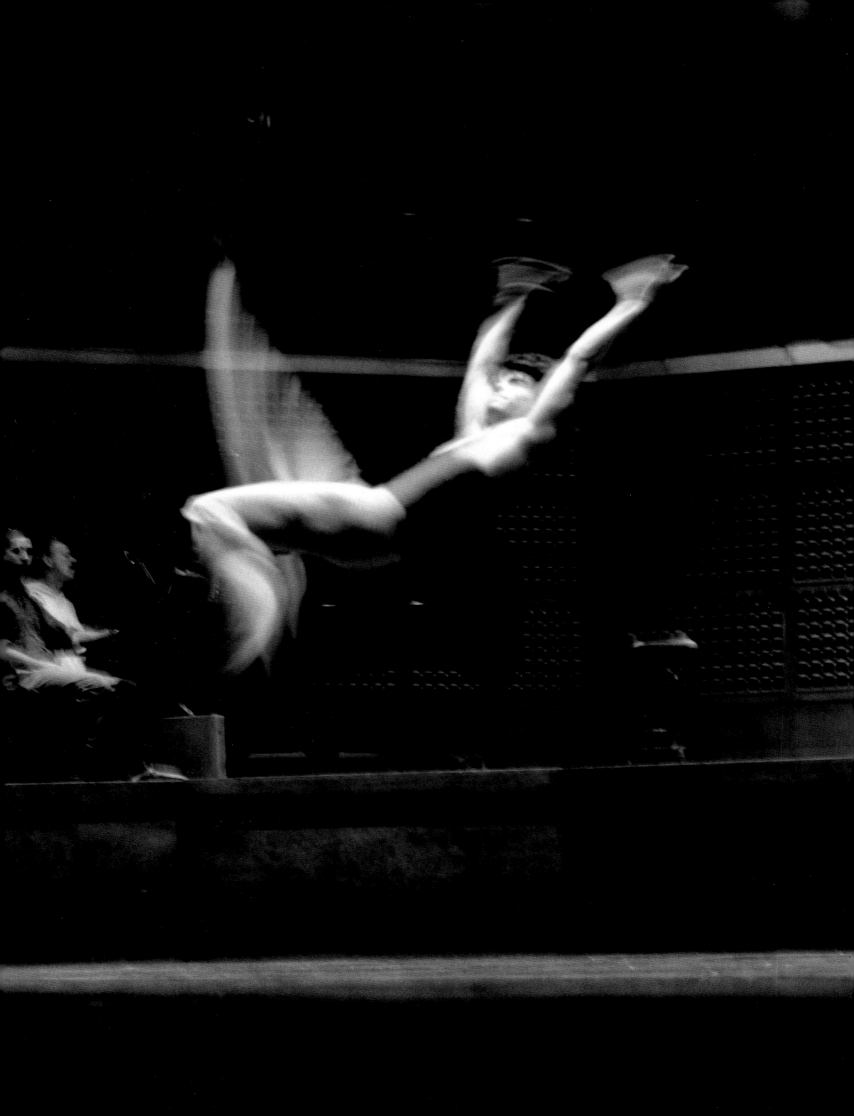

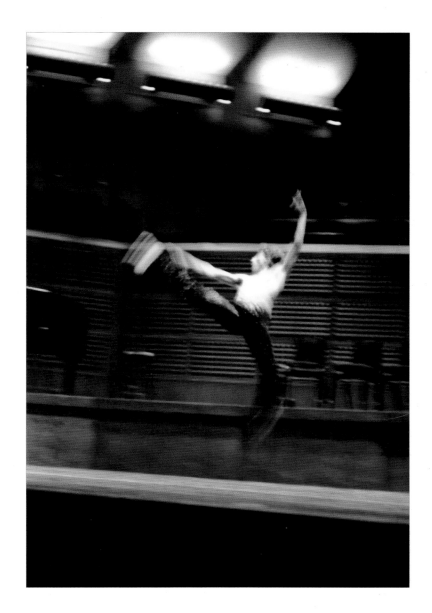

"I don't say, 'I can't do that.' I say, 'I want to do that.' That's the only way to live. Even if I think I can't do something,
I always want to try." - *Roman Rykine. Principal dancer Roman Rykine in a dress rehearsal for* La Bayadere *(above).*
Principal dancer Joan Boada rehearsing Vassili Vanonen's Flames of Paris *(left).*

A GOOD POINT IS ALWAYS

IT'S NOT ALWAYS GREAT to be comfortable. It's very easy to get set in one's ways and to get defensive. You are tempted to fall back on what has worked for you. So at a certain point, people are less likely to approach you with advice. The trick is not to become an old dog, but to continue to be open and listen to people even if they have far less experience than you.

Robert Joffrey was a mentor; he had a way of communicating things to me. Despite the brashness and know-it-all attitude that comes with youth, I would listen to him. He was a genuine person, and it was obvious he had compassion for his dancers and his art. His professionalism and work ethic had a lot to do with who I am today. Kelvin Coe and Paul de Masson, two Australian Ballet principals, also took me under their wings. They were always helpful and encouraging and said great things to me as Robert Joffrey had.

I feel I have managed to excel at the extremes in the art form and I like to move between those extremes. The most classical roles are more of a stretch, but stretching pulls more out.

Prince Siegfried in *Swan Lake* stands out as a favorite role for me, yet so many people said I would never do it. I told myself 'That's only one person's opinion.' I've always looked at obstacles as a challenge. If you can figure out a way to get over it, around it, under it, through it, then it improves you.

In looking back, my greatest regret is that I didn't continue to do other things along with dance. I should have gone to school at night or on weekends. I can see that the newer generations have started to realize it's possible to do this. It's easy to let this job overwhelm you. When you are young the amount of energy you have is boundless, and you shouldn't be afraid to use it because more will come the next day. I am continually learning as I work on new things and I have started choreographing recently. I love it and I would love to make a career out of it.

As I'm putting on the costume before I dance *Rite of Spring,* sometimes I think, 'Do I really want to do this tonight?' So I tell myself, 'It's okay; you're not gonna die. You might throw up, but you're not gonna die.' Like in any athletic profession, we hit the wall physically. Discipline, motivation, and love for the art form, all make the rest easier.

Now, realistically my goals have been to be the best possible dancer I can be and I have not yet gotten there. It keeps me working every day, week, month, year." - *David Palmer*

David Palmer in dress rehearsal for David Bintley's The Dance House.

A GOOD POINT, NO MATTER WHOSE MOUTH IT COMES FROM. *- David Palmer.*

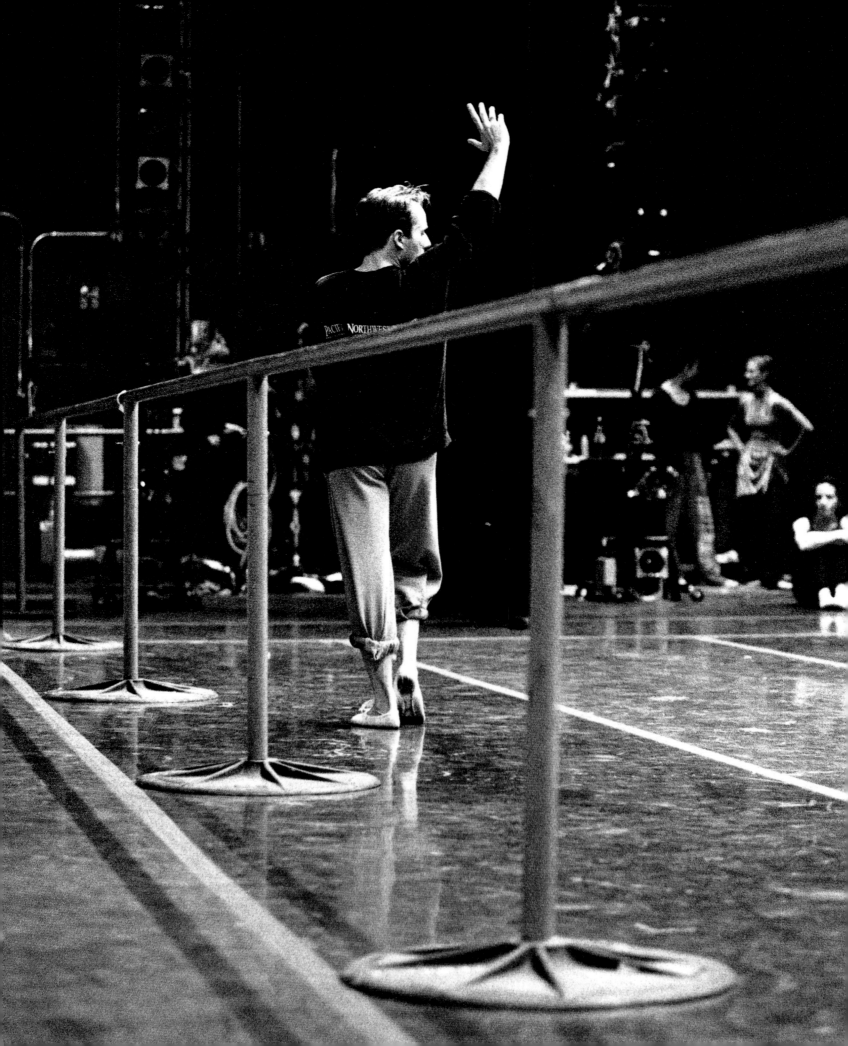

How did you come to work with San Francisco Ballet? Helgi saw *Sons of Horus* in London at Covent Garden in 1986 and he asked me to come to San Francisco to do that piece. So I did and I had a great time. Since then, I've gone back every other year. In 1990 I did *The "Wanderer" Fantasy*, in 1992 it was *Job*, and then in 1994 it was *The Dance House*. These were all new pieces for the company. *What was your inspiration for* The Dance House? I had the idea for a dance of death in the back of my mind for a long time, and I had this sort of diabolical idea that the devil and death have the best tunes—you know, the demonic fiddler idea. So the dance of death is a rather virtuoso piece where decay sort of takes hold. And I have this friend who died. He was a dancer in this company (Birmingham Royal Ballet), and I sort of grew up with him in the company. And then suddenly he left, and we heard that he died of an AIDS-related disease. Because I'd had this idea of the dance of death in my mind at the time, the two became completely linked in the idea of a ballet that would take place in a dance room—a dance-practice setting—almost remembering Nick as a dancer. We did an excerpt—the pas de deux from the second movement—here at a gala that was done for an AIDS benefit. It had a very profound effect on a lot of the members of the company, because people knew it was for Nick. I put a lot of Nick into it. He used to like nothing better than doing adage at the barre and he had a beautiful line. Those who knew him saw that, and so it had a cathartic effect on people in the company. And Nick had a great sense of humor, which inspired some of the passages at the end. When I figured the piece originally, I was also quite influenced by *Angels in America*. I was influenced not so much by the reality, but the fantasy elements of it. *Tell me about your collaboration with composers.* It depends on the person. I've worked with composers who want you there as often as you can be, and they're dealing with passages of music as short as two or three minutes. They want to know if this is the right romantic idea or the right harmonic idea before they go into any sort of depth. However, I did do one piece where I talked and talked with a composer for six weeks, and the score was entirely written before I heard anything, and that worked very well. For the most part, it's somewhere in between. *Do you begin with a story?* I only commission music for things that have a plot now, because I've gotten stuck a few times where I have people writing—for lack of a better word—abstract music, and it doesn't work quite as well because the possibility that you might get off track is much greater.

If you've got a story, or at least some strong theme, then at least you're talking about something that is in common between the two of you. So I tend to just commission music that is narrative now, and, yes, I give the composer a very detailed scenario with a breakdown of anything as short as thirty seconds and as long as perhaps eight minutes. *What do you feel is your strength?* I don't know, I guess I can tell a story, and not a lot of people want to tell stories these days. I like stories, and the ironic thing is, audiences like stories. *And you seem to have a knack for humor.* That's a useful thing, people especially like comedy. What I've always admired in Fred Ashton's work, and what I've tried to emulate—because I don't like silly steps and people falling over—is comedy that springs from humanity. You're laughing at somebody's foibles, so you're laughing affectionately. That kind of laughter where you don't know whether to laugh at something or cry at something. And there are a lot of moments in *Hobson's Choice* where I think that kind of thing is true, where this poor little guy is very funny, but it's kind of touching as well. I think that's true of *La Fille mal gardée* as well—the widow is very funny, but in the end she's very lovable and very real. It's not just slapstick. If you play it as a kind of camp joke, it's not real. *What do you feel is your weakness?* I think one of the things—I'm kind of over it now—is that I would have been quite happy to keep working in a very academic way. I love classical ballet in its purest form. That's why I'm such a Balanchine fan, because he keeps going back to that. In a piece like *Ballo della Regina* he's a man virtually at the end of his life, and he's just taking some old opera music, and he's using one girl and one boy, a few demi-soloists, and a corps de ballet. It's a ballet he's done a thousand times, to different scores at different points all the way through his career. And even in his eighties he's going back to the source all the time. And I adore that. I think there's a great sort of humility in it, But I think I was born just out of the time to do that. And, I think perhaps I don't have the talent to do it in the way that Balanchine did. Perhaps it has to do with timing. *Did you have a mentor?* I guess the person who gave me the most opportunity was Peter Wright who was my predecessor as director of this company and Sadler's Wells. He was the one who took me from the school into the company and gave me all my chances. My real mentors would really have been (Sir Frederick) Ashton and (Dame Ninette) De Valois. I mean, when you have people like that gunning for you, then it's great.

Principal dancer Christopher Stowell in rehearsal for David Bintley's The Dance House.

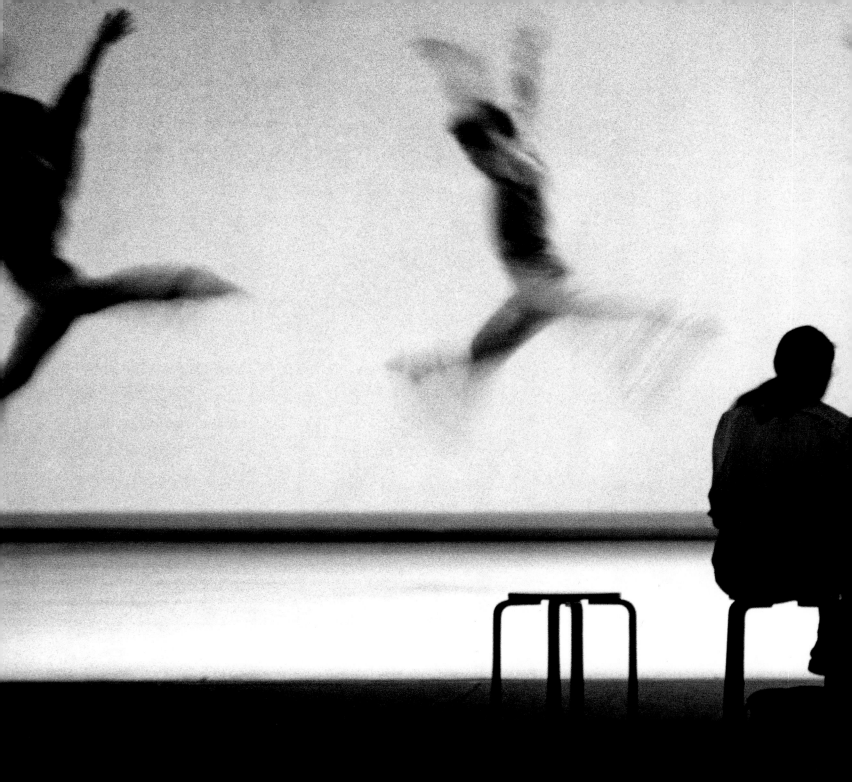

"I GET A GREAT DEAL OF JOY from seeing dancers let their bodies go. I used to enjoy that when I danced."
- *Ballet mistress Betsy Erickson, sitting second from the left at a rehearsal for Paul Taylor's Company B*

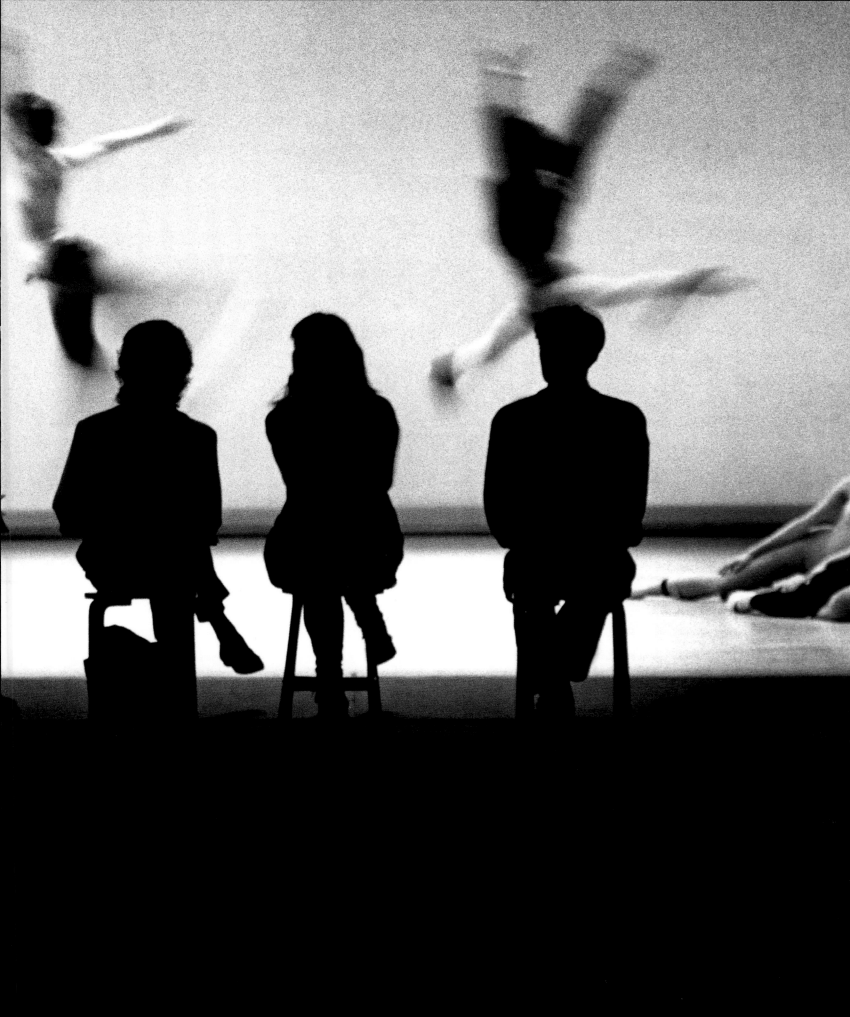

I NEVER DIDN'T WANT TO DANCE.
Not for a moment. When I was seventeen, I remember
saying to my dad that I wished there were guarantees
that I would make it. He told me there are none in life
and I could only do my best. My dad, having a theatri-
cal side, was totally into it. My mom absolutely loved
it but her practical side wanted me to have a backup.
She still supported me 100 percent. My parents went
to a ballet on their honeymoon.

Onstage, I think I have a human, accessible quality,
and I think I'm versatile. Music is my number-one
priority and I want to include the audience in my
dancing. I'm trying to say 'Isn't this hilarious or fun,
or, can you believe how gorgeous this music is?'

I love creating something new with choreographers and
really understanding what they are after. I also enjoy
the atmosphere and sense of community in pieces like
Company B, creating a mood with other dancers. It's
important to me to be in a positive workplace. I want
laughter and ease and for people to enjoy the experience.

ONSTAGE sometimes you're thinking, 'Oh, I forgot
to call so and so.' But ideally you are totally in the
music. In terms of the steps, you are on autopilot and
free to respond to whatever is going on around you or
happening to you. The lights can create an intimate,
warm, and protective atmosphere, almost like being
underwater. I feel confident and safe onstage."
- Joanna Berman

Principal dancer Joanna Berman in rehearsal for
Jerome Robbins's In the Night.

IT'S THRILLING TO DANCE CHOREOGRAPHY THAT

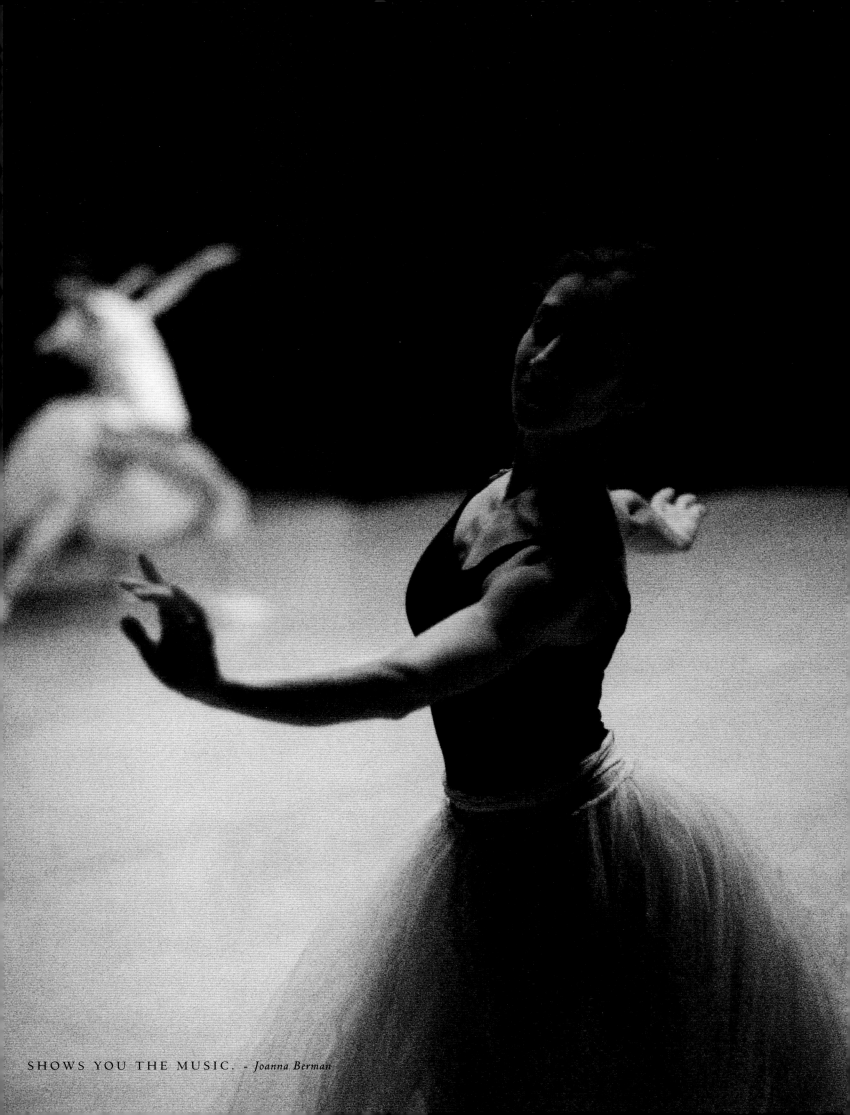

SHOWS YOU THE MUSIC. - *Joanna Berman*

Why did you choose to work with San Francisco Ballet? Because they're good. I hadn't seen them for years and then I saw them perform at City Center, and I liked them. I like the company very much. *When did you decide to become a choreographer?* I made the first dance that I think was good when I was fifteen. I showed that in my first concert in New York in 1980. So I have been choreographing since I was fifteen, and now it's all I do. *In your career so far, what are you most proud of?* That I'm alive! *Why do you say this?* Because a lot of people are dead, and a lot of companies are dead, and there isn't a great deal of demand for the sort of work that I do. My company has a great deal of work, and I'm doing exactly what I want, which is what I hope everybody can do. *Do you have to make decisions these days based on money, or are you allowed to think only of your work?* Sure. But because I have a great staff, I don't actually deal with raising money or negotiating contracts or anything like that, but it is a very expensive undertaking. I am informed of the costs and I keep track of what I'm doing. But we are in a very, very good position. I work only with live music, and we travel all the time, and I make up new work. It's great. *Did you have a mentor?* The word "mentor" has taken on a postmodern meaning that I don't like. I had people who were behind me, and there are people whose work I've admired certainly, but not one person. It would range from my mother, to Merce Cunningham, to Handel, probably. *What do you feel is your strength?* (Laughs) I'm not sure how to answer that. The answer is that I do really good work and people like to watch it. And I like to watch it. I would probably say that my musical education—my musical consciousness—is what distinguishes my work from other people's, but I don't know. *Do you have a motto?* No, not really. I work hard, and I do my best all the time to have things work out. If something is disappointing or something falls through, it's not necessarily a bad thing. I take it all. It's my life and it's very, very satisfying. *Have you achieved your professional goals?* I never set any goals, and I continue not to. What I do is make up dances and perform them all the time. So, I'm doing exactly what I want, and I never imagined I would not do what I want. The fact that other people like that is a great bonus; it's what keeps my company going. But as far as goals, I don't have plans that I meet or don't meet. I have dances, productions, or offers of some sort that are planned for a year or two in advance. Those things I work on, and when they are finished I show them. *Can you describe the process you go through when you choreograph?* I find music that I think would make a good dance and then I study that music. I listen to it, I read the score, and if I'm lucky, I have a few ideas of who's in it or what the tone will be or some sort of physical themes that correspond to musical motifs. I do everything else in the studio with people there.

That's why I do commissions instead of selling older pieces: I want the people who are going to perform it to be there when I make it. No dance ever turns out the way I think it will because I don't make it up in advance in my head. A lot of people who aren't choreographers imagine that I listen to music and see a dance and spit it out, but it doesn't work that way. *What qualities do you look for in dancers?* I like dancers who are fabulous and musical and intelligent and spontaneous and exciting and thorough. *Which ballets do you like to watch?* Several of Balanchine's works: I think *Napoli* is genius, and also *Giselle,* and *La Sylphide*. Balanchine was a far better choreographer than Petipa was. But I always like pieces if they're done well and the music is great. And, actually, it's not so much the piece itself that I love; it's the execution of a piece that I love. *You always seem to be giving everything you have in rehearsal. Isn't that exhausting?* Sure it is, but it's the part of my job that I enjoy, and the point is to generate enough interest and energy and fun to get the work done clearly, without everybody freaking out. I just like to work straight out and work hard and work fast and be as direct as I can be. Then the dancers do the same thing, and they are valued for what they do, and it's not a trained-dog act or anything. It's always been my desire that everybody in a piece—and this is true with my own company—that everybody in it knows everything else about it. As opposed to learning just one part, they know how the piece is put together, they know how the dance relates to its music, and they know how the dance relates to itself. I encourage everyone to know what's going on the whole time. And then everyone understands better why that particular work makes sense; it's easier to remember, it's more fun to do, and it's a better community activity, instead of being contentious. I try to be honest and frank, and I try to give them credit for the very, very difficult job they do. *How have things changed for you since you have become so well-known?* I'm asked to do more things than I can or want to do, and I get good tables at restaurants and stuff like that, but I'm also very busy a lot of the time. It's pretty swamping actually; there are a lot of demands made on me. Right now, for example, my company is getting ready to go to New Zealand and, because I don't need to be there, I'm listening to music and reading and doing some interviews. I was working on *Capeman* for a year straight, and I didn't have more than one day off for a very long time, so I'm regrouping. I just finished making up a new dance, and we are touring and performing a lot. I'm doing exactly what I want, and I'm surrounded by people I really like. My life and my job are the same thing, and that's a pleasure. I enjoy traveling and I travel; I enjoy dancing and I dance; I like spending time with people and I do it; I love music and I spend all my time working with music.

Choreographer Mark Morris with Tina Fehlandt in rehearsal for his ballet Drink to Me Only with Thine Eyes.

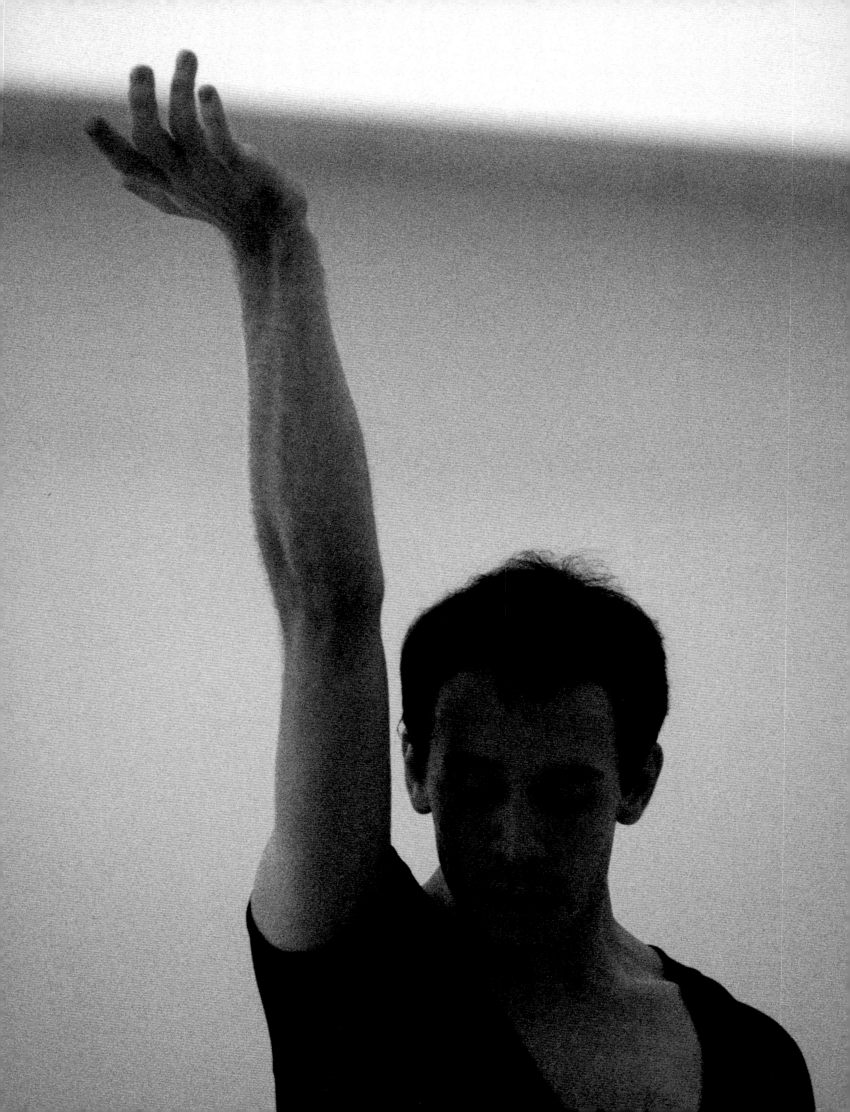

Soloist Paul Gibson rehearsing Rhapsody, *a piece he choreographed for the Student Showcase (left).*
Principal dancer Yuan Yuan Tan (above) rehearsing Jules Perrot's La Esmeralda.

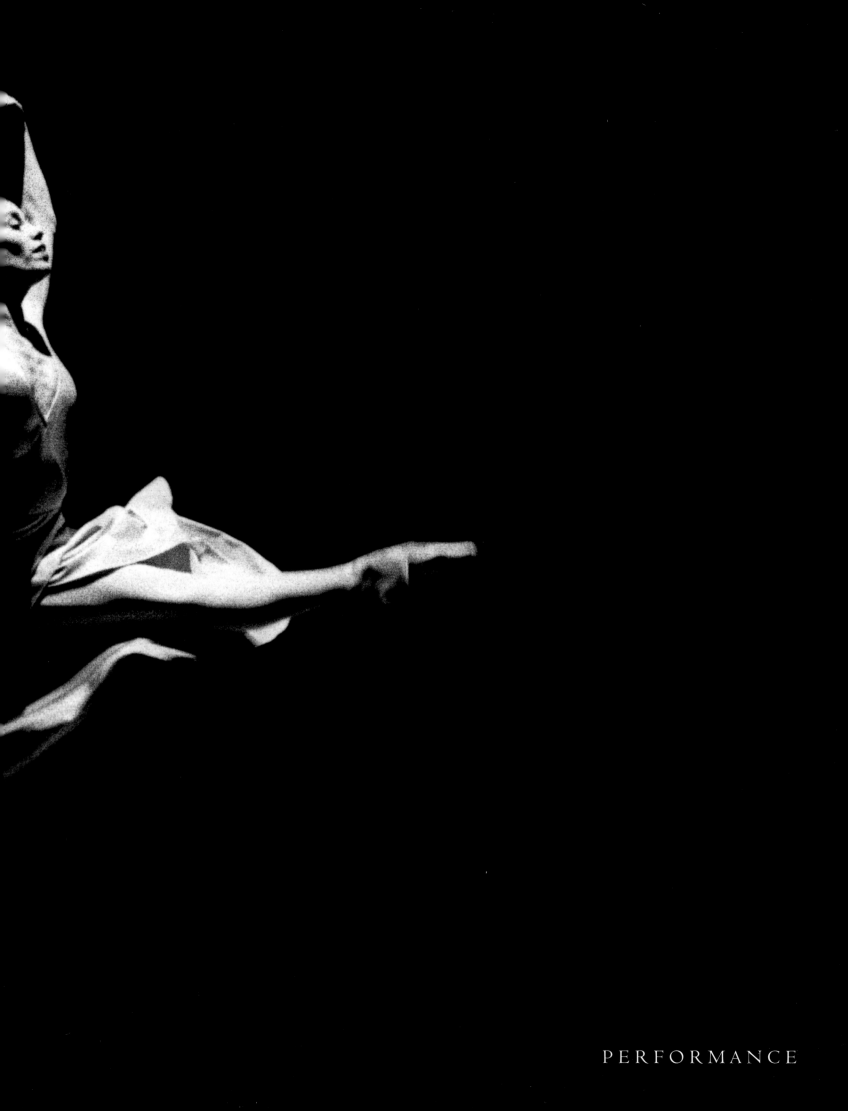

PERFORMANCE

THE PERFORMANCE is the final synthesis of work, study, and interpretation connected with the creative vision of choreographer and dancer. It is the culmination of months of preparation where the movements and gestures have all become second nature. The sets, lighting, and costume designs merge with music, motion, and a live audience, to create the feeling that what happens is somehow for the first and only time. In striving to harness this energy, dancers often look to a place inside themselves before the curtains rise. *Corps de ballet dancer Ikolo Griffin, principal dancer Katita Waldo, and corps de ballet dancer Alex Ketley just before the curtain goes up (above). Corps de ballet dancer Sara Sessions (right) warms up before a performance of George Balanchine's* Stravinsky Violin Concerto. *Previous page: Principal dancer Evelyn Cisneros in Tomasson's* Confidencias.

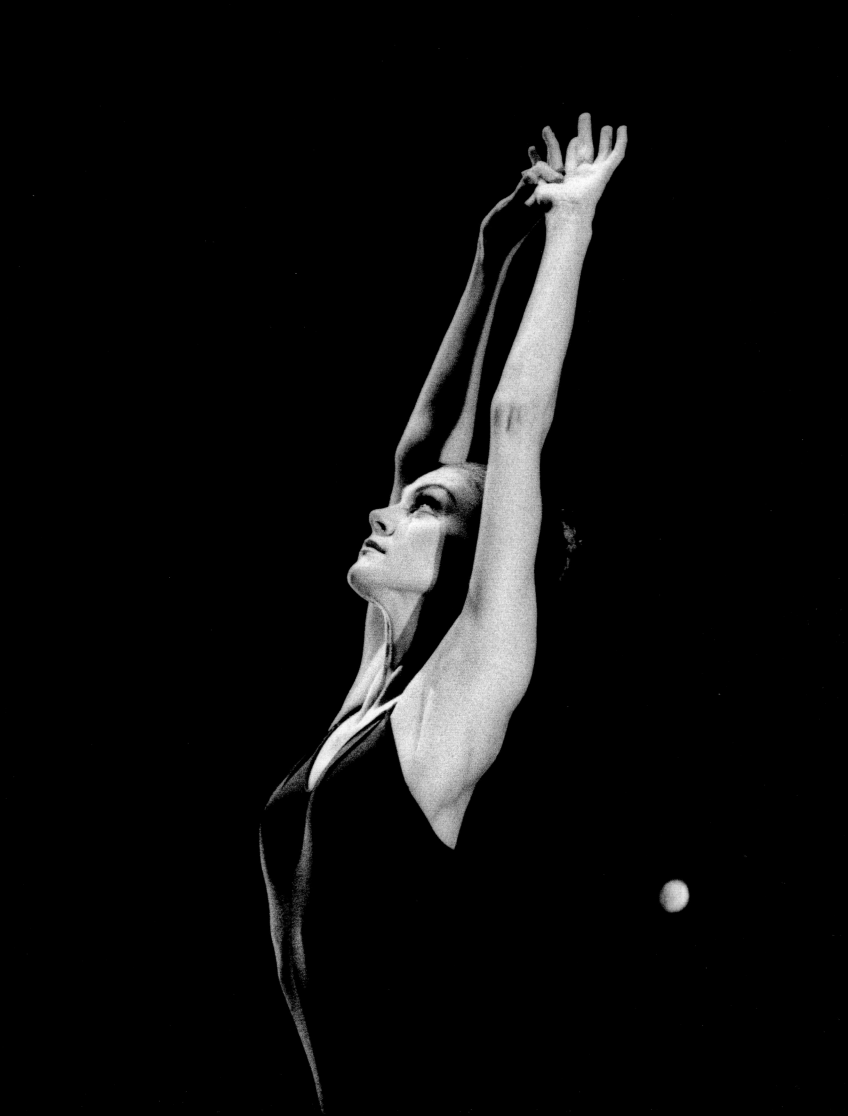

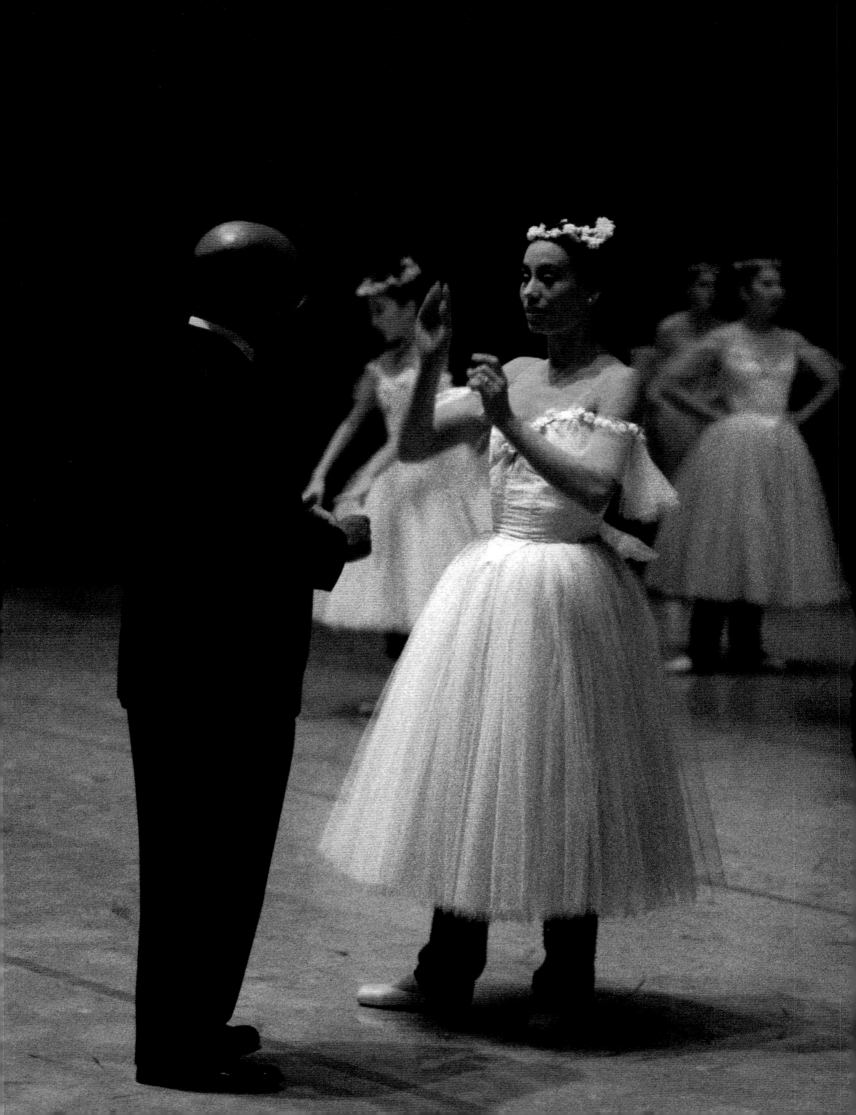

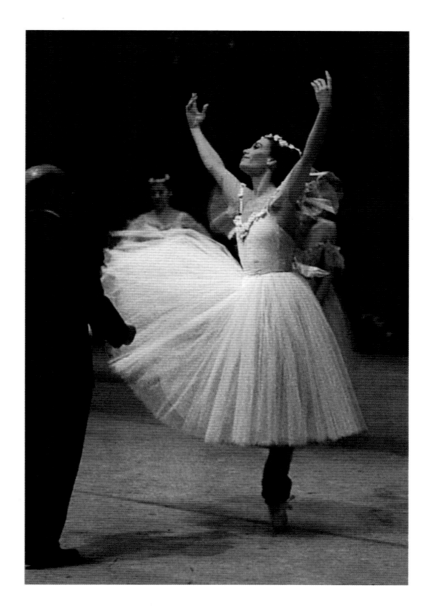

PRIOR TO EVERY PERFORMANCE, it is customary for the principal dancers to go over the tempos
of the music with the conductor. "There are only four tempos in ballet: too fast and too slow." - *Maestro Denis de Coteau.*
Principal dancer Evelyn Cisneros talks with Denis de Coteau before she performs the lead in August Bournonville's La Sylphide.

"EVELYN COMES ONSTAGE and even before she dances she has the entire audience in the palm of her hand. She exudes sheer joy of just dancing and she's also tremendously musical. So for me, watching her dance is like accompanying a pianist in a piano concerto. She'll phrase ahead of the music, or behind, but always for a musical reason. People ask me if it's hard to accompany dancers but I always say 'no,' because when you have someone like Joanna (Berman) or Evelyn (Cisneros) they're just so musical and it makes it fun because we're both playing with the music. I'm not just conducting and they're not just dancing to the beat." - *Conductor Emil de Cou. Principal dancer Evelyn Cisneros performing with pianist Daniel Waite in Tomasson's* Confidencias.

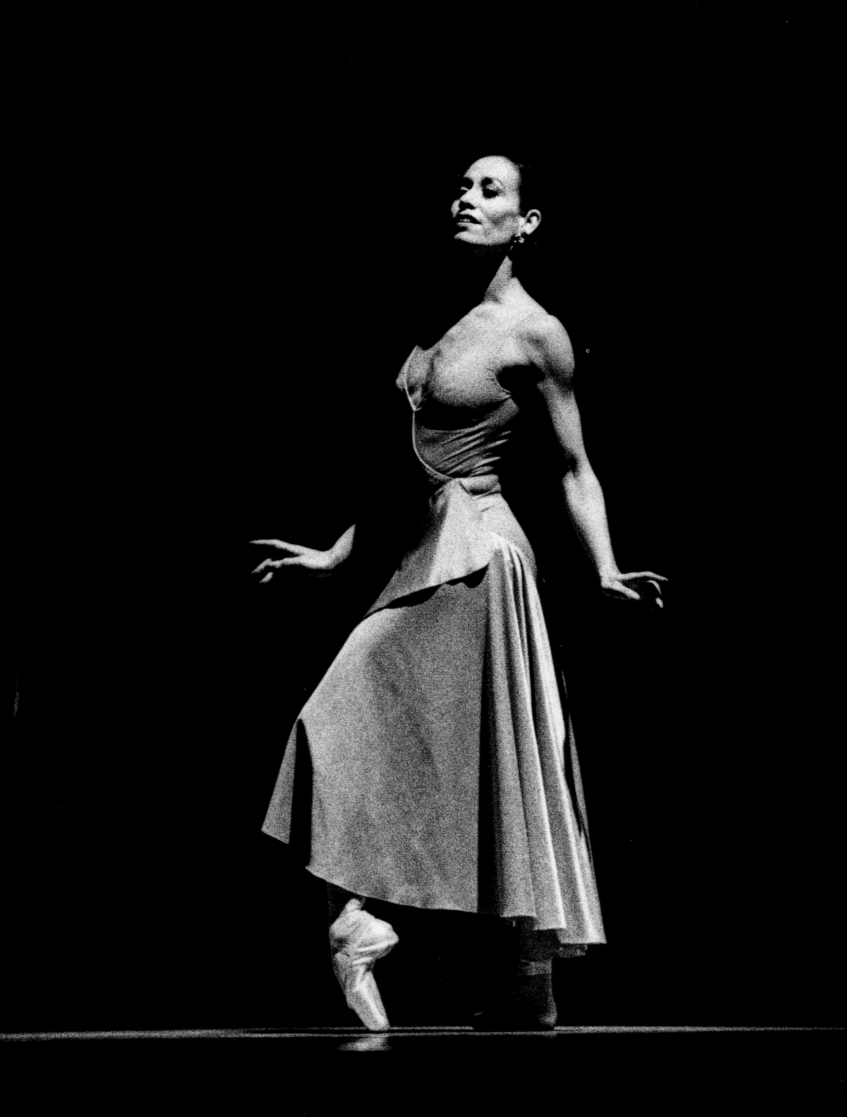

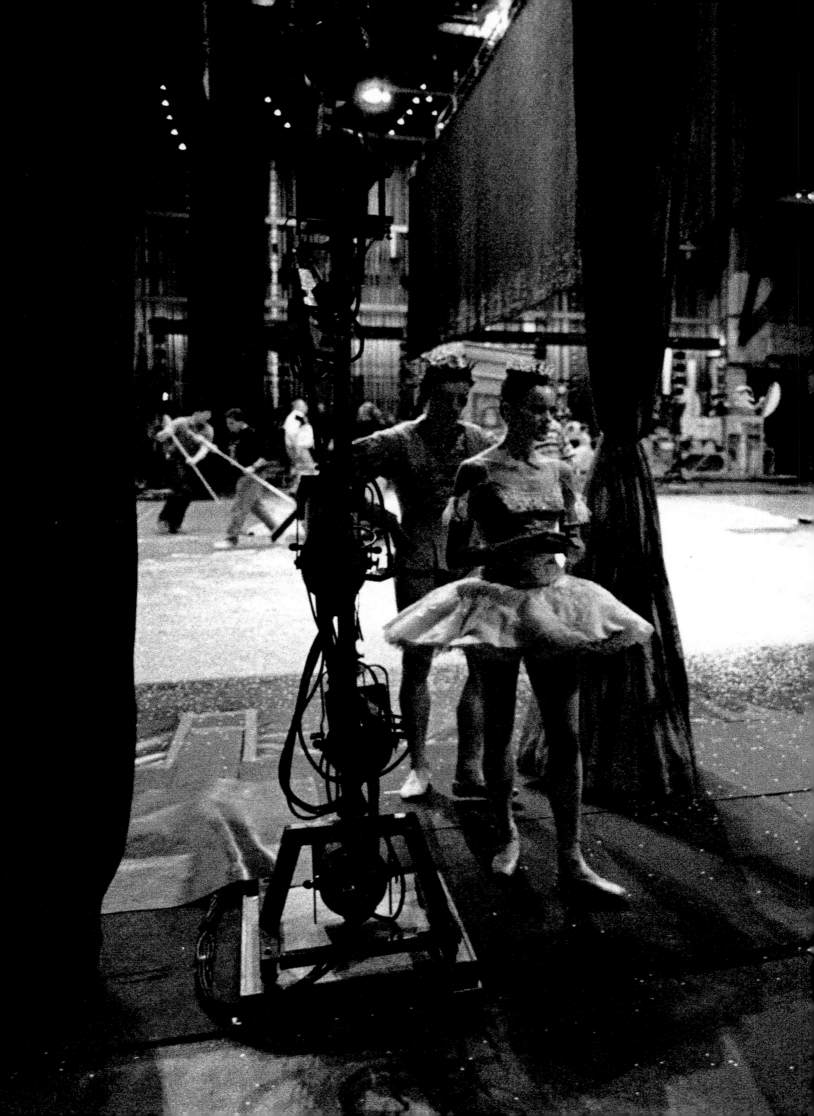

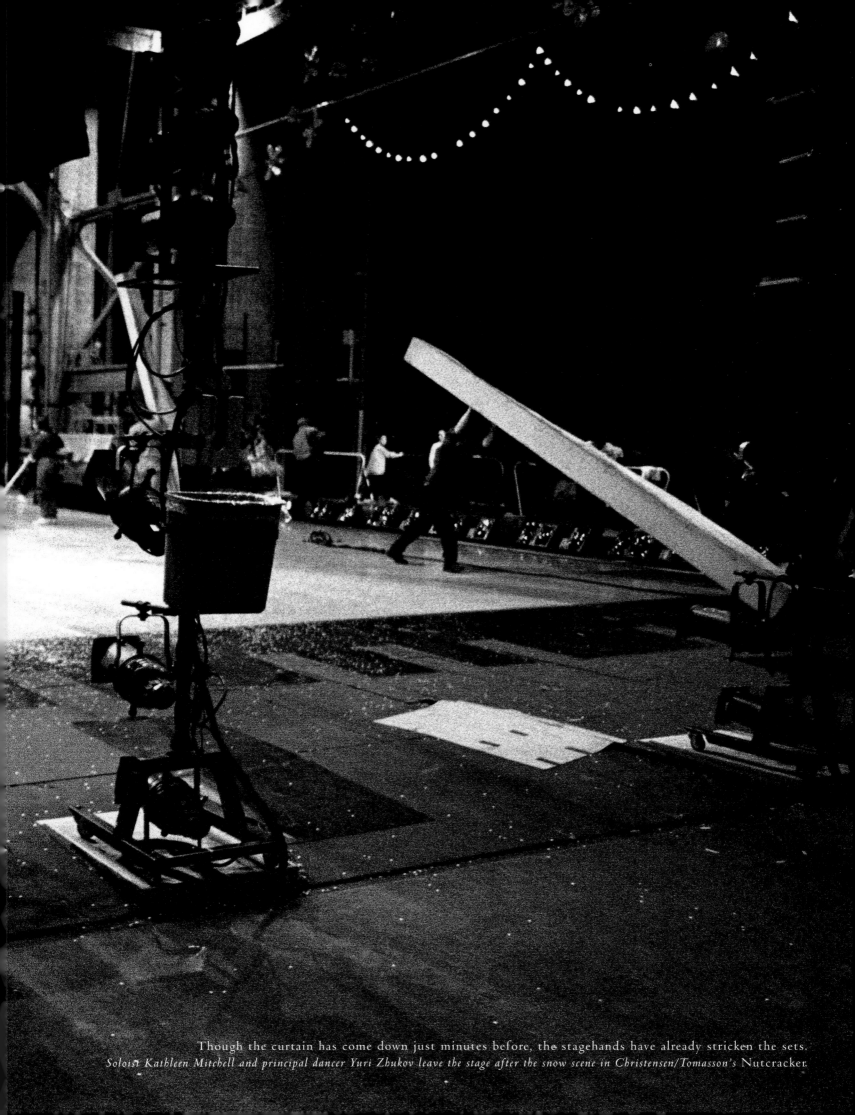

Though the curtain has come down just minutes before, the stagehands have already stricken the sets. *Soloist Kathleen Mitchell and principal dancer Yuri Zhukov leave the stage after the snow scene in Christensen/Tomasson's* Nutcracker.

"I ALWAYS THINK OF A SEDUCTIVE QUALITY. It's a way of projecting passion and drawing the viewer in. I also try to bend and flow with ease, like bamboo—strong but flexible." - *Soloist Eric Hoisington, performing in Val Caniparoli's* Lambarena.

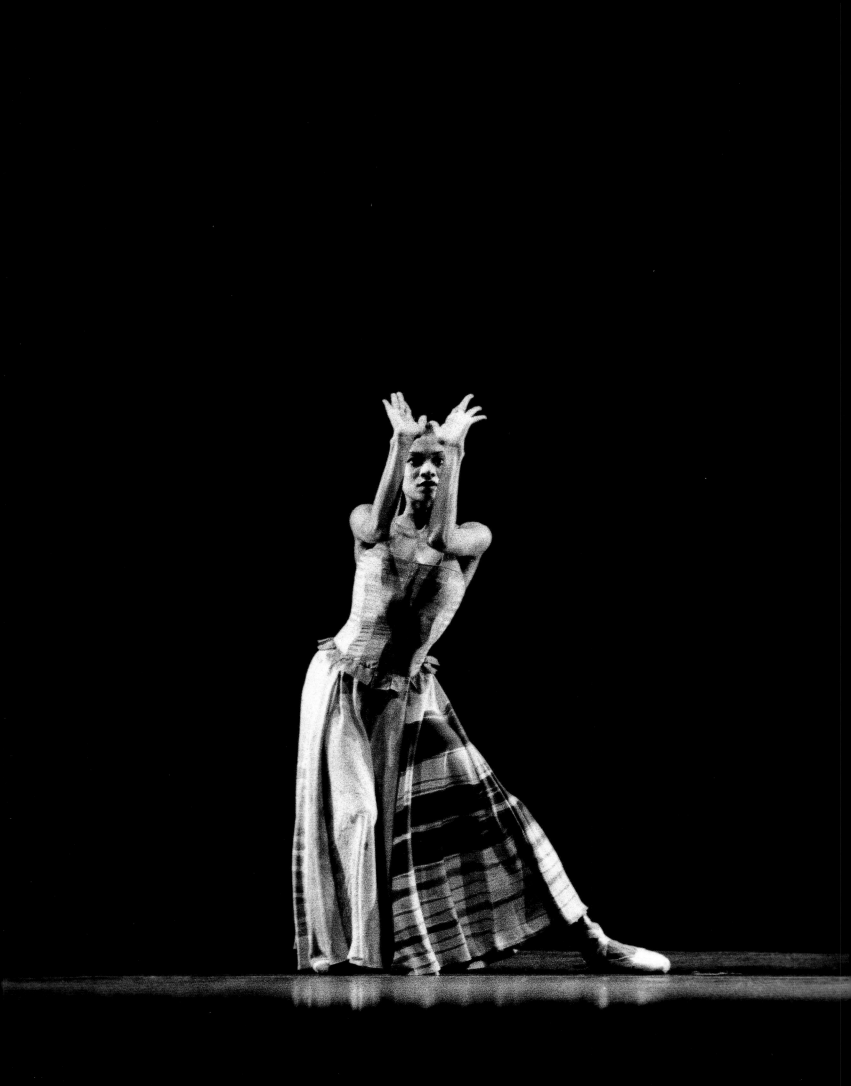

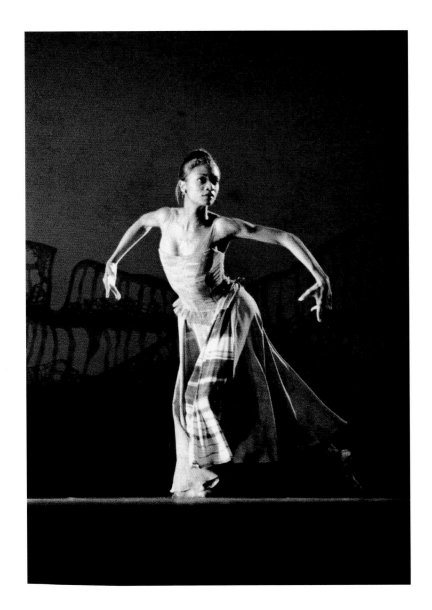

"WHEN I WORKED ON THIS BALLET with Val, I watched rehearsal a lot so I could see what he was doing. It was a great piece to work on. Val and I just sat together and talked and brought in every idea that might apply. I would juxtapose the ideas of the period Western dress and African dress. They're all things that don't really go together, but what can be more down-to-earth than African dance, and what can be more *up* than ballet? Val did this incredible job blending those two qualities in this ballet." - *Costume and set designer Sandra Woodall discussing her collaboration with choreographer Val Caniparoli on* Lambarena. *Corps de ballet dancer Yolonda Jordan performing in Val Caniparoli's* Lambarena.

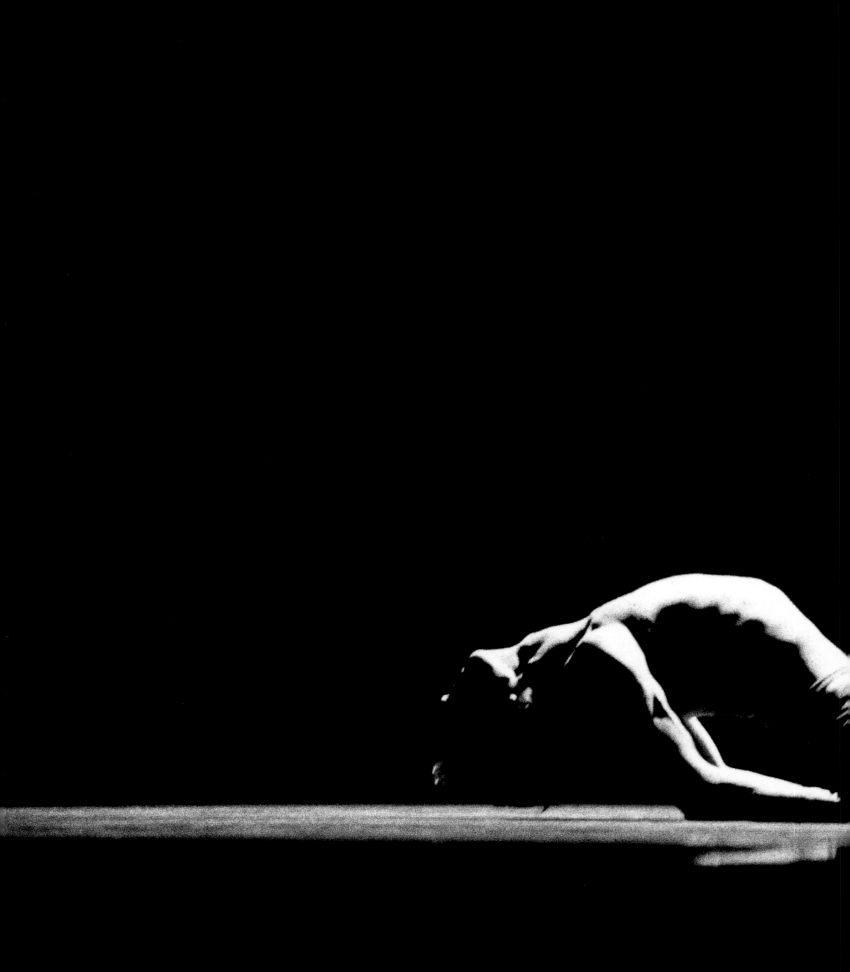

"If you can light ballet, you can light anything. Often there is no scenery to convey the choreographer's intent. All you have is light,

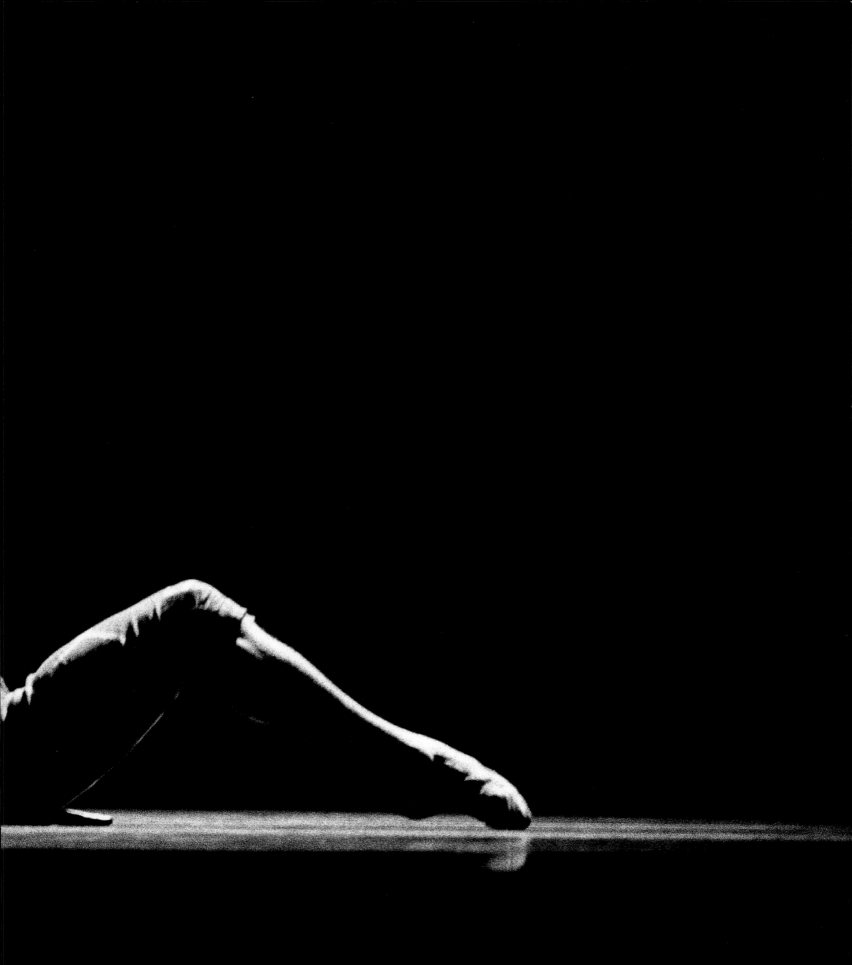

a physical body, and black space." *- Lighting director Lisa Pinkham. Principal dancer Yuri Possokhov in Val Caniparoli's* Lambarena.

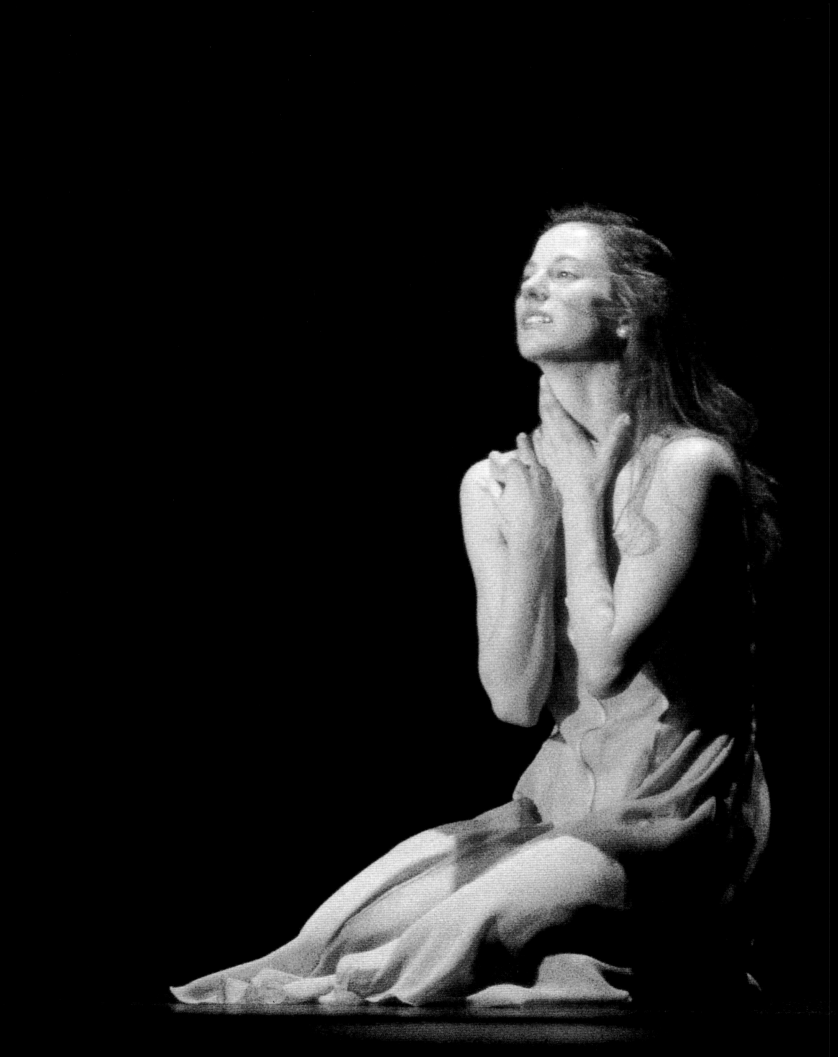

PART OF ME IS IN *NANNA'S LIED*. I IDENTIFY WITH THIS ROLE BECAUSE I GET TO WORK OUT

" I TRY TO TAKE THINGS from everybody. I get inspired by watching the younger dancers in the corps who will try anything, and, by watching the way other principals approach things. In the past, I didn't watch other casts—I was afraid to—but now I do. For *Swan Lake*, I got all the videotapes I could find, and I watched other dancers. Then I applied what I learned. I think it's important not to be satisfied with yourself. Once you get content you stop growing.

When I was young I just thought I was going to be a dancer. I never imagined I would be a principal. I used to practice *Swan Lake* in my sister's bedroom and, of course, I was the Swan Queen.

My strength is my determination, my desire to improve and be more than I am, to go that extra step. It's definitely not my body. I think I have strong technique, and onstage I feel like I'm in my element. Also, I love to become another person; acting is one of my favorite things.

I gave up more of an education than I wanted. For the eighth, ninth, and tenth grades I was tutored, and I taught myself. I did not have a good education, which is frustrating now but I was able to dedicate important years to physical training. If I hadn't done this, would I be the same dancer I am today? I'm not sure.

I've never been one to shrink back from a challenge. As a principal you are often left alone so you have to be very self-challenging. In general, though, I am too hard on myself. I demand perfection, and it's impossible to get. I am Irish and Italian, and I have a big temper. I don't hide my emotions. Still, I try to keep things in perspective. I love the art form. It's my outlet. I've had a wonderful career so far, with great partners, and it's been nice to be nurtured."
- *Elizabeth Loscavio*

Principal dancer Elizabeth Loscavio in Tomasson's Nanna's Lied.

MY FRUSTRATIONS ONSTAGE. - *Elizabeth Loscavio*

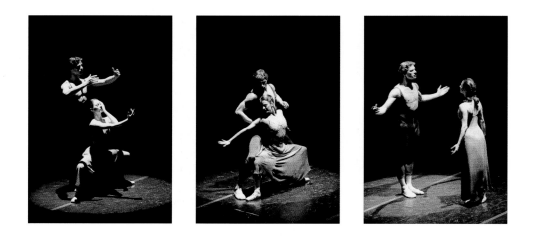

OCCASIONALLY CHOREOGRAPHERS ARE SO INSPIRED by artists in the company that they create pieces specifically for them. Dancers dream of this kind of collaboration because it can mean that the movement will suit their style of dancing and showcase their particular strengths and abilities. Visiting Australian choreographer Stanton Welch created this pas de deux, *La Cathedrále Engloutie,* specifically for principal dancers Elizabeth Loscavio and Yuri Possokhov. *Principal dancers Elizabeth Loscavio and Yuri Possokhov in Stanton Welch's* La Cathedrále Engloutie.

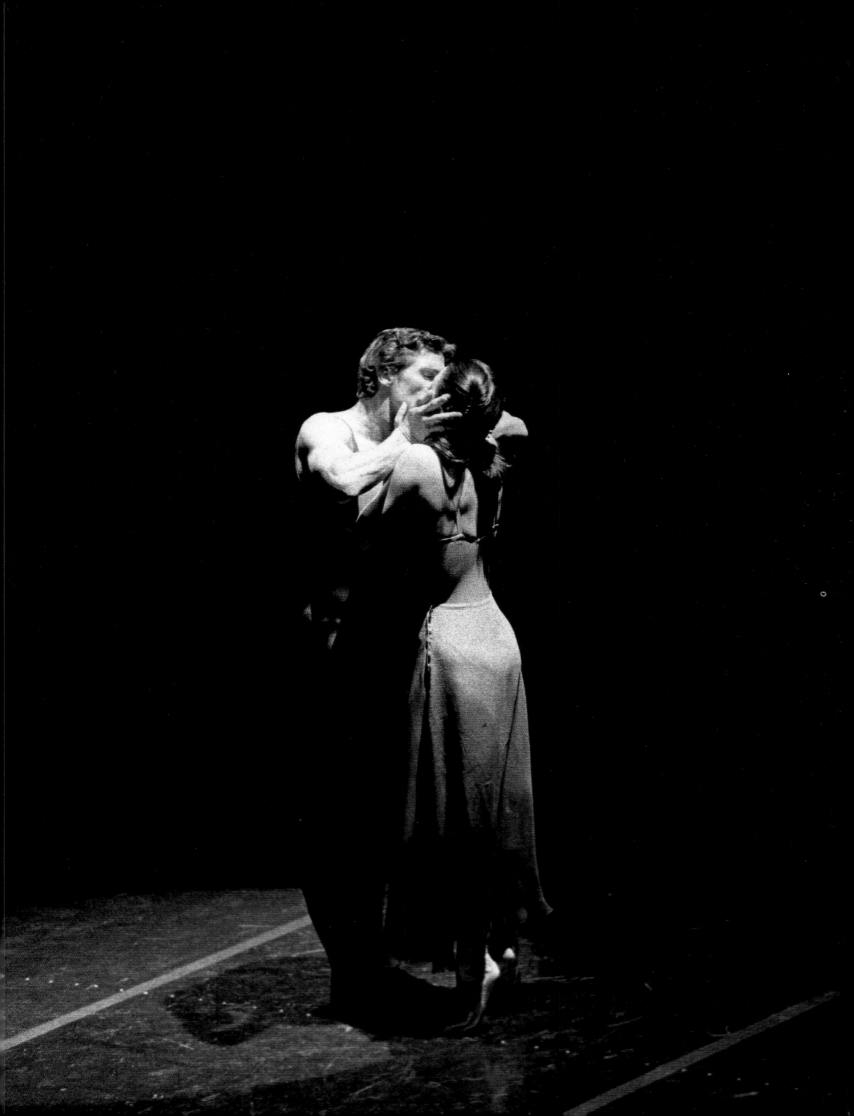

"

I HAD NO CONCEPT that theater was anywhere in my future. It was not part of our family life, but I realized there was an acceptance and a freedom in theater that was marvelous. I went into architecture, then I went into painting, and of course I tried to act, but I was really bad. I directed, then people recommended I try costume design.

The first time I worked with SFB was when Mark Morris asked me to work on *Maelstrom.* Mark is such a personality. He's so smart, you don't know what to do with him. It's always been very interesting working with him because Mark came from a background of modern dance, in which costumes were something almost to be avoided. Even though what he and I have done has been very designed, there is a sense that his artistic credo is often a found-object sensibility, like T-shirts and shorts, secondhand dresses—a certain funkiness. He has such an open mind that if you ask if the dancers will be wearing pants or shorts or skirts, he'll say 'yeah.'

I think I'm a very good collaborator. I find it exciting to be in a room with people when ideas take form, to hear some music, watch things that someone like Helgi has done, have other designers around, and actually be able to engage in something and pull ideas from that time. It's something that I am good at and that I'm happiest doing.

CLOTHING IS CLOTHING, but in a way it's a machine. There's a visual level, a physical level, and a comfort level and we have to make these garments more comfortable. Hopefully that will create a sleeker visual image as well. Also, you want to know that what one petite dancer can wear, one fabulously tall dancer can wear.

I'm not here to please myself. The first person I'm here to please is the person I work for, the choreographer or director or actor. That is actually a credo for me. Often, I will just sit there and listen and just try to get in their head. It's not just mine onstage. Collectively, a lot is going on. I think anyone in showbiz would have to admit that it is multi-layered. There are times when you'll use a particular costume because you know it will bring joy to an audience. You'll think 'Put a red dress in the show,' because everybody loves red dresses.

I am pretty free about sharing information, especially with younger people. I learned because people shared with me, so I'm carrying through with that."
- *Costume designer Martin Pakledinez*

Principal dancer Katita Waldo with members of the corps in Tomasson's Tuning Game (*costumes by Martin Pakledinez*).

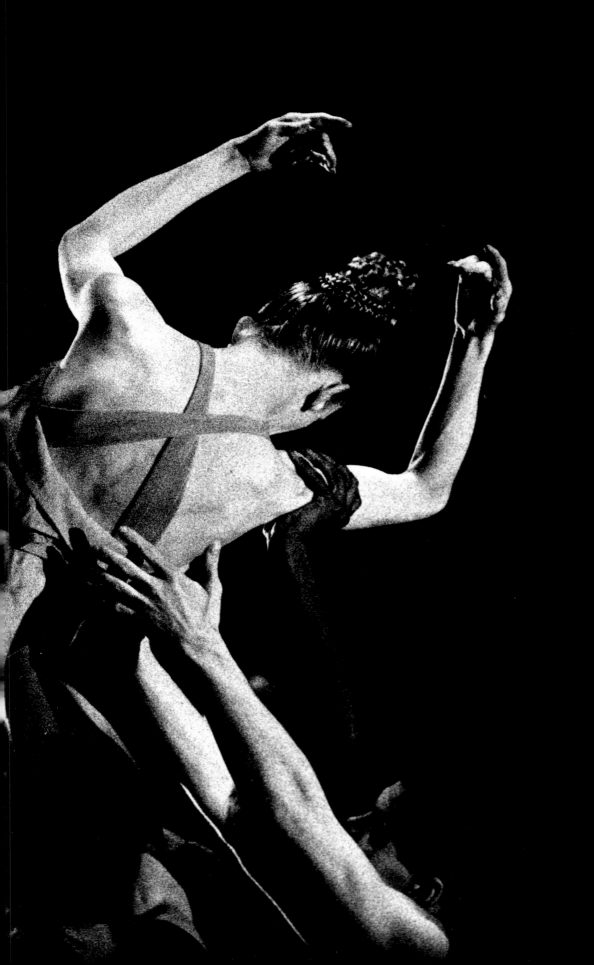

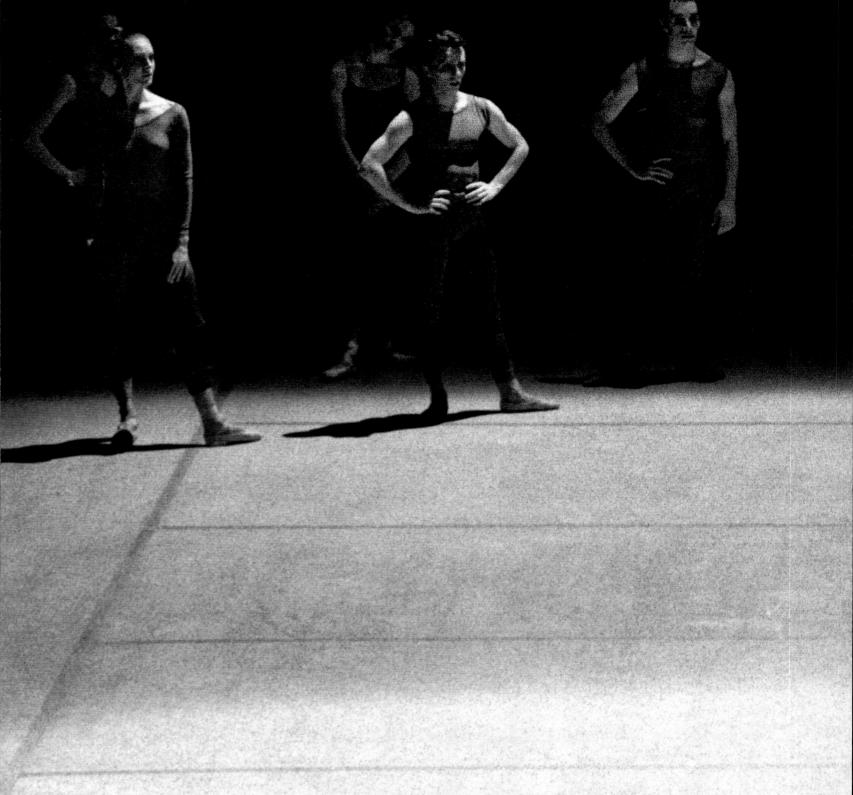

TOURING IS AN IMPORTANT ELEMENT OF EACH SEASON. A successful tour in other major cities can revitalize a company while boosting confidence and creative excellence in its artists. Exposure to new audiences, venues, and critics provides essential diversity in the careers of dancers, choreographers, directors, and others involved with the company. *Principal dancer Muriel Maffre (front) during a performance of William Forsythe's* in the middle, somewhat elevated *on a tour at the New York State Theater.*

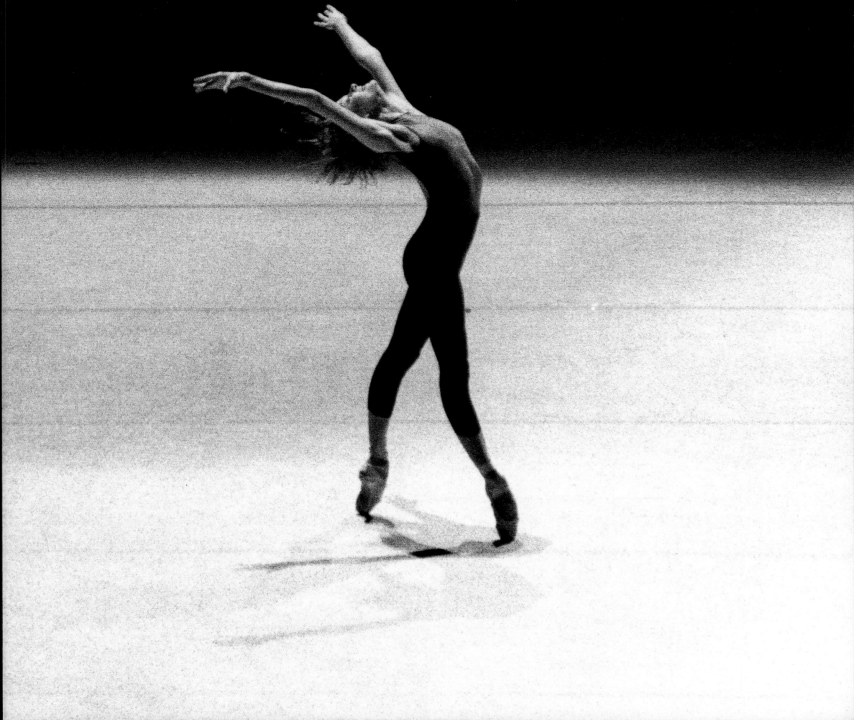

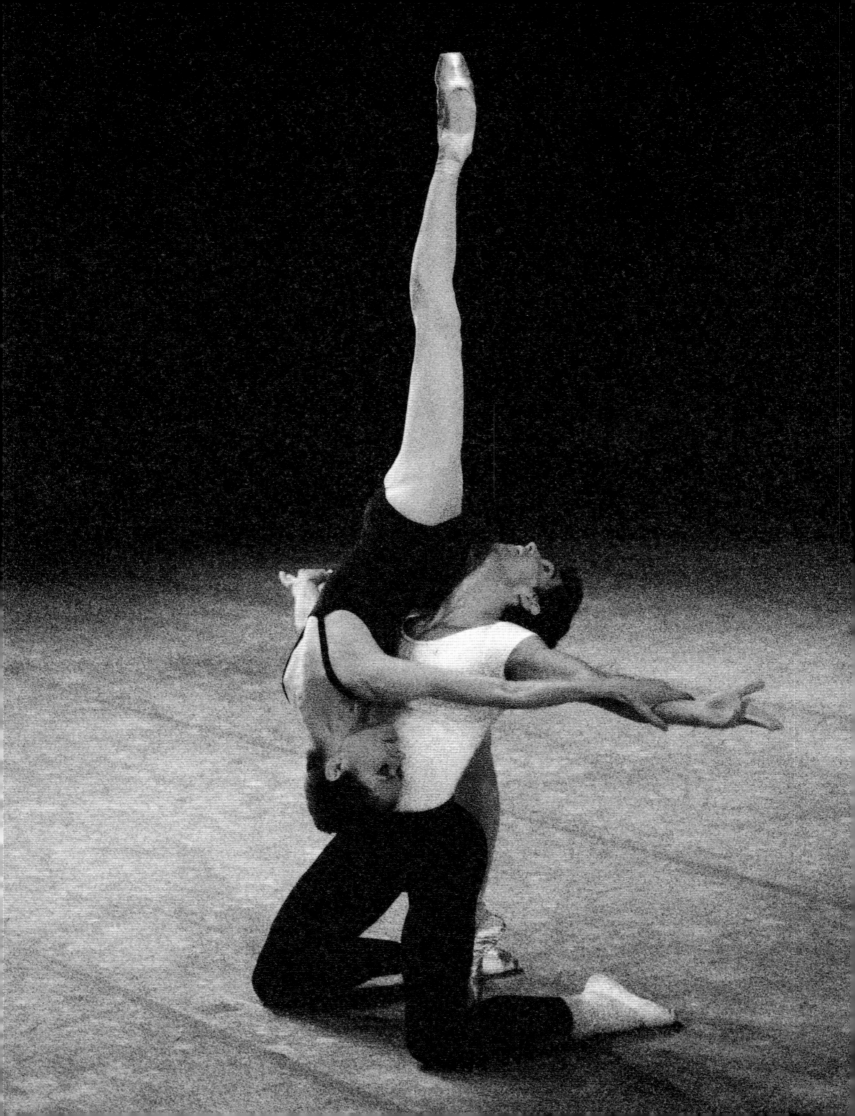

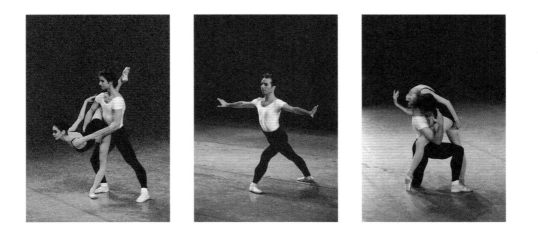

"I STRIVE TO ACHIEVE A FREEDOM; to experience the exhilaration of creating something unique and knowing it is the final exclamation point to a long process of hard work and dedication." - *Principal dancer Benjamin Pierce.* *Principal dancers Muriel Maffre and Benjamin Pierce (left), Lucia Lacarra and Stephen Legate (above, left and right), and Christopher Stowell (above, center) performing George Balanchine's* Agon.

"

YEARS AGO, I SAW *SWAN LAKE* with the Houston Ballet in New York. During a scene in which the queen tells the prince that he must marry, there was a contraction in his body that was so meaningful. It was then that I realized I could combine theater with athleticism in dance.

So far in my career, I am proud of my collaboration with David Bintley and with Helgi in *When We No Longer Touch*. The creative process is so fascinating—the way you can improvise and find an organic sense of motion that fits you.

In ballet, there is such a history of passing things down. Teachers nurture us and give us so much. Teaching is also an intriguing position to be in, because you are absolutely lifting the students up. For a director, knowing what to give and what to take from dancers is a gift.

I feel there is a reason for everything. If you get injured, you have to listen to your body. And we are forced to listen all the time. I'm thirty-two, and I'm still trying to become a better dancer. I'm learning more efficient, more natural ways of moving.

Ballet is about you, the dance, and the observer. It's really no fun dancing in a room by yourself. If there is a dog in the studio, I will dance for it.

I HAVE SO MANY REGRETS. I regret that I didn't start until I was seventeen. I wish I had become a famous boy soprano. I regret that I started smoking at an early age, and I regret that I spent my twenties fucked up. I wish I didn't regret anything.

In other dancers I admire a sense of focus that is constant in their performance, a commitment that doesn't break, and a thoroughness in planning what they are going to do, like Elizabeth Loscavio dancing the potion scene in *Romeo and Juliet*. She thought out every action and every phrase of the music.

I'm learning only now that there is truth in everything and that you must become vulnerable to the teacher to learn. Never assume you know the position. My yoga teacher taught me that. Because conflict comes from resistance, you need to remain vulnerable.

So far, I haven't wanted to become a principal dancer here, because I think to reach that level you have to have certain things under your belt. But I do watch the principal dancers in rehearsals to motivate myself.

What I like the least is the pain. You are utterly afraid accidents will occur. But I don't want to contradict myself here, because pain is an opportunity to evolve, to deal with issues. In the future I hope to choreograph and to direct, but not a classical ballet company. I want to continue to express myself with voice and subtle physical senses." - *Eric Hoisington*

Soloist Eric Hoisington performing James Kudelka's The End.

CAPTURING OTHER PEOPLE'S SPIRITS. *- Eric Hoisington*

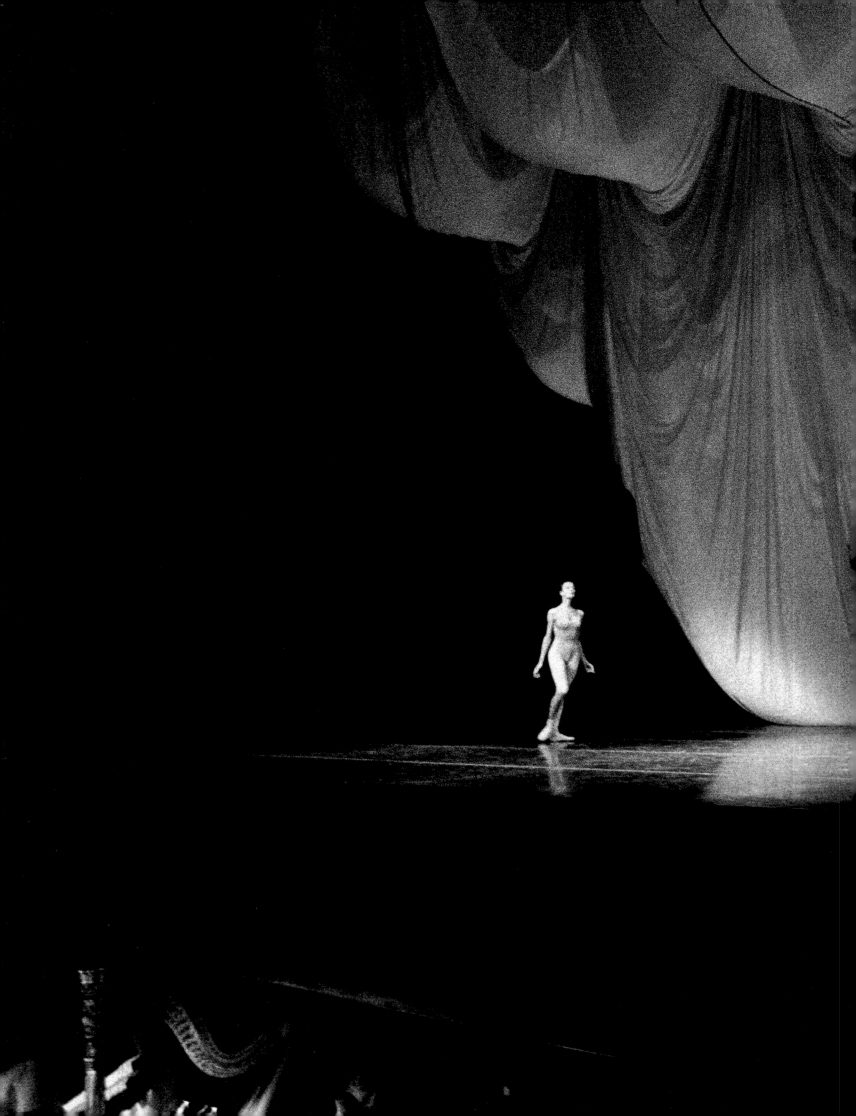

"WHEN I'M PERFORMING I always think of a story in my head.
I imagine there is a relationship and I am protecting someone, showing them the world."
- *Soloist Jais Zinoun. Principal dancer Muriel Maffre and soloist Jais Zinoun in Ben Stevensen's* Four Last Songs.

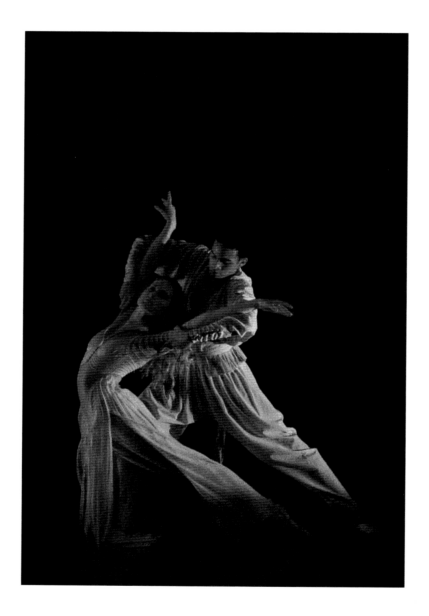

" THE LATE Jens Jacob Warsaae designed the costumes for many of the ballets in the company's repertoire. When asked why he went to such great lengths to incorporate intricate detail into all of the costumes—detail that the audience would never see—he replied, 'The dancers will see it, and they will perform better.'" - *Costume supervisor George Elvin. Principal dancer Julia Adam (right) in Tomasson's* Swan Lake. *Corps de ballet dancers Jennifer Blake and Ikolo Griffin perform Paul Gibson's* Rhapsody *(above).*

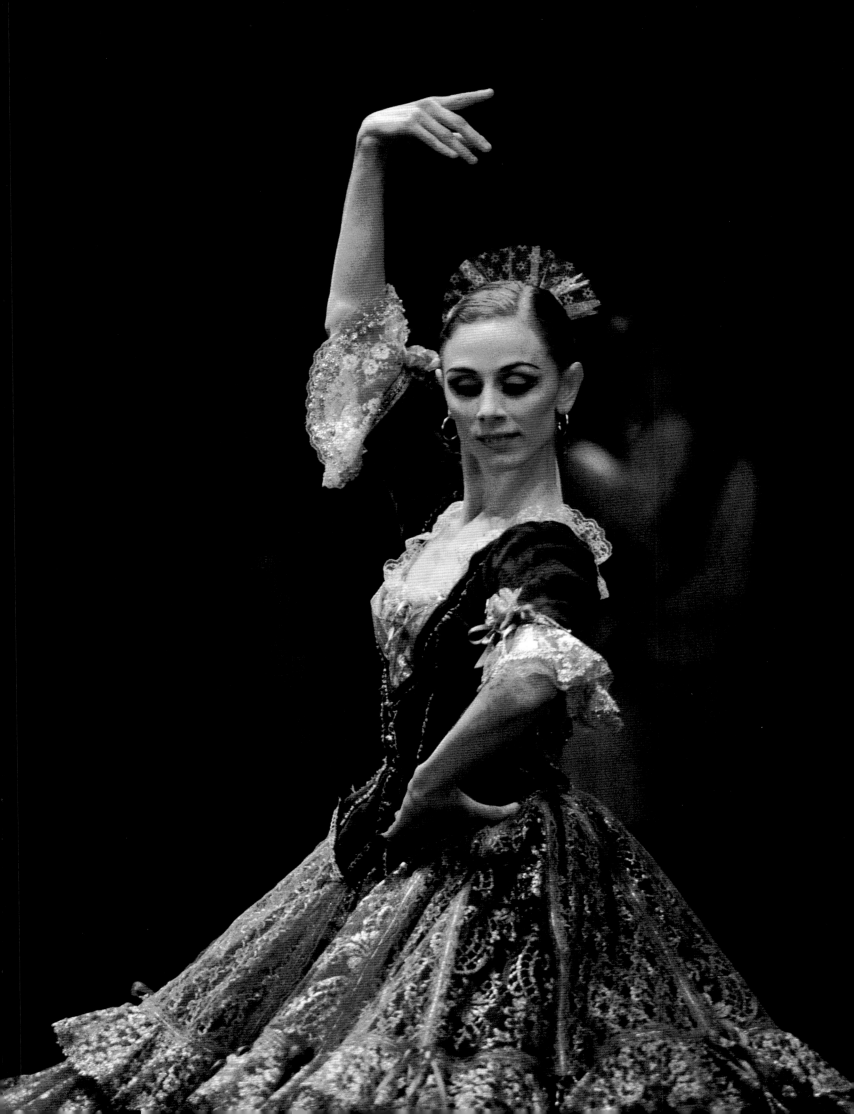

"THE FIRST THING PEOPLE SEE in a performance is the shape of the body and the line. But what I'm really looking for is to feel something. If I feel something or cry, that's the most memorable dancing, maybe because this is what I'm trying to give when I dance.

What I love is the fifteen minutes, the hour, or the two-hour journey onstage. When I finish and I'm in the dressing room, I feel great. It's something you can't explain.

As a child, I was always saying to my mother, 'I want to be onstage. I don't care if I am not the first one, I don't care if I am the last swan in the last row. I want to dance.' But I didn't start ballet until I was ten, because I was born in a little town in Spain where there was no academy. Once I started, I had to work for four years to earn the money I needed to go away to Madrid and continue my studies.

Leaving home at fourteen was a great sacrifice. Living in a big city for the first time without family or friends, without anything, you have to laugh to continue. I was so blue, so homesick, that I would spend hours on the phone with my mom. After talking with her for two hours I would really shine again.

All the work I'm doing is so that I can connect with people. In the studio I am dancing for training; when I am onstage, I am only thinking of giving something. My adrenaline is flowing and I feel an energy. If not, I would dance at home in front of a mirror.

A lot of people have helped with my dancing at the right moment. In general, I feel there are always people there in the right place at the right moment; you only have to look to see them.

I'm not someone who looks to the future all the time. I live day-to-day. If, at the moment, you can't understand why you are doing something, you will see after. And I'm not trying to arrive. I never think about that. Instead, I am trying to do the little things in the best way, and if that will help me to arrive in a good place, then great. But I don't have just one goal.

In ballet you are never at the top. There is always something to work on. And sometimes at the end of the week I want to go back to Spain, go to the beach, take a holiday, forget everything. I want to be a girl of twenty-two watching TV, because I have too much responsibility and too much to think about. But that's not for me. I am proud that I am doing what I've always wanted to do. It is my life.

If one day I have to leave the dance floor, then I want to continue with something related to the dance world. I would like to be a ballet mistress, giving what I feel when I watch the dance, trying to give that to other dancers, to help them show more of what they have inside." - *Lucia Lacarra*

Principal dancer Lucia Lacarra performing in Victor Gsovsky's Grand Pas Classique.

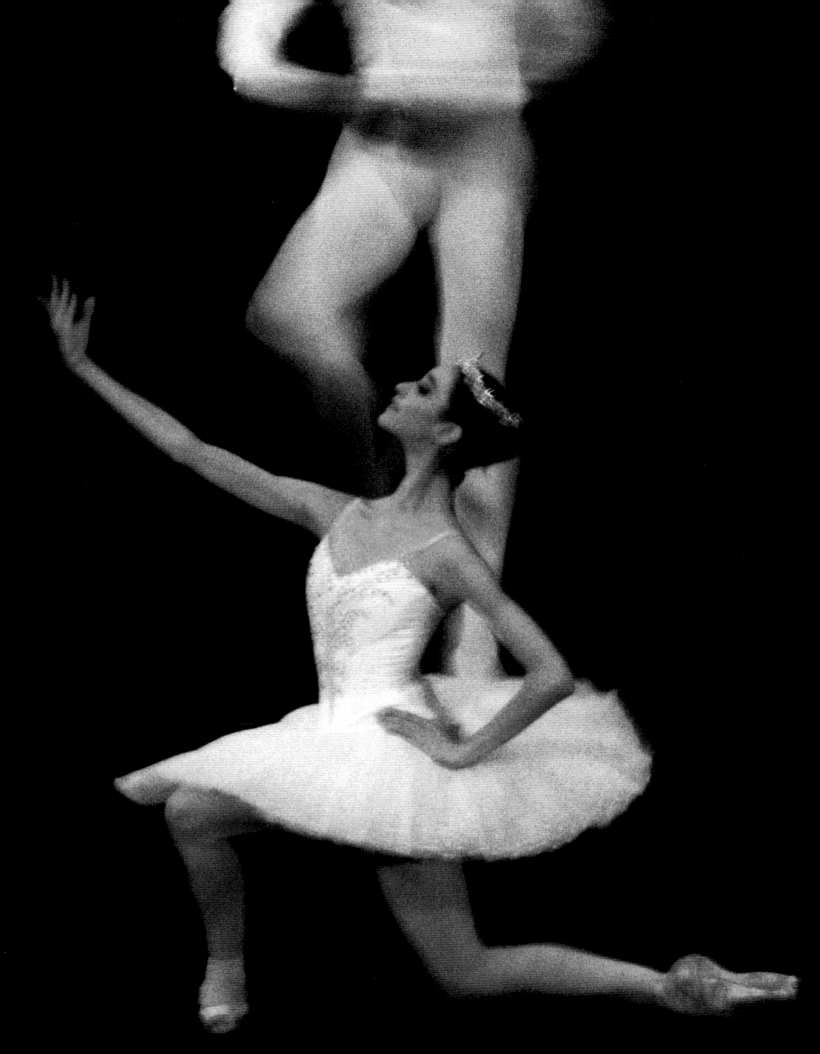

ALL OF MY PROBLEMS. I WAS REALLY FEELING SOMETHING INCREDIBLE.' *- Lucia Lacarra*

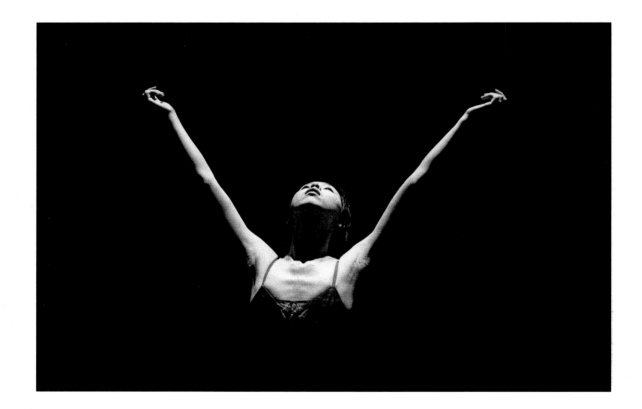

"I'M ALWAYS LOOKING FOR MUSIC, and I came upon the score for *Maninyas* by chance. I was in a one-street town and I went into a store that had three classical CDs, and this was one of them. I listened to the music as I was traveling around in a bus looking out into the Australian landscape, and the combination inspired me. There are these vast, open spaces in Australia that are beautiful, dangerous, and rugged, and that's what I felt in the music. I see this piece as a process of unveiling. As people get to know each other more closely, they take off their veils. They undress themselves spiritually as well as physically." - *Choreographer Stanton Welch (excerpted from program notes by dance writer Sheryl Flatow, 1996). Soloist Leslie Young (above) and principal dancers Yuan Yuan Tan and Benjamin Pierce (right) in Stanton Welch's* Maninyas.

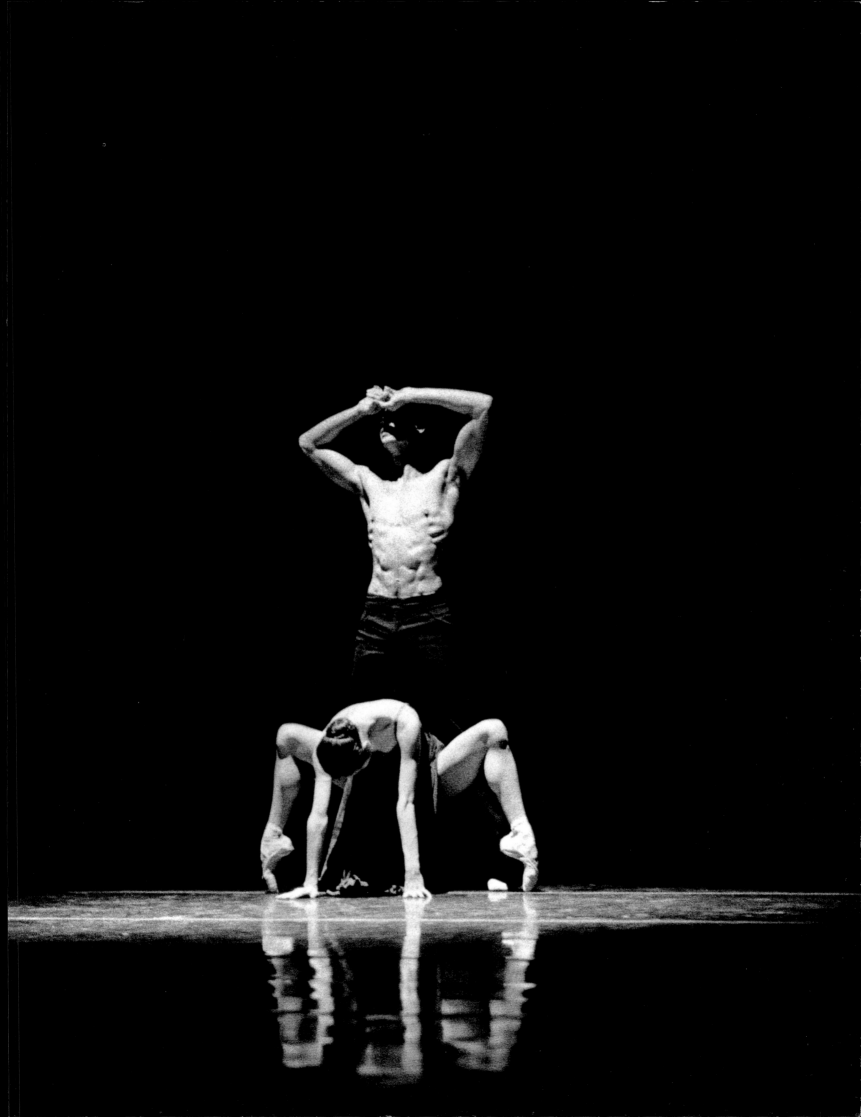

"I DEFINITELY HAVE SOMETHING IN ME that makes me act, that makes me perform. It's like a light in me that's

always shining." - *Corps de ballet dancer Askia Swift in Stanton Welch's* Maninyas.

Principal dancer Sabina Allemann and principal character dancer Jorge Esquivel during the third act of Tomasson's Swan Lake.

"The idea for this ballet was an abstract picturing of the Sons of Horus, who were ancient Egyptian guardians of the viscera, as they were being removed from the deceased person during mummification. Isis presides over these events and then leads a procession to the field of reeds, which was a kind of Egyptian heaven. I'm a mythology and history fan. I was interested in the pictorial quality of hieroglyphs and their relation to classical dance with its very stylized movements." - *Choreographer David Bintley. Members of the corps de ballet (above) and principal dancer Muriel Maffre as Isis (right) in David Bintley's* The Sons of Horus.

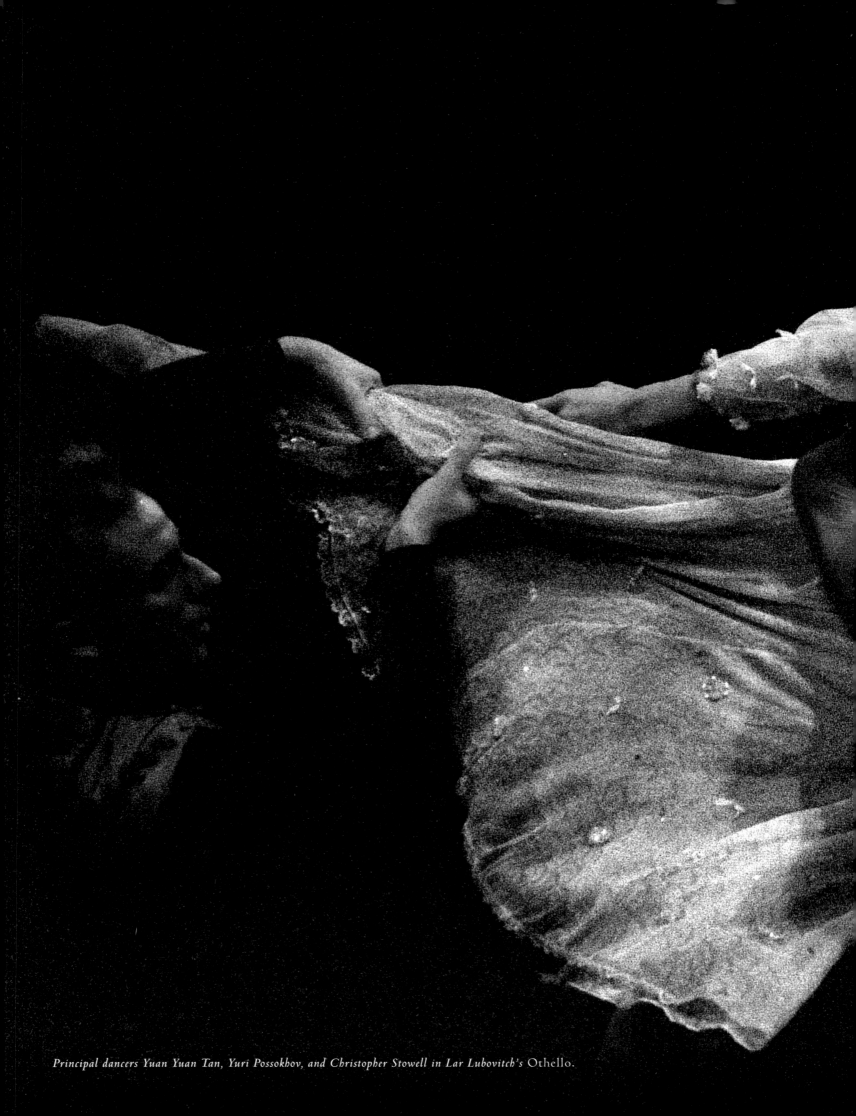

Principal dancers Yuan Yuan Tan, Yuri Possokhov, and Christopher Stowell in Lar Lubovitch's Othello.

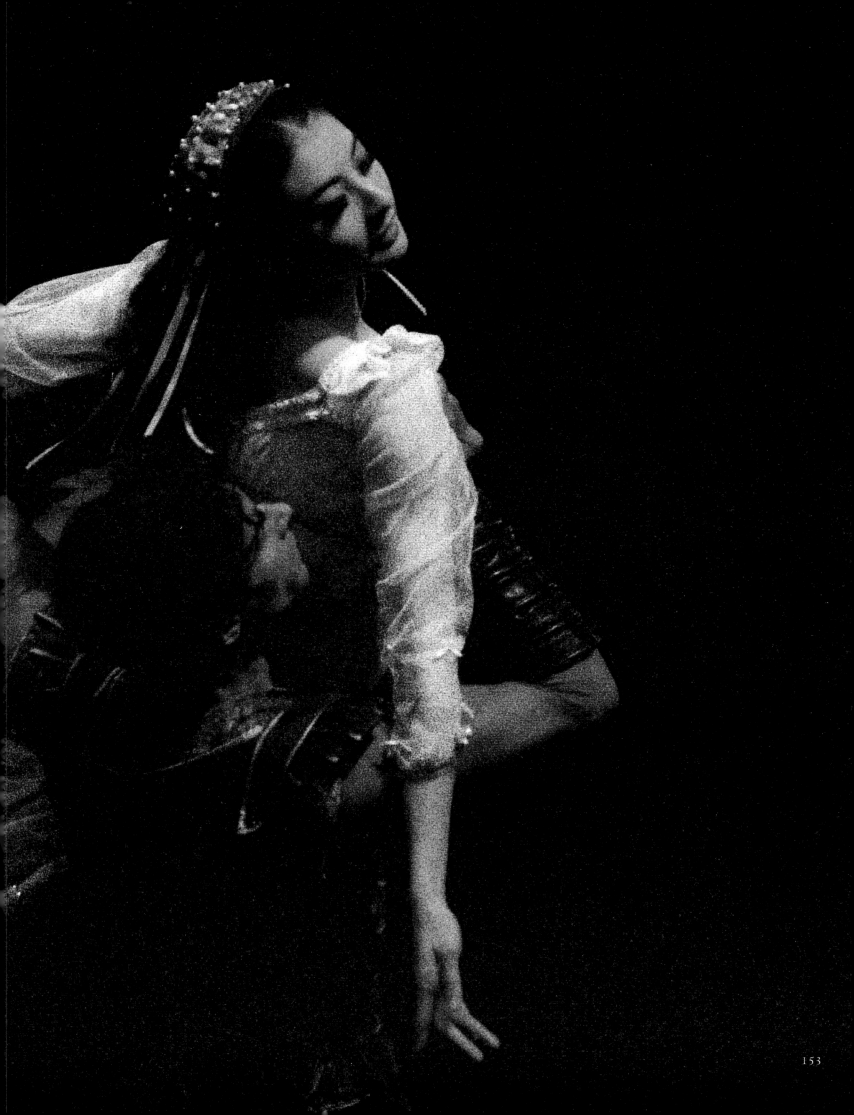

"IT WAS LIKE FATE. When I was eight years old, a strange feeling brought me to dance, as if my legs went by themselves. Though I had never seen ballet before, it quickly became the main thing in my life.

I studied at the Moscow Ballet School, which is like a huge ballet factory. Every year about two hundred start, and after eight years maybe forty are left. We had to pass many exams: flexibility and jumping, medical condition, and higher levels of physicality and extension. And we had so many subjects to learn. In addition to mathematics and literature, there was history of ballet, music, piano, ballroom dance, character dance, folk dance, jazz dance. We started school at 8:30 in the morning and we finished at 8:30 at night. For us, it was home. It was a great school and a rich experience, and it is a huge base for me now.

The system of coaching in Russia is not like here. A coach in Russia is a little bit like a partner, even family. He's responsible for everything, from the first second onstage until the end of the performance. He prepares the ballet with you and talks about everything. It's a more intimate connection.

For years I was in the Bolshoi Ballet, and it was kind of a stressful time. I decided I had to change my life, my vision of dance—everything. I moved to Denmark and danced with the Royal Danish Ballet for two years. Helgi came there to stage *The Sleeping Beauty* and then he talked to me after the first performance.

Dancing is always challenging. Every day is a challenge, and every day you are disappointed with yourself. You are suffering in the class, you are suffering in the rehearsals, always. It's kind of nice suffering; I like it, but only with the feeling that it's for something. I have to have barricades in life to feel life. If I have not challenged something I cannot feel life.

I fight with myself, with my negative side. I should concentrate on the positive side, or I will be smashed. I like Tony Randazzo, his way of life. I like the way he's always striving and he's not panicked. Or maybe he is panicked, but nobody sees it. David Palmer is the same. He's a fighter; he's pushing himself and he's moving forward.

NOW I'M TRYING TO CHOREOGRAPH, which is completely different from dancing. You should reject everything that you did on your own in dance. You must change your mind, which is difficult, because there are so many influences from the past. You have to be gifted by God to be a choreographer. I'm trying, but I don't know if it is to be. I'm sure that I can be a teacher or coach, but that doesn't push me.

Dance is a great expression of feelings. It is unreal, mystical. It's a world not from the Earth. When you are dancing it's mysterious. You are coming into a world of magic. It's a kind of drug for me."
-*Yuri Possokhov*

Principal dancer Yuri Possokhov in Lar Lubovitch's Othello.

WHEN YOU ARE SATISFIED, IT IS JUST FOR A MOMENT. BUT, THOSE FEW MOMENTS OF

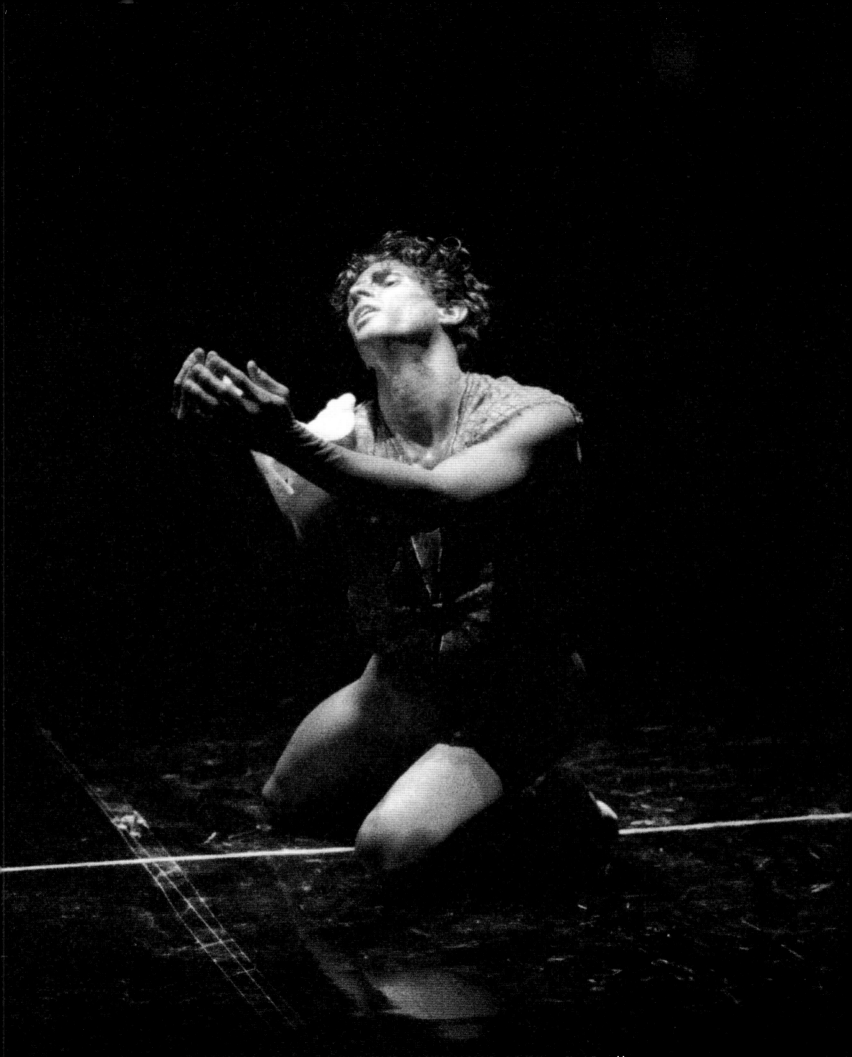

SATISFACTION WILL NEVER COMPARE WITH ANYTHING ELSE. - *Yuri Possokhov*

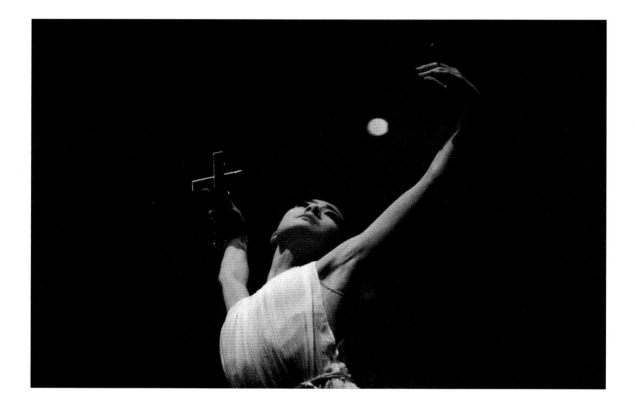

"IN BALLET there is so much focus on the poses, but I try to get into the piece and make the steps in between very important—to connect the whole piece." - *Yuan Yuan Tan. Principal dancer Yuan Yuan Tan as Desdemona (above) and with principal dancer Yuri Possokhov (right) in Lar Lubovitch's* Othello.

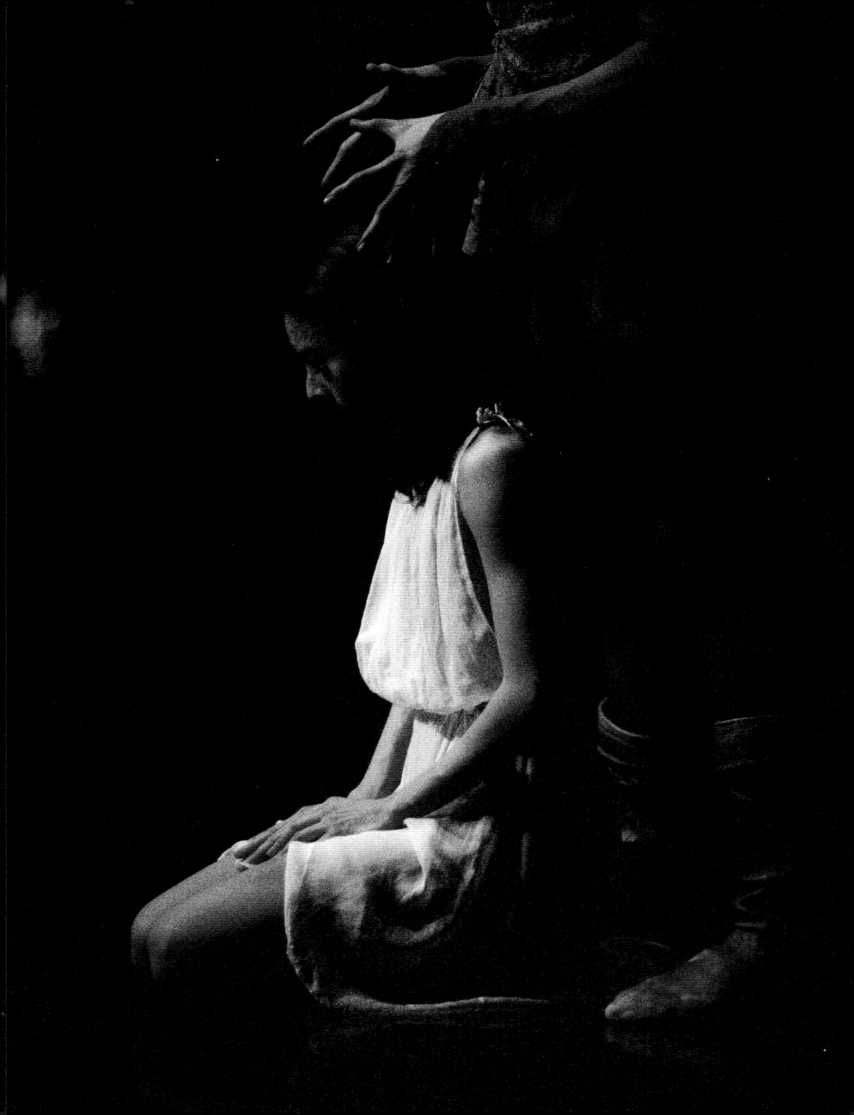

"MY MOTTO IS: 'No te pueden quitar lo bailado,' which means: 'They can't take away what you've danced.'"
- Principal dancer Katita Waldo. Soloist Claudia Alfieri in Lar Lubovitch's Othello.

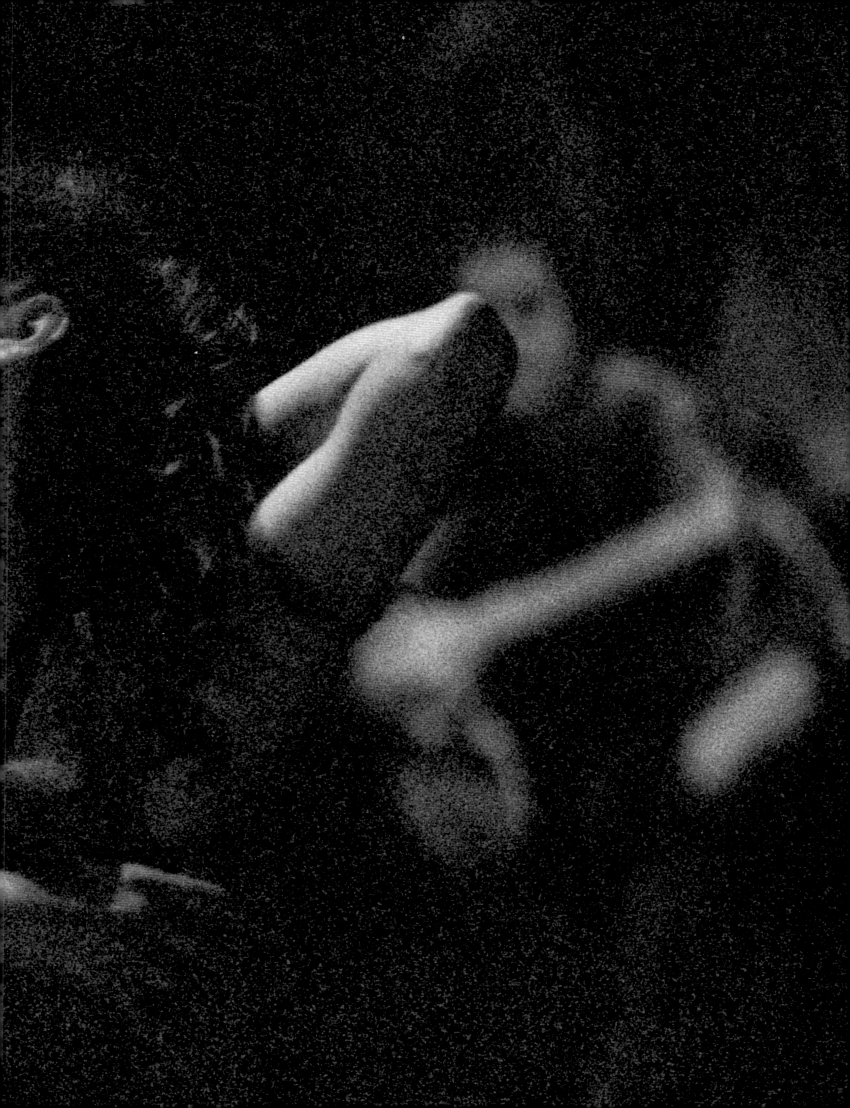

ACKNOWLEDGMENTS

Special thanks to: Susan Backman, Joanna Berman, Lola de Avila, Alvin Henry, Philo Holland, Diane Kounalakis, Pamela Lord, Patricia Manwaring, Charles Miers, Erik Ostling, Elise Paul, Christopher Ulrich, Alex Tart, Helgi Tomasson, and all the remarkable dancers in San Francisco Ballet.

Also: Julia Adam, Lynne Baer, Debra Bernard, Bonita Borne, Jody Brotman, Regina Bustillos, Peter Butt, Linda Candelaria, David Chaplin, The Christensen Society, Anne Culbertson, George Elvin, Betsy Erickson, Felissimo Corporation, Dan Friedlander, Gamma photo labs, Thyra Hartshorn, Patrick Hinds, Dennis Hudson, James and Carla Hunt, Jeff Hunt, Megumi and Doug Inouye, Irina Jacobson, Arthur Jacobus, Nancy Johnson, Benjamin Lee, Carol Lee, Richard Lee, Rhonda and Wilson Low, Michael Mabry, McRay Magleby, May and Sperry Manwaring, Glenn McCoy, Tom McIntyre, Ray Morales, W. John Mullineaux, Carol Oune, Anita Paciotti, Lisa Pinkham, Paul Rice, San Francisco Ballet Auxiliary, Bobby Score, James Silverberg, Jim Sohm, Christopher Stowell, Martin Takigawa, Marlene Tomasson, Urban Digital Color, Sarah Vardigans, Ashley Wheater, Kazuhiko Yazaki, and many others who helped with the project.

Additional notes: For technical advice and endless help, thanks to Erik Ostling, whose photograph graces the pages of 28 and 29. For editorial advice, writing, and much more, thanks to Patricia Manwaring. For overwhelming assistance and support, thanks to Pamela Lord. For persistence and patience with black-and-white printing over the years, thanks to Susan Backman. For inspiration, thanks to Maria Vegh, Toni Lander-Marks, and Willam Christensen. For being a wonderful editor to work with, thanks to Alex Tart. For making this book possible, thanks to Christopher Ulrich.